Art and Ideas

Art and Ideas

An Approach to Art Appreciation

PATRICK CARPENTER AND WILLIAM GRAHAM

MILLS AND BOON LONDON

First Published in Great Britain 1971 by Mills and Boon Limited,
17–19 Foley Street, London, W1A 1DR

Printed in Great Britain by Jarrold & Sons Ltd, Norwich

Contents

Introduction

The visual arts are a very subtle form of expression, a complex network of intellectual, emotional, and sensuous perception which cannot be fitted into any absolute pattern or formula, but which, on the contrary, may be open to a number of different interpretations.

This book is concerned with how we may understand art, having regard for this complexity. Its main aim is to help the reader to think imaginatively about art, not as an isolated academic subject, but as a vital process which is in a constant state of change, and by which man lives more fully.

This study, therefore, is not to be regarded as a conventional history of art, and it is not, in fact, the kind of book which an art historian would write. For the facts of art history the reader may refer to the many excellent books which are readily available. Here we are concerned, not so much with *what* happened as with *why* it happened.

This approach follows from the authors both being practising artists who believe that an insight into a particular work or style is most easily gained by putting oneself imaginatively in the position of the artist who produced it. It is an attempt to explain art from the inside rather than the outside; its infinitely variable relationships to reality, and the equally various responses it may evoke in different viewers.

Thus the reader must not expect any tidy pigeon-holing of styles. The book is deliberately full of speculative ideas, and avoids the temptation to reach any fixed conclusions; the intention is rather to suggest lines of exploration and interpretation which the reader may develop further for himself. It needs to be emphasised that verbal discussion and analysis is a rather crude instrument for exploring the subtleties of visual expression. If, therefore, some of the statements in the following chapters seem to suggest that the processes and development of artistic creation are simpler and more logical than in fact they are, the reader should be cautious of such over-simplifications. They result from the limitations of language rather than from any desire to be dogmatic.

The book will have achieved its object if it helps to dispel some

of the muddled thinking and prejudices which continue to separate the artist from the public, and if it leads the reader to respond freely to any work of art, unhampered by limiting preconceptions.

I
The Meaning of Art

WHAT IS A WORK OF ART?

The visual art of mankind is so various and there are so many ways in which it may be studied, that it is very important that we should begin here by attempting to arrive at a definition of art which will serve as an adequate foundation-stone for our examination of styles in the following chapters.

If we ask the basic question, 'What is a work of art?', it would seem to be a reasonable and straightforward answer to say, 'A thing of beauty created by man.' But this apparently simple answer raises two difficulties. Firstly, we are faced with the further question, 'What is beauty?', and since this is an age-old question which still exercises philosophers, psychologists and art experts alike, we should merely get involved in an inconclusive discussion which in fact is not important to the main purpose of our study. Secondly, it is by no means reasonable to suggest that a work of art must always be beautiful in the generally accepted sense of being something which makes us feel pleased and relaxed. Only an age which confuses art with entertainment, as ours often seems to do, could be happy with such a limited definition. A visit to any great collection of art will demonstrate that some of the most moving and profound works are terrifying and agonised in their forms, and by evoking in us feelings of pity and compassion rather than pleasure, lead us to a deeper understanding of the tragic aspects of life.

Of course the art we choose to live with, as when we select pictures for our homes, is generally of the kind that gives us pleasure, and because, for many people today, the main use of art is in furnishing and interior design, they will answer our question by saying that art is simply for decoration, and they may tend to reject anything creative which disturbs them as being 'bad art' or not 'art' at all. It is true that decoration plays an important part in much of the world's art, but it has never been the main role of the greatest painters and sculptors. Clearly a painting such as Pollaiuolo's (fig 1), although undeniably decorative and pleasing, gives us a different kind of visual experience than when we look at a well-designed curtain or wallpaper. What is it, then, which makes art more than

decoration? The obvious reply, in this case, is that the picture has a subject – it describes a person in a way that a decorative pattern does not. For this reason many people, therefore, would say that art is visual description. We must agree that description like decoration, has been an important quality in the art of many ages, and the artist was valued for his ability to make an accurate visual record of people and important events. This was especially true before modern methods of recording visual appearances existed. But the description of things, except perhaps in Flemish art (see Chapter 4), was always one of the artist's less important roles, and today we have photography which can give us a much more *factual* and immediate record of everyday happenings than the artist can, not to mention cinematography which can also record movement and the sequence of events in time.

If we compare the painting with a photograph of the same subject – a female portrait (fig 2), it is obvious that they both have in common the quality of description, a visual impression of two different girls. But it is equally obvious that the painting is something special and invididual, whereas the photograph is only one of many similar ones, and that the uniqueness of the painting depends on some quality which is absent from the photograph. What is this quality? It is the quality of *expression* through *organisation*.

The organisation of the photograph is elementary and partly accidental, a record of one fleeting moment in time; such expression as it has depends on the passing mood of the girl, rather than on anything which the photographer has done.

On the other hand, the impression which the painting conveys to us depends, not on the action of the girl, but on the way the artist has organised all the elements of the picture – the shapes, colours, lines, and their relationship one to the other. What he tells us about this girl is not how she felt at one particular moment, but what kind of girl she was, her status in society, and he also tells us a great deal about the time in which she lived. And all this he does in a purely *visual* way. Every part of the painting is organised so as to express the *idea* of a young Italian noblewoman. We notice the importance of the outline – the contrast between the profile of the face and that of the neck and shoulders, the pattern of the hair and cap, and the contrast between the simplicity of the head and the rich complexity of the costume – all of these combine to create a feeling of delicate youth, beauty and wealth. The placing of the head against the sky and the way in which the shapes open up in the direction in which the girl looks seems to express the poetic humanism and optimism of the Early Renaissance period.

In short, the painter has not only given us a likeness of the girl,

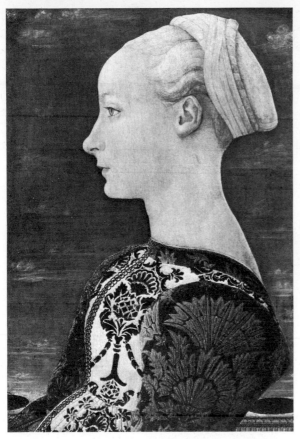 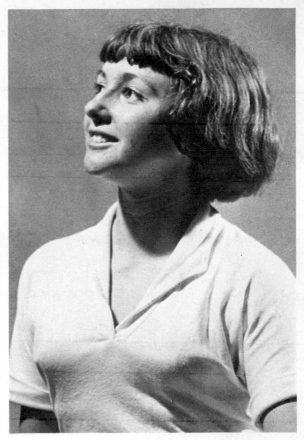

and a decorative picture, he has explored reality in terms of her existence, and has expressed his feeling and ideas about his subject through visual organisation.

With the recognition of this last quality in the painting, we suggest that we have at last reached a definition of art which will serve us throughout the following study. That is, that art is a process by which the artist explores reality, and a visual language by which he expresses his ideas and feelings about it.

As ideas change from age to age, so the language is changed and added to, and it is because of this that we get a constant change in styles.

Fig 1. *Head of Woman*, Antonio del Pollaiuolo. State Museum, Berlin

Fig 2. Female Portrait. Keystone Press Agency

ART AND SOCIETY

If we are now agreed on our basic definition of art as a visual language of expression, we can go on to consider another fact about art which is all-important to our understanding of this visual language – that art is a *social* activity as important to man's progress and well-being as is religion, science, politics, or any other human activity.

The history of man is the history of his ever-growing understanding of himself and the world, and of his growing control over the forces of nature. At every stage in this development art has contributed to helping him to work better, feel better and understand more about reality. To demonstrate this fact we cannot do better than to take as example the earliest art known to us – the paintings of Cro-Magnon man.

Created sometime between twenty and forty thousand years ago the finest of these prehistoric paintings are to be seen in caves at Altamira in northern Spain, discovered in 1879, and at Lascaux in France, discovered in 1941. In these remarkably sophisticated paintings, our early ancestors have left a record of the animals which roamed the European tundra at the end of the Fourth Ice Age.

With few exceptions the paintings are concerned with animals; mammoth rhino, horses, cattle, reindeer and wild boar which Cro-Magnon man hunted, as the main source of his livelihood. The precision and intensity with which the images are drawn show the extent to which man's imagination was dominated by the main activity of hunting. While we cannot know exactly why or how these paintings came to be made, it is clear that they had a much more serious intention than mere description or decoration. They are usually found, as at Lascaux, in deep caves, difficult to reach, and not in the cave mouths where man normally lived; this would seem to show that the sites chosen for painting were regarded as very special magical places suitable for the practice of some kind of early religious ritual which was almost certainly concerned with bringing success in the hunt.

The detail from Lascaux (fig 3) shows a section of the cave wall with a leaping cow nearly ten feet long, and a frieze of horses below. We should note here, with reference to our later explanation of style, that the representation of the animals is not imaginary, but is based on direct and accurate observation as a result of the hunter's constant and close contact with the actual animals which he pursued – that they are what we shall later define as perceptual images.

To return to the detail, the angled line in front of the cow's chest may represent a spear or arrow, while the mysterious grid pattern which appears at many points in the spaces between the animals could represent a primitive trap. As happens in the magic rituals of many primitive hunting peoples who still inhabit parts of the earth today, it is probable that prehistoric man believed that the making of an image of a particular animal would ensure its existence in reality; the rites performed by flickering torch lights in the depths of the earth would serve as a kind of rehearsal for the collective effort of the hunt, and the thoughts and energies of the

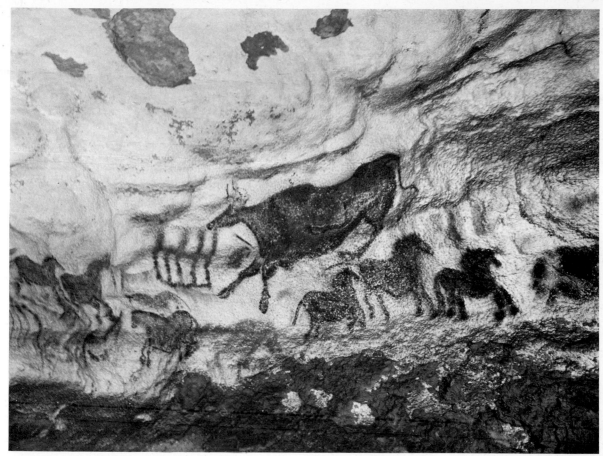

hunters would be concentrated and stimulated by the visual images.

Thus art played an essential part in helping early man to live a more abundant life by contributing to his efficiency as a hunter. From this example of prehistoric art, therefore, we wish to make the important point that art changes man; it broadens and deepens his understanding of reality and equips him to live more happily and efficiently.

The needs of prehistoric man were, of course, very simple and the relation between his art and everyday life very direct. In the succeeding phases of man's development, his needs and way of living become more and more complex and the connections between art and life become more subtle and often difficult to explain. None the less, we shall see in the following chapters how art, whether it has been associated with temples, churches, palaces or private houses, has always remained a social activity. In any age, therefore, the ideas expressed by the artist are not only personal; they are the ideas of the society in which he lives and works.

If, then, art is a language of expression which plays an essential

Fig 3. Cow and Horses, Lascaux Caves. Archives Photographiques, Paris

part in society it is clear that if we are fully to understand the art of any age we must study not only the language of shape, line and colour, but we must also know something of the historical circumstances in which the work was produced.

Before going on to examine the artist's methods and techniques, therefore, it is necessary to say something of the main circumstances which contribute to a work of art and which decide its form. These are:

1. *The Cultural Climate*

In every age the attitudes which man adopts to himself and the world in religion, in philosophy, in politics and in science, and the way in which these are carried into action (e.g. in religious practice, in social and political organisation, in scientific research and in technology) create a constantly changing pattern of human thought and feeling – a kind of ideological atmosphere caused by the interaction of all aspects of activity – which we may call the 'cultural climate'.

Art is part of the cultural climate, but its very special value is that it fuses all the elements into a unified visual expression; that is to say the artist is the man who understands intuitively the relationships of thought and feeling within the cultural climate and he expresses this awareness in visual images. And, because the artist is a kind of intuitive explorer of reality, he often perceives and makes us aware of new emerging patterns of life, before they have become clear to the rest of us.

It is for this reason that the artist has often been referred to as a prophet, and why he can help us through his work to adjust ourselves to inevitable changes in the pattern of life. The artist is always concerned with immediate realities, and great art is always part of the mainstream of life.

Thus, in an age when religion plays the most important part in life, art will necessarily be mainly religious, or in a scientific age art will take on a strong scientific character; in time of revolution or rapid social change art will be concerned with politics. In an age when people are united by powerful common beliefs, as in medieval Christianity, the artist will be at one with the community in expressing their beliefs in his work. In an age of individualism such as our own, art turns to personal expression, the artist's individual response to reality being of the greatest importance, and, therefore, often difficult for the public to understand.

In short, as the pattern of one age gives way to the next, so the artist must invent a new language to express the realities of his time, while the public finds new uses for art in each age.

2. The Artist and his Patron

The character of a work of art is always greatly influenced by the way in which the artist is employed – by the economic position and social status of his patrons. It is only in a community which has surplus wealth and leisure that art on a grand scale can be produced.

Prehistoric man found just enough time to create his essential magic symbols, but it took the food reserves of a prosperous agricultural society to create the monumental temples, sculpture, and painting of Egypt, just as mercantile wealth also made possible the art of Greece, Rome and Renaissance Europe.

From what we have said of the cultural climate it follows that the relationship between the artist and his patron varies greatly from age to age. In some periods the patron has had almost complete power to decide what kind of art the artist should produce, even down to detailed choice of colours, as, for example, when the early Christian Church laid down rules as to what images should be used in churches and how they should be presented (see fig 23).

In Renaissance Italy under the patronage of the Church and merchant princes, artists were still required to confine themselves to well-established subjects, religious or classical, but they were given great freedom both in their interpretation and in the technical handling of these themes. For the most part they were still in harmony with the ideas of their patrons, although disputes between artist and patron became more frequent as the artist gained more individual freedom. Michelangelo's quarrels with his patron Pope Julius are famous, while Rembrandt became the first great painter to sacrifice secure patronage in order to be free to develop his own ideas and style.

It is only in modern times, beginning with middle-class society in Holland after the Reformation, that the artist loses direct patronage generally and must now produce his work without being commissioned, selling it competitively in the open market like any other modern commercial product. This development has had both great advantages and drawbacks for the modern artist. On the one hand it has freed him from the restrictions imposed by the patron, enabling him to experiment and to explore every aspect of reality and thus to expand the language of art to a degree that was hardly possible in the past. This may be thought by many to outweigh any possible disadvantages, in an age which places so much value on individual freedom.

On the other hand this complete creative freedom has resulted in the modern artist being, strictly speaking, unemployed at the outset of his career. Unlike other trades and professions he is not guaranteed employment at the end of his training but must work and live

precariously until, if he is lucky, he gains the interest of some individual patron, or of an agent who considers his work saleable. His artistic freedom may sometimes prove to be an illusion if he is then required to adapt his style to what is merely fashionable. But perhaps the most serious result of the modern artist's independence is that the development of artistic language in the 20th century has taken place as an activity among artists and 'experts' only, and has been divorced from the public at large.

However, the relationship between artist and public is already improving as an ever-wider public comes to understand the aims of modern art, and as the contemporary artist is more and more drawn back into the mainstream of life through the popular art movements which have arisen in recent years.

There are many signs that the coming generations may provide a new and exciting kind of patronage, just as they will inevitably create a new kind of art.

3. Artistic Tradition and Theories of Art

The form of a work of art always depends to a great extent on what other artists have done in the past, whether the artist is improving or extending the existing language, as for example Leonardo da Vinci, perfecting the language created by Giotto, or whether he is deliberately reacting against a previous style in order to make a breakthrough into some new form of expression more suitable to his own time.

Furthermore, a knowledge of the theories, styles and techniques of the past is essential to the artist's training, since ideas and methods which may lie unused for centuries frequently assume a new significance in the face of new problems of expression, and can lead the artist to solutions which might take him years to discover on his own.

If a working knowledge of past styles is one of the essential elements in the artist's development, an equally important one is his reaction, not only to the general cultural climate, but to the artistic ideas of his time in particular. Since each age must expand the existing artistic language, or invent a new one appropriate to its view of reality, so every age has produced its own theory of art. The artist works not in isolation, but in an atmosphere of constantly changing ideas about art. This atmosphere is created by a combination of philosophical speculation, art criticism and the cross-fertilisation that always goes on between the different arts.

But above all, new ideas about the nature of art arise from the essentially experimental and exploratory nature of art itself. Parallel with the scientist who works with a conscious analytical method,

the artist is in the forefront in exploring new aspects of reality and in creating new relationships between thought and feeling. Through his intuitive perception of nature the artist discovers new ways for us to understand ourselves and the world, just as the scientist finds new explanations of reality in terms of conscious scientific method; like scientists, artists are constantly inspired and influenced by the work of their contemporaries. There are, of course, always those individuals of great talent or genius who lead the way, making the new leaps into the unknown, but the typical work of art in any age not only embodies aspects of past traditions but draws its inspiration from many different sources in its own time.

Each age has its own great centres of art where the concentration of artistic activity is greatest, and the interchange of ideas is most vital – 15th-century Florence, 16th-century Rome, 17th-century France and Holland, 18th-century England, 19th- and early 20th-century Paris, and today London and New York.

4. Materials and Techniques

The artist's selection of his materials and the way in which he uses them is the most obvious factor in deciding the form of a work of art.

The relationship between the artist's imagination and his materials is always subtle, and varies from age to age. At times the artist may invent new materials and techniques because none of the existing ones are adequate to the new kind of images he wishes to make. For example, artists in the 15th century found it necessary to perfect the flexible medium of oil-paint which could be worked in many different ways to give the illusion of the textures and colours of the visible world, effects which were impossible with the older techniques of tempera and fresco. In some periods, on the other hand, the artist has allowed the material to dictate largely the finished form of the work; this is most often the case when art is abstract or symbolic rather than naturalistic. For example, mosaic with its reflections of candlelight, or stained glass with its richness of translucent colour were both materials admirably suited to making the two-dimensional semi-abstract images required by the symbolism of Christian art. The artist exploited their rigid but emotional qualities to enhance the grandeur and monumentality of his art (figs 22 and 23). Or again, the importance of materials in stimulating the artist's imagination is frequently seen in modern art, as for example in the work of Henry Moore who always allows the character of his materials – the density of stone, or the grain of wood – to guide his hand towards the final shape of his sculpture. Other artists, notably Picasso and Rauschenberg, have gone even further by starting with materials or

objects, ready made, and without preconceived ideas, letting the materials inspire the actual image.

More recently many artists have been inspired by the processes of machine production to create expressive objects capable of multiple production by machine, i.e. a new kind of work of art suited to both the spirit and economic conditions of the machine age.

5. *The Artist's Personality*

The manner in which the artist organises his compositions, and how he handles his materials, will always reflect his temperament, and it has become customary in modern times to speak of the artist's personal 'handwriting', meaning how his personality is imprinted on the work by his use of line or application of paint, or his handling of stone, clay or other material.

This individual element in art was not considered of much importance in ages when the artist thought of himself as a humble craftsman serving the common beliefs of society, or when he applied his talents completely to satisfying the requirements of his patrons. Today, however, the success of an artist is judged, more often than not, on the originality of his personality and the power with which it is expressed in his work.

But even in the past the temperament of the artist played an important part. A style as apparently uniform and anonymous as Gothic sculpture reveals, on close study, a wide variation, not only in technical ability, but in imaginative handling of the subjects; or to take the admittedly more individualistic art of 15th-century Florence, we have only to compare the work of Piero della Francesca (fig 28), with its balanced order of vertical and horizontal composition, with Botticelli's flowing lines (fig 36), to discover two very different personalities, one disciplined and intellectual, the other lyrical and emotional.

Furthermore, the artist's personality can change as a result of deep experience, and this change is always reflected in his work. The early painting of Botticelli was lyrical and luxurious while he remained in accord with his princely patrons, the Medici, but later changed to a melancholic and expressionistic style after his conversion to the puritanical ideas of Savonarola. Or, to take a modern example, how clearly we can trace Van Gogh's changes of personality from the intense determined strivings of his early work, through the elation of his greatest paintings when he was at the height of his power, to the desperation and torment of his last tragic pictures.

Modern pscychology has given us new insight into the nature of personality and its expression in art, and some study of the artist's

personal life and formative influences is, therefore, clearly necessary if we are fully to understand his work.

All these factors – current ideas, the demands of patronage, artistic tradition, the possibilities and limitations of his materials, and the creative capacity of his own personality – are reconciled and brought into balance by the artist when he creates his work. His ability to produce unity out of diversity is the artist's unique contribution to Life.

2
The Language of Art

VISUAL EXPRESSION AND COMMUNICATION

Having said enough for the moment of the external factors which make up the framework of life within which every artist must work, we can now go on to examine more closely how he works, and to study the various elements which go into the making of the work of art itself.

The first necessity in approaching any work of art – painting, sculpture, architecture or design – is to understand that the visual language of art exists in its own right independent of the written or spoken word.

Partly because the divorce between artist and public has made us unfamiliar with visual communication, and partly because the main means of communication since the invention of printing in the 15th century have been through words, we are conditioned to explaining everything by speech or writing rather than through visual images. When we look at a painting or a piece of sculpture, therefore, there is a tendency always to try to describe what we see in words. When we try to force what we see in a visual image into words we are usually only partly successful, and we reduce both our understanding and our enjoyment of the work.

We must accept, therefore, that the language of art is made up of purely visual elements – composition of shape, line, colour tone and texture – and that these are equivalent to, but not necessarily inter-changeable with, grammar and words in speech and writing. From this it follows that we must learn the language of visual organisation and communication just as we would learn a foreign language, if we are to understand and communicate with the people who speak it.

CLASSIC AND ROMANTIC ART

The work of art starts with the artist's response to some aspect of reality; that is to say the artist translates his thoughts, feelings and sensations into visual form. His whole personality is involved in the process of creation; his intellect, emotion and senses. Influenced by the factors already discussed in Chapter 1, and depending on whether he is interested in expressing ideas or emotions, one or

other aspect of the artist's personality will tend to dominate his work.

If we look at European art from the Greeks onwards we can divide the most typical works into two main categories – classic or intellectual, and romantic or emotional art.

The main aim of the classic artist is the expression of ideas outside and greater than himself – universal ideas which are true at any time and in any place. It is an aim in which his intellect governs his emotion. Any number of artists, anywhere, at any time, if asked to draw a figure with three sides, all the sides being straight lines and all being equal in length, will all draw the same ideal shape – an equilateral triangle (fig 4). The idea expressed in the shape is universal and exists quite apart from the artist himself. The value of a classic work will be judged by how close the artist comes to expressing objective ideas.

The romantic artist, on the other hand, is primarily concerned with expressing his personal feelings about reality. Asked to express emotion by a spontaneous scribble (fig 4), no two artists will produce the same drawing since their individual feelings constantly change and are different one from the other. The value of a romantic work of art will be judged by the individuality and power with which it expresses the artist's emotional response to reality.

Classic art generally appears during periods of social stability and progress, when man feels in harmony with the world and when the artist is in harmony with society. Romantic art is usually characteristic of periods of change and upheaval when old standards are giving way to new and revolutionary ideas. The romantic artist is generally a non-conformist, reacting against and criticising the old-established order, and identifying himself with the new forces of change.

Classic art is balanced geometrically, disciplined in its organisation, expressing stability; every detail is clearly drawn, and nothing is left to the viewer's imagination. Romantic art, by contrast, is asymmetrical, curvilinear in its rhythms, expressing movement and

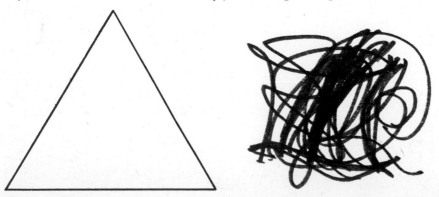

Fig 4. Classic and Romantic Symbols

Fig 5. *The Crucifixion*,
Raphael. Reproduced by
courtesy of The Trustees,
The National Gallery,
London

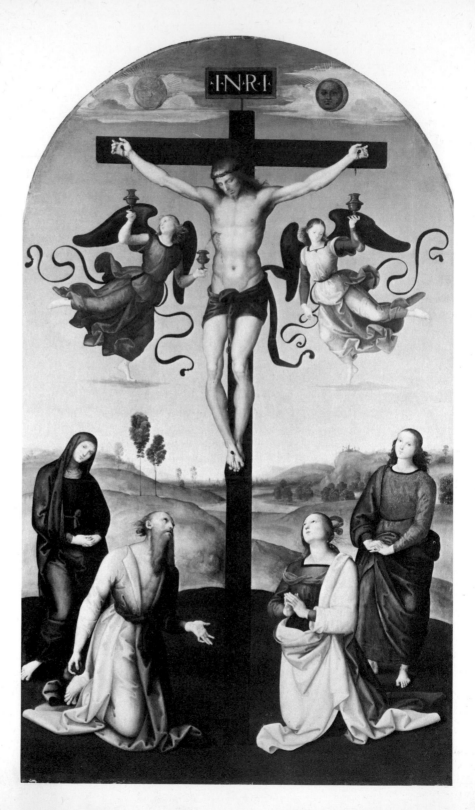

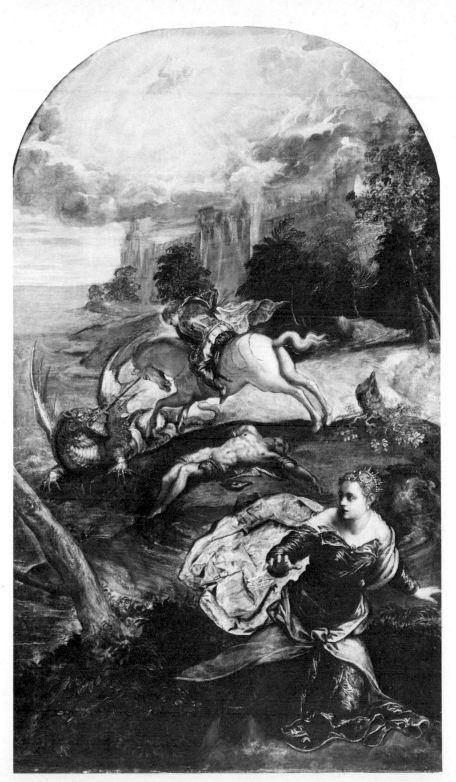

Fig 6. *St George and the Dragon*, Tintoretto Reproduced by courtesy of the Trustees, The National Gallery, London

Fig 5a. Analysis of fig 5

Fig 6a. Analysis of fig 6

change; atmospheric effects, spontaneous handling of materials, dramatic use of light, all suggest more than the eye can see as well as expressing the artist's emotion.

The examples in figs 5 and 6 and the diagrams analysing them (figs 5a and 6a) explain further the differences between classic and romantic art. It is clear from the organisation of 'The Crucifixion' that Raphael was aiming at an ideal of balance and proportion. The composition is almost symmetrical; the variation within the symmetry of the main shapes prevents the picture from becoming boring. The circle enclosing Christ was probably symbolic, since the circle was regarded in many ages as an ideal shape expressing universality. By contrast Tintoretto's organisation of the elements in his 'St George and the Dragon' is dynamic and emotionally expressive. The repeated curves moving downwards towards the left-hand side of the picture are intended, not to create ideal harmonies, but to express the excitement and drama of the subject.

The division of art between the classic and romantic approaches applies not only to the past but also to the art of our own time. In fig 7 the artist is again concerned with creating an ideal form, the harmonious relationships of squares and rectangles and circles. In fig 7a the artist appears to have no other intention than that of expressing his feelings as immediately and spontaneously as possible.

The terms 'classic' and 'romantic' should not be taken to indicate two different kinds of art. Rather do they stand for the two poles of artistic expression. Any single work of art will tend towards one or the other pole, although it will be found that all works of art contain both classic and romantic elements in varying proportions.

THE VIEWER'S RESPONSE

We must digress for a short while from examining the work of art in itself, since it is necessary at this point to say something of how we look at art in order that we may establish how to judge its value.

We notice from the examples given that classic compositions, from whatever period they come, are basically similar in character, as also are romantic works of different times. This division of art into intellectual and emotional also explains why each person responds differently to a particular work of art.

If we can divide artists into these categories then it is reasonable to expect that each one of us, according to our psychological make-up, is either mainly classic or romantic in temperament. If, therefore, we are more intellectual about things, if we have a liking for balance and tidiness in our surroundings, it is almost certain that we will find classic art more satisfying than romantic. If on the other hand we are more emotional by temperament, less fond of order and precision, liking things to be somewhat mysterious rather than clearly explained, then we will generally prefer romantic works.

Of course we must be careful not to make the viewer's response to art sound over-simplified; the way we react to art, as to other things in life, is also a matter of mood; most reasonably balanced people alternate between periods of intellectual and emotional activity. So, for example, it may be that if we regularly visit one of our large public galleries containing a mixed collection, we find that on one occasion, having the need for order and restfulness, we are strongly attracted to the classic works, while on the next visit, needing emotional stimulation, we are most responsive to the romantic.

This variation in response due both to temperament and mood means that no two people ever react to a work in exactly the same way and, therefore, while a certain measure of agreement by a number of people may be possible about a particular work, no final

or absolute judgment of the work can ever be arrived at. That is to say any judgment made of a work is true only in relation to the person making it, and to the time and place in which it is made. For not only does individual response differ but each age views the art of the past in a different light, and furthermore the work may be enhanced or, more commonly, detracted from by being seen in changed surroundings. However impressive we may find, say – a piece of Gothic sculpture displayed in a modern museum, when viewed in the motley company of other art lovers, gaping tourists, and people merely sheltering from the rain, we cannot possibly see and understand it in the same way that medieval man experienced it in the serenity of the cathedral contributing to his religious belief.

If our artistic responses are so variable, is there any way in which we can make a worthwhile judgment of a work, beyond merely expressing our liking for this or our dislike for that? Apart from our personal preferences, are there any standards by which we can say what is good, and what is bad or not so good? When we are confronted with an unfamiliar work, or one we simply dislike, it is always tempting to take another work which we know, and use it as a standard of comparison, saying, for example: 'That portrait by Gainsborough is better than that one by Picasso.' This judgment by comparison is always wrong and misleading.

What we are perfectly entitled to say, however, having studied the work of both men, is that having regard for what each aimed at in his art, this one or that is the better artist of the two.

We suggest, therefore, that there are three basic questions which might be asked in front of any work, in trying to arrive at a just and worthwhile evaluation of it:

Fig 7. *White Relief, 1935,* Ben Nicholson. The Tate Gallery, London

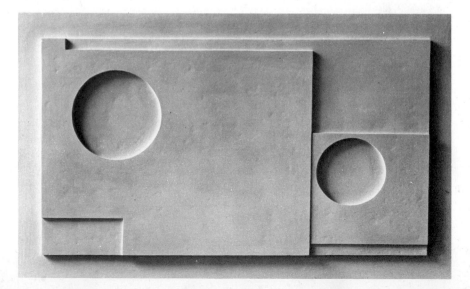

1. What was the artist's intention in creating the work (i.e. what was he trying to express or communicate)?
2. Was his intention worthwhile?
3. If it was worthwhile, how successful was he in achieving his intention?

The answer to the first question may be clearly seen in the subject of the picture if it is fairly simple and straightforward, as for example in a portrait. But the artist's real intention may be disguised or hidden, as in symbolic or abstract work, in which case the answer will depend on our knowledge of the factors affecting its creation which we examined in Chapter 1.

The answer to the second question depends on the artist's grasp of reality and how seriously his work contributes to the art of his time. All living art is concerned with expanding the language of visual expression in order to represent new and significant aspects of reality. The artist's intention will only be worthwhile if he is trying, to the best of his ability, to reveal new aspects of things or to present familiar aspects in new ways which increase our feeling and understanding. The value of the artist's intention will be reduced to the extent that he treats his subject so as to present a false or over-sentimental view of life, or to the extent that the subject is trivial and adds little to our experience. Likewise, the artist's intention cannot be regarded as being of great value if he is merely repeating, however expertly, what others have already said as well or better.

If the artist's intention is worthwhile, then the answer to the third question will depend on our ability to judge his competence in translating his vision into material form – that is in our knowledge of how the artist gathers the information which is the source of his inspiration, and how he expresses himself through technical control of his materials, in organising line, shape, tone, colour and texture. It is to this, the core of our study, that we now return in the following pages.

HOW THE ARTIST SEES

There are three main approaches to nature which the artist may adopt in translating visible reality into images – three kinds of vision which we may call Perceptual, Conceptual and Expressionist.

PERCEPTUAL ART

Perceptual art results when the artist in creating an image, relies altogether on purely visual perception, putting down on paper or canvas only what his eye sees. This he achieves by direct and accurate observation of nature from which he takes directly the shape and scale of things, and the space they occupy, through the use of perspective, and the subtle rendering of light and dark on surfaces through a sensitive use of tonal values.

In the drawing (fig 8) the artist has attempted to put down as accurately as his skill and materials will allow, his visual impression of a mug. Likewise in fig 9 Degas was obviously mainly concerned with showing what a young and graceful ballet-dancer actually looked like.

All European art from Giotto (page 51) to Cézanne (page 115), is perceptual to a greater or lesser degree, but the perceptual way of seeing is most clearly shown in the work of the Flemish and Dutch schools, and in 19th-century Realism and Impressionism.

It is the kind of art with which we, in the West, are most familiar, and for this reason we often tend to compare other kinds of art unfavourably with it.

However, we will find that the greater part of the world's traditional art, as well as most modern art, is not perceptual, but either conceptual or expressionist.

CONCEPTUAL ART

Instead of drawing simply what appears to the eye from just one viewpoint, the artist may make an image of the object as he knows it to be. In fig 8a the artist has tried to depict his mental idea of the object, combining as much knowledge as he can in one image. This means representing different aspects from many viewpoints,

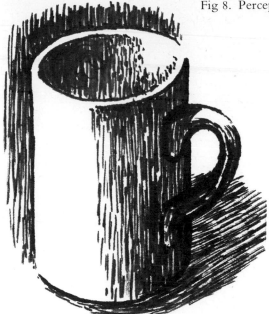

Fig 8. Perceptual Image

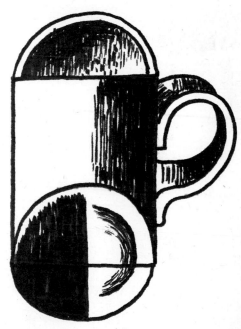

Fig 8a. Conceptual Image

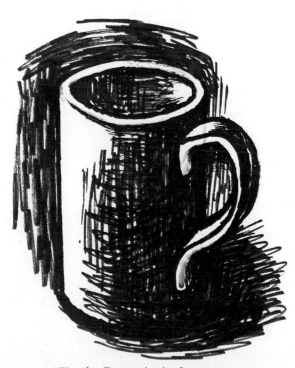

Fig 8b. Expressionist Image

Fig 9. *The Little Dancer Aged Fourteen*, Edgar Degas. The Tate Gallery, London

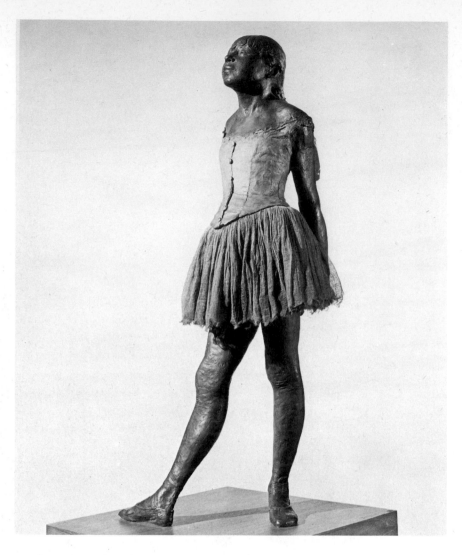

as, for example, showing the inside as well as the outside, in order to create, if possible, an image of the complete existence of the object.

In fig 10 Henry Moore combines the ideas of a reclining female figure, landscape, shapes of stones and pebbles and bone formations, conveying in one image related aspects of reality which could not be presented in a single perceptual image.

Other examples of conceptual art will be discussed in the following chapter and in the chapter on Cubism.

EXPRESSIONIST ART
Instead of representing what the eye sees, or making us aware of the total structure of the object, the artist may wish instead to express his feelings about the object. In fig 8b the artist, using his

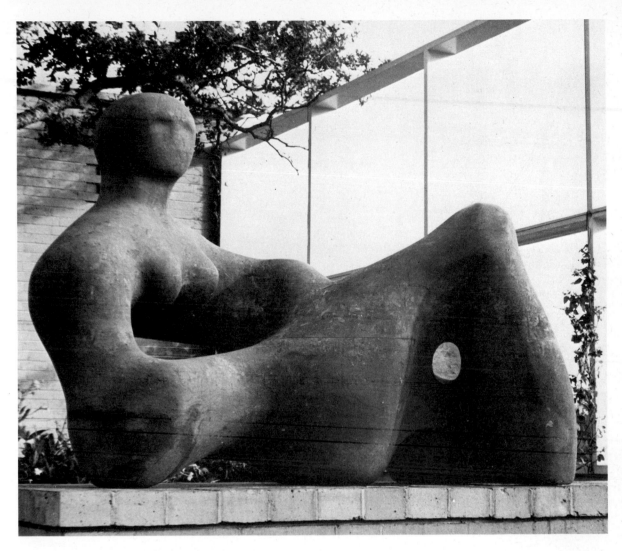

materials freely and dynamically, and with little concern for the
appearance of the finished drawing, succeeds in using the mug as a
focus for his emotions, translating it into a kind of expressive hand-
writing. And in fig 11 Giacometti is trying, not to describe what a
figure looks like, nor to convey ideas about anatomy, but to express
a very personal subjective view of humanity, his tragic perception
of the isolation of human existence.

The expressionist artist often distorts natural forms in order to
intensify emotional feeling, exaggerating shapes, changing the
natural scale, heightening colour, and by emphatic handling of his
materials. The work of Van Gogh is typical of this approach and
will be discussed with other expressionists in Chapter 8.

It should be emphasised that the terms we have been explaining

Fig 10. *Recumbent Figure, 1938*, Henry Moore. The Tate Gallery, London

Fig 11. *Standing Woman*, Giacometti. The Tate Gallery, London

– classic, romantic, perceptual, conceptual, expressionist – represent extreme positions. Most works of art lie somewhere between these extremes, containing in greater or lesser degree, elements of all these categories.

Thus Degas's dancer is to some extent expressionist in so far as he also attempts to convey the girl's feelings; the figure by Moore also has some perceptual and expressionist qualities just as the Giacometti has certain perceptual and conceptual qualities.

Obviously we can link our definitions of classic with conceptual vision, and romantic with expressionist. These connections will be examined in more detail in the chapter on Cubism and Expressionism.

VISUAL FORM

When we say that a work of art has 'visual form', we mean a certain order of relationships and equilibrium between the parts that is both expressive and visually right. There is a kind of inevitability which suggests that out of unlimited possibilities the artist has found the one correct way of expressing his vision.

Form is a fine fusion of harmony and contrast. A work of art should be sufficiently complex to engage and hold our attention without being so complicated as to be incomprehensible and confusing. That is to say, it must avoid the extremes of repetition and boredom on the one hand and chaos and confusion on the other. The creation of form is, therefore, always the result of a kind of tight-rope walk between these extremes, in which the artist succeeds in finding the right tension between harmony and contrast. Clearly we can also relate this idea to the extremes of classic and romantic art. A work which is over-intellectual and controlled, in which all emotion is squeezed out, will be dead and boring because it lacks formal tension. Or at the other end of the scale a work which is the product of pure emotion, lacking in intellectual restraint and control, will be a chaotic mess, also lacking the tension of form. We can, therefore, also define form as the fusion of the opposing forces of reason and emotion.

The two basic elements of form are – structure which is made expressive through relationships of shape, mass and space; and surface, which is expressive through colour, tone and texture.

There are infinite variations in the ways that the artist may combine these elements to achieve the harmony and contrast of formal organisation. In a painting, for example, he may introduce harmony by repeating certain shapes and contrasts by the use of different colours; or he may do the reverse, contrasting shapes, while harmonising his colours.

The organisation of shape, mass and space calls for an analytical

and intellectual approach to structure, so that these elements are the main concern of classic art, whilst surface qualities are generally of less importance.

The elements of colour, tone and texture are emotionally expressive and sensuous and are, therefore, predominant in romantic art, in which structure may play little part.

The key to formal relationships in both classic and romantic art is proportion, a quality which we must now examine in some detail.

PROPORTION

Proportion may be defined simply as the relationship within one work of art of the parts to each other and of each part to the whole. It is a matter of measurement, the relation of height to width to depth and all the resulting relationships of shape created by both the masses and the spaces of the form.

The great architect and pioneer of modern art, Le Corbusier, suggested that man is only happy when he is surrounded by things arranged *in a certain mathematical order*, that is, an order based on relationships of proportion.

What is this particular order?

While it may be impossible to agree on a single precise definition of beauty, it would nevertheless appear that those things which most people find visually satisfying are considered so because they embody a basic relationship of proportion which is universal and which occurs in all the great art of the world. It was the Greeks who first clearly explained, by their mathematics, this basic universal proportion, and they called it the 'Golden Section'.

Look at fig 12 and ask yourself which division of the rectangle you find the most satisfactory. Most people will intuitively choose the middle one, which happens to be divided in the proportion of the Golden Section – approximately 8:13. However, other proportional divisions may be used by artists for expressive or other reasons. For example in Raphael's 'Crucifixion' the main division of the picture is in the centre because it was necessary to place the most important part of the subject in that position. The horizon, however, lies almost exactly along the Golden Section division of the main rectangle.

Again, looking at fig 13, let us consider which rectangle of the three we prefer. The one on the right is a Golden Rectangle with its sides in approximately the proportion of 13:8. Put more precisely, the Golden Section is an irrational proportion, known to man at least since Euclid, which can be defined as the division of a straight line so that the larger part is to the lesser as the whole line is to the larger. Expressed geometrically a line A B divided thus at C will give the proportion $AC/CB = AB/AC$; or algebraically a line divided

Fig 12. Proportion – comparative divisions of a rectangle

Fig 13. Proportion – Golden Rectangle and comparisons

in the proportion into two parts, a and b, will give the equation $a/b = (a+b)/a$; or in arithmetical terms, $1 : \cdot618$ (see also the Fibonacci Numbers, page 31).

As a result of repeated tests by the authors with different groups of people (both art students and laymen), a recurring pattern has been observed in the response to the different relationships of proportion shown in these rectangles. The Golden Rectangle has been found to appeal to the majority of people in any group, and especially to those of a classic temperament.

The elongated rectangle on the left, with its suggestion of upward movement, is more emotional or spiritual in its proportion, and we find it often in religious art, as for example the Gothic cathedral or in the expressive elongations of El Greco's figures (fig 38). This elongated rectangle seems to appeal to people of more intuitive or romantic temperament. It does, however, also contain the Golden Section proportion, since it is composed of two Golden Rectangles standing one on top of the other.

The middle rectangle has been found to attract the least number of people, and its choice seems to indicate a very individual, and perhaps

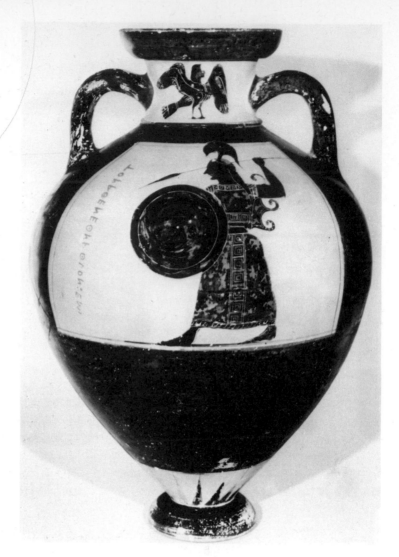

subtle, response to proportion, in that it has neither the obvious
balance of the Golden Rectangle, nor the immediate expressiveness
of the elongated one. None the less it also contains the classic propor-
tion, being made up of two Golden Rectangles lying horizontally
one on top of the other. Similar tests have been carried out else-
where by both psychologists and researchers in art, and while
variations have been found from group to group the pattern descri-
bed above does predominate. The reader might usefully test these
observations for himself.

We are faced then with this important and intriguing fact, that
the majority of people appear to be happiest with shapes in art and
design which are based on the Golden Section proportion. A study
of varied examples of the art of the world from many times and

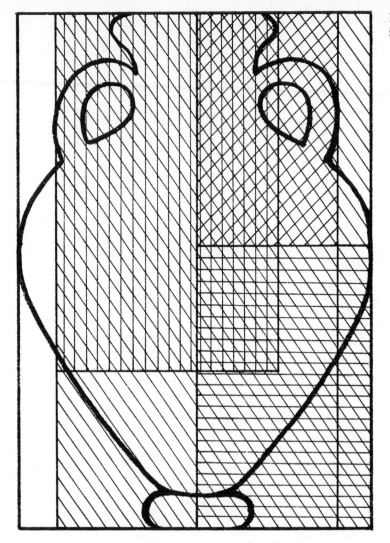

Fig 14a. Analysis of fig 14 into Golden Rectangles

places reveals another important fact – that this proportion is found, not only in the classical art of the Greeks, who first understood it mathematically and used it consciously in their art, but also in the art of other ages and civilisations, where it was arrived at intuitively rather than consciously. We find it, for example, in aspects of Egyptian art and in the proportions of Chinese pottery.

Why is it that this one proportion plays such an important part in the creation of art and in our ideas about what is beautiful? The Greeks were the first to answer this question, suggesting that the Golden Section was a universal proportion and the basis of an ideal order of relationships which lies behind the accidents of the visible appearances of the outside world.

The two great discoveries of the Greeks were mathematics, which

seemed to them the key to understanding universal order, and Man himself whom they saw as the centre of this universe. The philosophy, and the art which they developed as a result, became the foundation-stones of European civilization.

The vase (fig 14) shows both the mathematical and humanistic genius of the Greeks. Its size (25 inches high), and design are such that it is easily handled, and its proportions are based on a subtle use of the Golden Section. Each rectangle marked in the diagram (fig 14a) is a Golden Rectangle. The decoration represents Athena, Goddess of Wisdom.

The section of a decorative frieze (fig 15) shows the classical idealism with which the Greeks viewed man. In their art the image of the human figure was always created in a clearly defined order of mathematical proportions, and the relationship of men and horses in this composition will be found to be governed also by the Golden Section.

The Greek theory of a universal proportion was further expanded by Leonardo Fibonacci (1175–?), a mathematician who worked at Pisa. Fibonacci studied, not only the Greeks, but was led through the great influence of Arab mathematicians, to study the ancient mathematical systems of the East. Eastern mathematics were less abstract than those of the Greeks, and were based more directly on measurements taken from nature. This led Fibonacci to measure living forms in nature, and from this he discovered that one of the

Fig 15. Horsemen preparing for the Panathenaic Procession – west frieze of Parthenon. Reproduced by courtesy of the Trustees of the British Museum

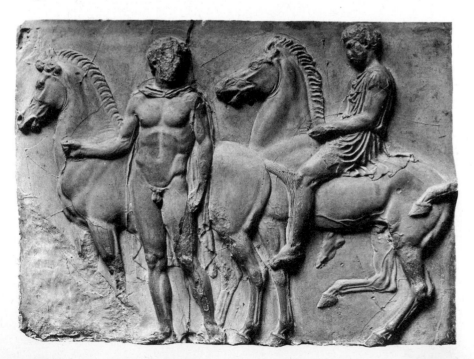

main growth patterns in plants and animals (fig 16) can be expressed as an arithmetic progression, thus:

Fig 16. The Golden Section in Nature

0: 1: 1: 2: 3: 5: 8: 13: 21: 34: 55, etc.

As the progression develops to larger numbers, each pair, e.g. 34: 55, comes closer and closer to the ideal proportion of the Golden Section.

The progression has come to be known as the 'Fibonacci Numbers', and has played an important part in art and design from the 13th century to the present day. During the Renaissance, when the ideals of classical humanism and mathematics were reborn in Europe, men like Leonardo da Vinci and Albrecht Dürer, and the philosopher-architect Alberti carried the study of proportion even further. In the study of human anatomy it was then discovered that even the subtle measurements of the human body also are in accord with the classical ideas of universal proportion.

In our own time Le Corbusier has formulated a theory of proportion in relation to modern architecture and design which lends new significance to the Golden Section and the Fibonacci Numbers. In his Modular Theory he restates and expands the ideas of universal form, suggesting that, when man creates, his art and design should derive its structure from the proportions and functional principles

of nature, and that everything man makes should be a projection of his own structure and scale, if he is to achieve an environment in which everything will exist in a satisfactory order of relationships.

Le Corbusier, therefore, would seem to give the answer to our question – that what we generally find beautiful and pleasing are those things in which we can recognise a proportion which is part of our own physical existence. It would be possible to pursue the philosophical and psychological implications of this idea much further, especially in view of modern scientific revelations which have extended our knowledge of the patterns of nature and the universe. However, it is sufficient for our immediate studies that we have established the primary importance of proportion in visual organisation.

LINE AND SHAPE

Proportion, then, is the formal framework within which visual unity is achieved. But within any given order of relationships it is the nature of the lines and the shapes which are used which creates the particular character of the images. Line and shape are not used by the artist simply to represent or describe objects: they are visually expressive in themselves. That is to say, a line, by its thickness or

Fig 17. The Expressiveness of Shapes

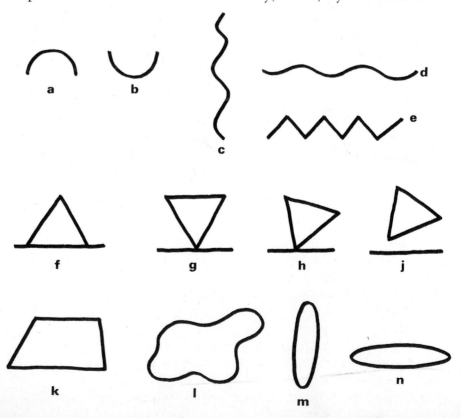

thinness, by its direction, vertical, horizontal or sloping, and by its character, curved, straight or angular, can express ideas or emotional states in a purely visual way.

Thus (fig 17a–e), a downward curving line suggests sadness; its opposite, upward curving, suggests happiness. An undulating or wavy line rising vertically suggests life and growth; the same line, moving horizontally, suggests relaxation or the slow rhythm of waves. By contrast, a zigzag line is harsh, dynamic and restless. It will be clear that the range of visual expression which can be achieved by combining lines of different character is limitless. The same is true of the expressiveness of shape. Take, for example, the simple relationships of a triangle to a horizontal base line (fig 17f–j). The four positions of the triangle express successively the very different ideas of solidity or permanence, balance, instability and flight. The angular shape (fig 17k) suggests rigidity while the curvilinear one (fig 17l) suggests fluidity. An oval shape standing vertically (fig 17m) is active, vital; lying horizontally (fig 17n), it is passive or at rest. The reader may, of course, make his own interpretation of these lines and shapes, and may experiment further by drawing ones of different character.

SURFACE – COLOUR, TONE AND TEXTURE

While the organisation of shape and line can be infinitely expressive, the richness of visual language is further extended through the treatment of surface by colour, tone and texture.

COLOUR

Colour is the most emotional and subjective element in art. It can reinforce the expressiveness of other elements such as shape, or it can by itself create the whole emotional impact of a work. It is that aspect of art which one can be least dogmatic about since no two artists use colour in the same way, while each of us reacts to colour differently.

Modern physical and psychological research is making us more and more aware of the powerful way in which colour can influence our response to reality, and it is surprising, therefore, to find how relatively limited was the use of colour up to the 19th century. The great exceptions are those spiritual and emotional styles, such as Byzantine mosaics and Gothic stained glass, where the ethereal splendour of the colours, whether created by the reflection of candle-light or the projection of sunlight through great windows, must have contributed to a spiritual elation in congregations not psychologically dissimilar from the effect of contemporary psychedelic light shows.

Apart from this symbolic use of colour in religious arts its develop-

ment progressed slowly throughout the ages, mainly due to the limitations of early pigments. In the field of ceramics, glass and textiles it was possible to find chemical pigments and dyes existing in nature which, being suited to the medium, were often exploited to give effects of great richness, as, for example, in the Near and Far Eastern traditions of jewellery and fabrics, or the Muslim tradition of pottery and tile decoration. But even here the range of colour was limited by the materials from which pigments were made, and these limitations are more evident where colour was combined with expressive imagery in sculpture and painting.

The painters of Egypt and the early civilizations were limited to a palette of black and white, a few basic earth colours and impermanent greens and blues. It is often impossible to say now how many works from early periods appeared originally, but one may suppose that the artist got the most out of their materials, using colour both descriptively and symbolically. The technical progress of the Romans in pottery and glass-making, combined with similar innovations in China and the Near East made possible the more permanent use of colour. These techniques became the basis of the Byzantine and Gothic styles already mentioned.

The use of colour remained relatively static throughout the medieval period, due partly to the limitations of materials used, but also to the fact that the Church had laid down quite strict rules as to how the sacred images should be presented and these included direction as to which colours were appropriate to particular personages, for example red for Christ's robe, and blue for the Virgin's. However, with the Renaissance came a new freedom and a demand for realism in art and with it new developments in technique. The new scientific investigation of the world led, with many other discoveries, to a greater understanding of the chemical nature of colour and how improved pigments could be made from oxides and other materials. The principle of the spectrum was still unknown, but a complete palette, almost exactly reproducing its range, now became available to the painter. To this was added the development of oil-painting which made possible the descriptive rendering of nature. The Florentine painters, while still working in the traditional techniques of fresco and tempera, were the first artists to employ descriptive or *local* colour; that is the copying of the actual colours of objects in nature. The pigments, mixed as accurately as possible to reproduce the local colours, were usually applied in thin glazes over a monochromatic underpainting. To the Florentines, who were mainly interested in drawing and composition, colour remained to a great extent a secondary element, descriptive and decorative rather than a main structural or expressive part of the painting.

The Venetians were the first painters in the new tradition of realism to make colour a primary element in their work. Less intellectual than the Florentines, they studied nature more directly than any painters before them, and thus developed an *optical* or *atmospheric* use of colour; that is the rendering of the physical sensation of colour as seen in nature, modified by the effects of light, atmosphere and distance – not just the copying of each local colour. The Venetians' rich use of colour, which they combined with the new technique of oil-paint, was also influenced by the luxurious styles of Byzantium and the Near East of which Venice was culturally a part. Their colour, therefore, in addition to conveying realistic atmospheric effects, had an emotional content which expressed the pleasure-loving life of Venice which contrasted with the more austere cities of the mainland. The Flemish artists also had perfected the technique of oil-painting, and, like the Venetians, they developed an atmospheric use of colour with which they combined the close observation of detail in nature.

The traditions of Flemish realism and Venetian opulence were combined by Rubens in his flamboyant Baroque style. It was he who finally created a style in which colour was given pride of place, even above drawing, as the main element in painting. This led, eventually, through the work of Watteau, to the famous 'Quarrel of Colour and Design' which split the French Academy into Rubenistes and Poussinistes. The latter, in opposing the style of Rubens, Watteau and their followers, insisted that drawing was the true basis of art. Here we come upon another example of the emotional and intellectual divisions in art, for it will be clear that the subjective nature of colour makes it one of the main vehicles for the romantic artist, while the analytical character of Renaissance drawing made it the natural instrument of classic expression.

The style of Rubens and Watteau was adopted by the court painters of the 17th century, Boucher, Fragonard and others, who refined colour as a means of lyrical and theatrical expression. The tradition was given new strength by the Romantic movement, and especially by the work of Delacroix. He already understood much of the modern scientific principles of colour, and he increased the expressiveness of colour by deliberate use of complementary contrasts and other innovations. Delacroix thus provides a link between the academic use of colour and the discoveries of the Impressionists, as also does the work of Turner and Constable (see Chapter 5).

The place of colour in modern art is discussed in some detail in Chapters 5 and 10. Here it is sufficient to note that the Impressionists combined scientific principles of colour with a new and thorough observation of the optical effects of light and colour. The style thus

created terminated the European realist tradition of the Flemish and Venetian schools, and at the same time opened the way to new freedom in the abstract use of colour. Subsequently Gauguin and Van Gogh led a new romantic revolution in painting, using colour for personal emotional and symbolic ends, thus liberating colour from the academic restrictions of the past. At the same time Cézanne succeeded in reconciling colour with a classical approach to painting, and made it a *structural* element in his pictures by establishing mass and space through the relationship of warm and cool hues. Thus, one might say that Cézanne accomplished what is perhaps the most revolutionary development in colour – he combined colour and design in a way that had never happened before.

The liberation of colour, which is one of the cornerstones of modern art, has been given a new direction by recent psycho-analytical research. The mind-expanding effects of colour are only beginning to be understood, but recent experiments into colour and light projection (i.e. colour in its purest form), incorporating it in kinetic art and light shows, are establishing colour as the basis of a

Fig 18. *Still Life with Apples and Pomegranates*, Courbet. Reproduced by courtesy of the Trustees, The National Gallery, London

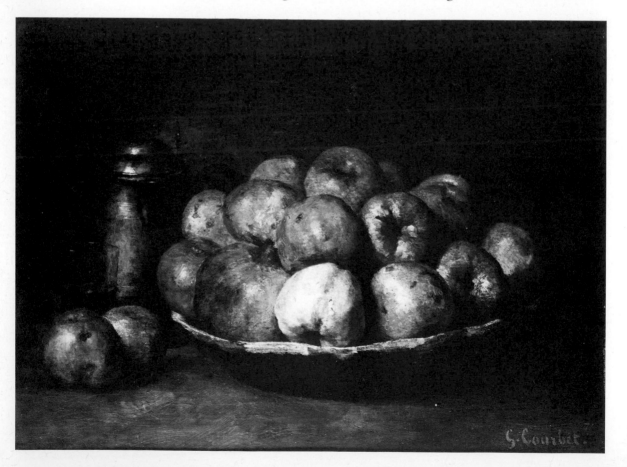

new style in art capable of evoking new responses to reality which are beyond the scope of conventional media. While the scientific nature of colour is now widely understood, research into its psychological effects is still in its infancy. However, in view of some of the exciting things which are happening in contemporary art, involving quite novel uses of colour, it may not be unreasonable to predict that a whole new style in art and design based on new techniques of colour application and projection may come into being in the near future.

TONE

Tone, that is modulations from light to dark, can be used structurally to give solidity to forms as in the work of Poussin (fig 47). It may also be used optically to create a purely perceptual image of the world as in the closely observed tones of Chardin (fig. 45) or Manet (fig. 57).

But by exaggerating tonal contrast from highlight to deep shadow, tone becomes one of the most powerful ways by which the artist can express feeling, emphasising inner spiritual qualities as in the portraits of Rembrandt, or dramatising themes of violence as in the paintings of Goya (fig 52), or suggesting the mysterious forces of nature as in the hazy tones of Turner (fig 53). The tonal organisation of a painting is always very important in creating the mood of the work.

TEXTURE

Texture – the roughness or smoothness of surfaces – like colour and tone, can be used perceptually to give an illusion of the actual world, as when Van Eyck copies in oil-paint all the textures of an interior (fig 34) or it can be used to convey feeling through the artist creating expressive textures with his materials as in Rembrandt's or Van Gogh's dynamic brush strokes. But perhaps its most special effect is in communicating the artist's sensations. The Van Eyck painting, apart from being a perceptual record, has the quality of making us identify ourselves with the ordinary things in the room, through stimulating in imagination our sense of touch. Likewise, in the work of a realist painter like Courbet, the way in which he conveys texture as well as the colour of apples (fig 18) tells us more about the fruit than what the eye sees.

In this painting he is concerned not only with the visual appearance of a bowl of fruit, but also with the weight of the apples, how they feel, and even, we might suppose, their taste and smell.

3
Art and Ideas

We are now in a position to sum up the main turning-points in styles, which represent fundamental changes in man's ideas, from the earliest times up to the present day.

EGYPTIAN ART

The art of Egypt represents the longest and richest tradition in Mediterranean civilization before Greek times. It is the first great style in which we can see clearly how the character of the artist's work results from the beliefs of his time, and the sophisticated uses to which art is put.

Fig 19. Ornamental fishpond in the garden of Nebamun, *c.* 1400 BC. Reproduced by courtesy of the Trustees of the British Museum

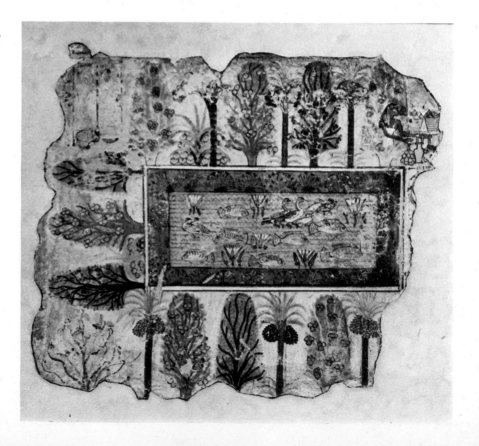

Prehistoric man had little need of subtle organisation in his art beyond the spontaneous creation of a magical image in simple materials on the ready-made wall of a cave. The art of Egypt is the product of a much more complex society, which had gone beyond sympathetic magic to evolve a profound religion and the new conception of an after-life.

Most of the art produced was concerned with the immortality of the Pharaoh and members of the ruling class. Much of it was tomb art, intended to provide the departed ruler with all the things which he had enjoyed in life.

It was necessary, therefore, that sculptural and pictorial representation should be as complete as possible, and for this reason figures and objects were shown from variable viewpoints so as to depict them in the most detailed and recognisable way.

In the wall-painting (fig 19) the fishpond is seen from above while the fish, birds and plants are seen from the side, arranged clearly in rows at right angles to the sides of the pond, with none of the forms overlapping or obscuring each other. In the next detail (fig 20) the Pharaoh is shown, with a fishing cat, hunting birds

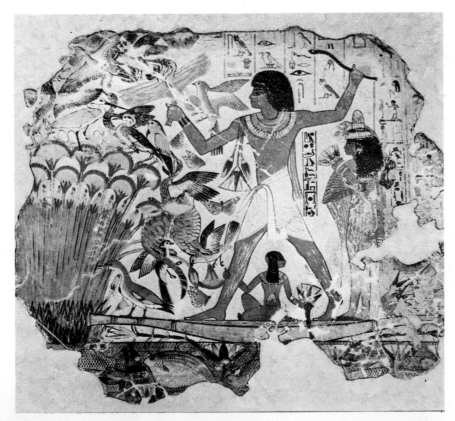

Fig 20. Fowling scene from tomb of Nebamun, Thebes. Reproduced by courtesy of the Trustees of the British Museum

from a boat on the Nile; his wife and daughter accompany him. The figure is treated in the same manner as the fishpond. Each part of the body is seen from its most typical aspect – the face in profile, the eyes and shoulders from the front and the hips and legs from the side; and the big toe is visible on both feet. The difference in the size of the figures shows their relative importance, and is not due to perspective depth. There is no attempt to represent space.

However, compared with prehistoric and other primitive art, which is concerned only with the single magical event, Egyptian art expresses man's new awareness of time. Events and activities are shown in a clear sequence, and the idea of infinite future time is conveyed in the almost indestructible forms of the pyramids, tombs and monumental sculpture. This new expression of time in art went hand in hand with the Egyptians' invention of the calendar, and follows naturally from a culture based on settled agriculture in which the seasons of flood, sowing and harvesting had to be anticipated and planned for.

THE GREEKS AND ROMANS

Egyptian art was strictly conceptual as can be seen by comparing the examples with the much more perceptual Greek sculpture (fig 15). However, Greek art, although based to a great extent on the observation of man, aimed not at describing particular people, but at producing an image of the ideal man, beautifully proportioned and in full command of his intellect and emotions. Many of their sculptures were based on the triumphant athletes of the Olympic Games, which had the same aim – to find the ideal man in whom all aspects of personality – physical, mental and imaginative – were fully cultivated. To the extent that it aimed at an ideal of perfection, Greek art was partly conceptual.

The Greeks were the first to liberate the human mind from the restrictions of conventional religion, thus enabling the individual to speculate freely on the nature of man and the universe. They thus laid the foundations of European thought and created the standards and ideals by which the secular art of the West was to be judged for five hundred years. But they were thinkers rather than doers; they despised the senses, and therefore lacked the capacity for direct observation and experiment which is the basis both of empirical science and perceptual art.

The perfecting of the mind through abstract thought, rather than the control of nature by practical means, was the main goal of Greek culture, and this is expressed clearly in the mathematical organisation of all their art and design. Plato even formulated the idea of a purely abstract art, independent of the sense of sight, when he said: 'I do

not now intend by beauty of shapes what most people would expect, such as that of living creatures or pictures, but for the purpose of my argument, I mean straight lines and curves and the surfaces or solid forms produced out of these by lathes and rulers and squares, if you understand me. For I mean that these things are not beautiful relatively, like other things, but always naturally and absolutely; and they have their proper pleasures, no way depending on the itch of desire.'[1]

The Greeks did not create any art quite as abstract as that envisaged by Plato, but he had given a definition which can apply precisely to much modern classic art which is concerned primarily with ideal mathematical relationships (figs 7 and 89).

In the 2nd century B C, following on their conquest of the Hellenistic lands, the Romans took over Greek art and culture. They adopted much of Greek philosophy, the classic system of proportion in art, as well as the motifs in architecture and design. But they adapted this borrowed culture to serve very different aims. Unlike the Greeks with their lack of experiment and emphasis on individual freedom, the Romans were a practical and materialistic people who believed in a society based on law and justice maintained by power wielded from above. To them material progress and the State, personified in the Emperor, were more important than abstract philosophy, or the freedom of the individual. Roman art, therefore, reflects very clearly the ideals of Roman civilization, and its particular adaptation of the philosophical ideas, inherited from the Greeks, to the conception of the all-powerful state. Much Roman sculpture is concerned with glorifying the power of the Empire and its Gods; at its best this work expresses the ideals of the Stoic philosophy to which the most conscientious of the Roman rulers subscribed. This is seen most obviously in a stern and dignified portraiture which creates images, not of ideal men as the Greeks did, but of practical rulers who endeavoured to transcend human limitations in the pursuit of an ideal path of duty (fig 21).

Side by side with these austere works one finds another, softer and voluptuous art which was probably that favoured by the pleasure-loving and immensely wealthy middle classes who were also possibly the first private collectors. This art, more commonly associated with domestic than public life, could be called Epicurean. Often, in its more extreme forms, it reflected the decadent tendencies in Roman civilization by contrast with the disciplined dedication to duty expressed in Stoic public art.

But probably the most remarkable and original Roman art is that of the extremely naturalistic portrait bust which has left us a revealing visual record of real individuals especially from the last days of the

[1] Trans. by E. F. Carritt; *Philosophies of Beauty* (Oxford 1931).

Fig 21. Bronze Head of
Emperor Hadrian.
Reproduced by courtesy
of the Trustees of the
British Museum

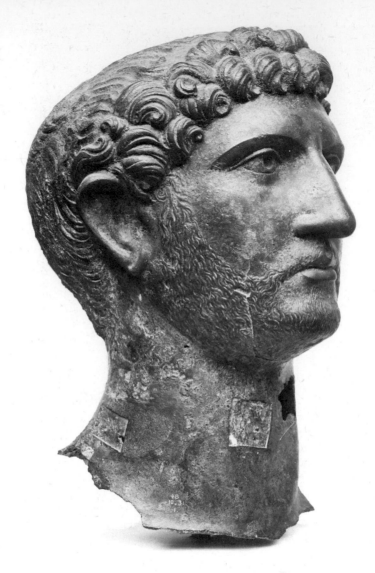

Empire. These images probably served the Roman cult of ancestor
worship, a religious form which came from the Romans' own
primitive origins rather than from the Greeks.

CHRISTIAN ART

Greco–Roman culture came to an end between the 3rd and 5th
centuries AD with the collapse of the Roman Empire. In the 4th
century Constantine moved the capital of the Roman Empire to
Constantinople, and made Christianity the official religion of the
Eastern Empire of Byzantium.

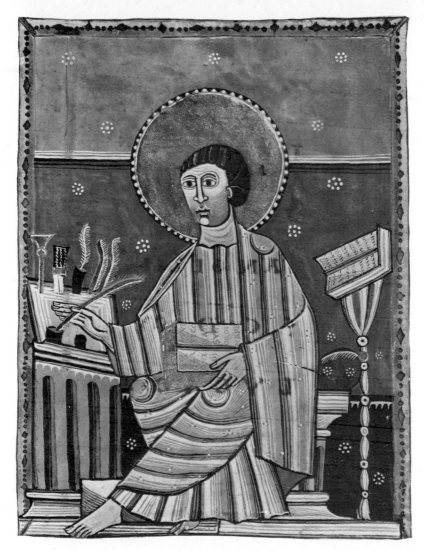

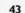

In the 5th century the invasion of the Germanic barbarians destroyed the Roman Empire in western Europe. From the wreck of the Empire grew a new form of society, Feudalism, with power decentralised in the hands of many landowning lords, each ruling over his own territory. Gradually, Christianity was carried northwards by missionaries from the Christian Byzantine Empire until, by the year 1000, a new Christian culture had developed in most of the countries of Europe.

In the early part of this development, during the period of transition from Roman to Christian culture, the art of the new Church kept many of the characteristics of Roman art, since most of the early Christian artists were converts from Roman paganism. But by the 6th century the Church had developed a completely new spiritual

style, expressing the new faith, and much influenced by the rich styles and techniques of the East with which the capital, Constantinople, had close contacts.

From then onwards, throughout the Middle Ages almost all the art produced was for the Church. The new religious art marked a swing away from the perceptual art of the Romans to a new imagery which was both conceptual and expressionist in character.

Christian art was concerned, not with the world of man, but with that of God, which was held by early theologians to be outside time and space. For this reason artists used a peculiarly other-worldly kind of drawing, with twisted perspective, probably done deliberately in order to emphasise that it was not the world of everyday human experience which they were representing. It will be seen (figs 22 and 23) that the perspective is sometimes reversed so that parallel lines diverge rather than converge as the object recedes into the picture.

In the detail of the stained-glass window (fig 24), there is no attempt to show depth or perspective; the image is entirely two-dimensional. The probable reason for this is that the artist was aware that the effect of light shining through the glass is such that the image is projected forwards, and that the material is, therefore, unsuitable for representing objects in depth.

In addition to this two-dimensional conceptual treatment, expressive of a spiritual world, Byzantine and Gothic pictorial art shows a lack of concern with structure, while emphasising the expressiveness of distortion, and of the surface qualities of colour and texture. The elongations and the shortening of the figures in both the mosaic and stained-glass details are expressionist in character and recall the two non-classical rectangles (fig 13). Moreover in the mosaic, the rich colours, dramatically enhanced by the flickering of many candles reflected from the uneven surface of the tesserae, (small pieces of glazed pottery or glass) served to create a feeling of spiritual elation in the congregation inside the church, which transported them away from the dreary world outside into the world of the spirit. In this way their art helped them to participate more fully in the liturgy of the Church ceremonies.

In the same way, the coloured light shining through the stained-glass which was held to be symbolic of the light of faith flooding into man's soul, created in the cathedral an ethereal atmosphere closer to man's imaginings of the longed-for next world than to the harsh realities of the actual world from which he sought salvation.

But even while Gothic art was at its height, focusing man's thoughts on the timelessness and infinite space of the spiritual world, events were taking place which were to challenge medieval belief,

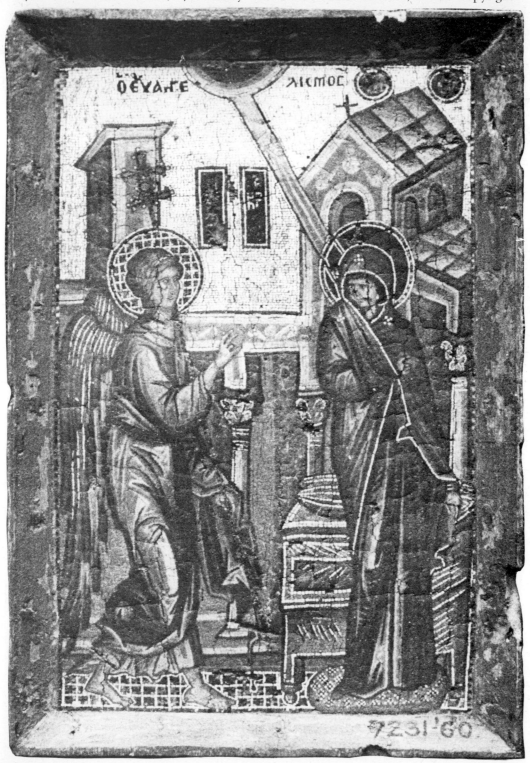

Fig 24. The Annunciation
– detail of stained-glass
window, Chartres
Cathedral; 12th century.
Archives Photo-
graphiques, Paris

and to lead man to a new vision of the universe and of his existence
in the actual world.

RENAISSANCE ART

In the 13th and 14th centuries the world of religious belief began to
give way to a new awakening of secular learning. The great cultural
movement which we call the 'Renaissance', or 'rebirth', marked a
new attempt to understand the real world.

In Italy, where mathematics played an important part in the early
development of science, the laws of linear perspective were dis-
covered, probably by the architect Brunelleschi, and were perfected
by artists from Uccello to Leonardo da Vinci.

Paintings then became like illusionistic boxes (fig 25) in which
all parallel lines vanish at the same point on the horizon; space is
seen from one fixed point of view, and objects are arranged in
receding scale, in the space thus created. Although the painting is
still concerned with the same religious subject, a strong sense of the
actual world is conveyed by, say, a comparison with the treatment
of the Annunciation in the medieval examples.

Renaissance art will be treated more fully in the following chapter.

Fig 25. *The Annunciation*, Crivelli. Reproduced by courtesy of the Trustees, The National Gallery, London

MODERN ART

One of the most important facts about the modern movement is that, in the last hundred years, art has again swung away from the perceptual back to a conceptual kind of art.

Here, the artist working in the Cubist manner, probably the most influential style in the modern world, has turned from the Renaissance single viewpoint to the more conceptual idea of representing objects from a number of different viewpoints all at once.

Fig 26. *Rain No. 1, 1927*,
Louis Marcoussis. The
Tate Gallery, London

In the painting (fig 26) each part of the subject seems to exist
in its own space, and to suggest a more complete view of the objects
than in the Renaissance painting. If we compare this picture with
examples of pre-Renaissance art (figs 20, 22, 23 and 24) we find that
they all have a great deal in common in their conceptual organisation
of form and space, although, of course, the modern artist adapts this
approach for very different reasons from those of the Egyptian,
medieval or Byzantine artists, as we shall see in the chapter dealing
with Cubism.

From this brief review of major styles, we will notice one very interesting fact; that art does not progress, in the sense of the art of one age being better than that of the preceding period, but rather that the development of art seems to follow an alternating pattern, like the swing of a pendulum, between the extremes of perceptual and conceptual expression.

We have traced the development of style from perceptual prehistoric to conceptual Egyptian, back to perceptual Greco-Roman to conceptual Christian, to perceptual Renaissance, and back again to conceptual modern. However, it is easy to over-simplify the development of art, and while this pattern seems to apply quite clearly to the styles of the past, it needs closer scrutiny when we come to examine modern art.

The Renaissance brought into existence the first great age of science with its unprecedented exploration and analysis, not only of every aspect of the external world, but of the very nature of man's innermost personality.

Geographical and astronomical exploration, physical and chemical analyses, nuclear physics and psycho-analysis have followed each other with bewildering rapidity, creating a fluid and complex culture which has largely submerged the old and relatively simple patterns of both classical idealism and religious belief. The art which our modern culture has produced, reflects its complexities and contradictions, making it more difficult to understand than styles produced before the 15th century.

If, therefore, we are to reach any real understanding of the meaning of art in our own time, it is to the styles of the past five hundred years that we must devote the last and more detailed part of our study.

4

The Age of Discovery: Renaissance and Baroque

PRELUDE TO THE RENAISSANCE

In order to understand fully the meaning of the Renaissance and the great changes which it brought about in art, it is necessary to examine the changes which took place in society, and, therefore, in patronage between the 13th and 15th centuries. The rigid organisation and beliefs of feudal society were reflected in, and supported by, medieval Christianity in which it was held that each man was born into a predestined place in society – king, nobleman, yeoman, and serf – that each must humbly seek salvation within the role given him by God, and that, especially for the lowest order, the serfs, it was sinful to try to change one's position in this life.

The patronage of art was completely in the hands of the powerful abbots and noblemen who were at one in preserving the inflexible laws of feudalism. It was this patronage which produced the Romanesque (or in England, the Norman) style which, in its solidity and four-square rigidity, so clearly expresses the ideas of this unchanging social order. Between the 12th and 14th centuries, however, due to conflicts between king and nobles, and peasant revolts against oppressive laws, the feudal system began to show signs of instability.

Perhaps even more important in bringing about social change were the Crusades which, in addition to disrupting the feudal patterns of power and civil war, introduced a new mobility into society. These great expeditions under the banner of the Church, but often undertaken chiefly for adventure and gain, enlarged the internal trade routes of Europe and opened up new ones to the Near East, and made feudalism more dependent on foreign trade.

The growth of cities which accompanied this expansion of trade was a new and major factor in bringing about the great social, political and artistic changes of the following centuries. The cities grew up at key points along the trade routes, and almost from their earliest beginnings they fought to be independent of the feudal landowners and abbots in their rural castles and monasteries.

The men who founded the cities were independent merchants and craftsmen; many had established themselves as traders in the foot-

steps of the Crusaders; many were serfs escaped from the restrictive employment of feudal lords.

These men constituted a new class whose enterprise and increasing wealth and power brought into existence a new kind of society. Their interests were opposed to the old order and, although the early cities paid tribute to local feudal rulers, conflict between city and landowner grew; the cities allied themselves with the king against the nobles and were eventually granted charters of freedom. In the great cities of Italy, France and Flanders the merchants and craftsmen formed themselves into Guilds to protect their interests. Their wealth and power increased far beyond that of the feudal lords, and with a degree of prosperity and leisure, unknown in Europe since Roman times, the cities rapidly became the new centres of learning and art.

The Church still retained its power over men's religious belief and practice, either through the genuine piety of members of the merchant class, or otherwise by bringing pressure on the new rich to contribute part of their wealth to the Church. The Church laid great emphasis on the dangers with which excessive wealth threatened man's salvation, and the question 'How may a merchant save his soul?' was echoed again and again in the preaching of the time. As a result, the surplus wealth of the Guilds poured into the Church in the form of a new patronage of art and architecture.

Secular luxury in art and design increased under the new prosperity of the cities, but it is the Gothic cathedral, with its soaring columns, flying buttresses, and symbolic richness of sculpture and stained-glass which is the characteristic expression of the new patronage of the City Guilds. Standing in a dominating position over the city, the Gothic cathedral was the focus of medieval life to which all activities were directed. Every part of its structure and ornament had symbolic meaning, so that it could be regarded as a great visual encyclopaedia of religious knowledge containing all that man needed to guide him to salvation. Such cathedrals stand today as witnesses to the last great age of communal faith and art in the West.

The unified patronage of religious art by the Guild was soon to be disrupted as powerful individuals emerged in the merchant class, men who not only often questioned the power of the Church, but turned their eyes and minds to a new vision of the real world.

GIOTTO AND THE RENAISSANCE IN ITALY
The continuing decay of feudalism led, in the 13th and 14th centuries, to greater freedom and power for the cities. Christian faith still had a profound hold on people's minds, but the authority of the Church in the conduct of everyday life decreased. The secular courts

of Europe became more independent of Church rule and, especially in Italy, the Church was weakened by corruption, luxury and increasing conflicts with secular power. There were many popular movements for the reform of the Church during this period, of which perhaps the most important was that led by St Francis which resulted in the Papal recognition of the Franciscan Order in 1223.

The ideas of St Francis helped to humanise medieval theology, through his emphasis on nature and all things in the actual world as expressions of God's creation. His practical love of animals and plants was an important influence in changing man's attitude to nature from one of medieval fear and superstition to one of acceptance, enjoyment and curiosity. The Franciscans permitted more free enquiry into nature than the orthodox theologians, and thus opened the way for a new scientific exploration of reality.

After the death of St Francis, the Order became very wealthy, having gained great influence over the middle classes in the cities, and came to exercise a more liberal patronage of religious art.

During this same period the conflicts between the middle class and nobility continued, resulting in the gradual triumph of the merchants. Nowhere was this development more dramatic than in Florence, where the struggle between the Ghibellines (nobility) and the Guelphs (middle and lower classes) led in 1293 to the Ordinamente di Guistizia (the Ordinance of Justice) which finally established the power of the middle class and restricted the nobles from interfering in the political and economic life of the city.

The men who achieved this power in Florence were the most typical of the new class that had broken out of the strait jacket of feudalism. Intelligent, enterprising and often ruthless, they showed that the individual, by his own effort, could change his position in society, contrary to the dogma of medieval belief; they felt, for the first time since the ancient Greeks, that the individual man is more important than the political system. Moreover, through the social and technical advances which they had achieved they demonstrated that man could change the world around him.

To these Early Renaissance men, the world was real; things in nature were no longer to be regarded as symbolic manifestations of the thoughts of God, or otherwise to be superstitiously feared. The world was for man's use and enjoyment, to be explored in terms of both science and art, and to be ordered to man's practical and imaginative requirements.

Thus the merchant class produced two fundamental ideas on which the culture of the Renaissance was founded – humanism and realism. It was still possible to reconcile these ideas with traditional religious belief and it was largely through the broadening effect of

Franciscan teaching that it became possible to express the new realities of humanism and realism through religious art.

It was into this cultural climate that Giotto (1266–1337) was born, and it was he, more than anyone else, who created the new visual language through which the ideas of his time were expressed. Giotto is rightly regarded as the father of European painting. Trained under Cimabue (c. 1240–1302) who had taken the first steps away from Byzantine towards a realistic style, Giotto worked as an architect as well as painter. He was employed almost exclusively by middle-class families, and by the Franciscans, and his most important work is to be found in the Franciscan Churches at Assisi and in the Arena Chapel at Padua, donated by the merchant family of Scrovegna.

The genius of Giotto lay to a great extent in the way in which he identified himself completely with the new ideas of his patrons, both in his painting and in his way of life. He became the richest artist in Florence, then turned to business, hiring out looms, at great profit, to the weavers of the city. (Florence was one of the greatest centres of textile manufacture in Europe, and Giotto's close contact with the industry is evident in his knowledgeable and sensitive painting of draperies.) In short, Giotto was not only an artist, but a businessman, in a society of realist businessmen, sharing the ideas and ambitions of the people who commissioned his work.

He broke away from the other-worldly stylisation of Byzantine art and introduced a new realism into the treatment of the human figure, making it as solid as possible. Above all he sought to emphasise the psychological meaning of his religious scenes by conveying in the human face the varied expressions of human emotions, and by using his composition to heighten the drama of events.

In figs 27 and 27a we notice how he turns the two principal figures so that they look at each other, an arrangement never found in early Christian art, how he enfolds Christ in the cloak of Judas, expressing the fact that Christ was in the power of Judas at that moment, and how all the large shapes and lines lead up to and enclose the main focus of the picture – the point of tension between the eyes of the two figures. Giotto presents us with not just an incident, but tries to show us how each person in his composition reacts to the incident. He is thus one of the first artists to emphasise the importance of the individual in relation to the events of the real world.

At about the same time as Giotto was working, other artists and scholars were making important contributions to the new culture. In literature, Dante (1265–1321) was among the first to reject Latin as the only language of the educated, and wrote his great work *The*

Fig 27. *The Kiss of Judas*,
Capella Scrovegna, Padua,
Giotto. Foto Scala, Firenze

Fig 27a. Composition
analysis of fig 27

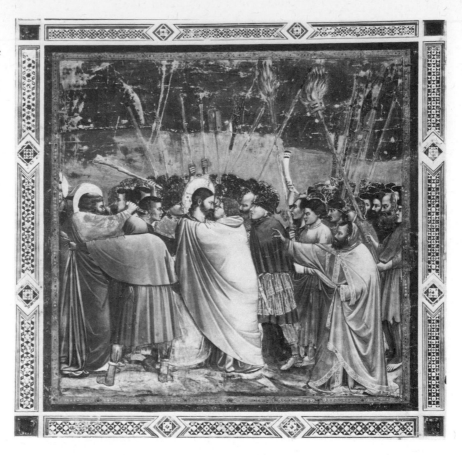

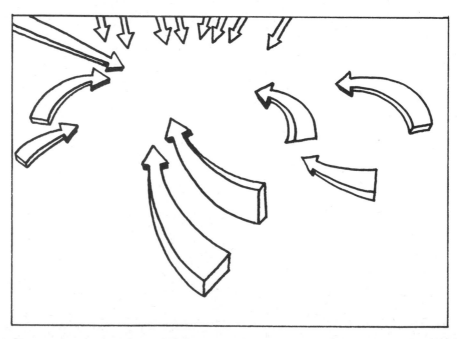

Divine Comedy in Italian. The poet Petrarch (1304–74) was one of those who led a new interest in Greco-Roman culture. Boccaccio (1313–75), author of the irreverent *Decameron*, was the first scholar of his time to learn classical Greek. Marco Polo (1256–1323) had already made Europe aware of the existence of an Eastern civilization greater than that of medieval Europe. Later Amerigo Vespucci (1451–1512), merchant and navigator, and Christopher Columbus (1446–1506), mathematician and scholar of astronomy, were to carry further the geographical exploration of our planet.

MERCHANT PRINCES OF THE 15TH CENTURY
In the middle of the 14th century, however, the upsurge of Italian middle-class wealth and power received a setback, due to renewed struggles between the upper, middle and lower classes.

The Hundred Years War brought about the bankruptcy of the middle classes, and for a while the new patronage of art lost its impetus. As a result, in the latter half of the 14th and the early years of the 15th century, little was added to the language created by Giotto, and the influence of the older Byzantine style continued in most paintings of the time.

During this period of depression only the richest and most powerful families maintained their position. From these tough survivors, some of noble, some of middle-class origins, emerged the great political and mercantile families who were to rule Italy at the height of her cultural achievement in the 15th century – the Strozzi, Pazzi, Visconti, Sforza, Borgia, and greatest of them all, the Medici. Attaining even greater wealth than their predecessors, these families modelled their lives on patterns of princely splendour and came to differ from the old nobility only in their even more luxurious way of living and in their modern and forward outlook on life.

The competition between these families was fierce, and in Florence, after a series of struggles which were a mixture of formal feudal battles and back-stabbing gang warfare, Cosimo de' Medici ended the strife in 1434 by making himself and his family virtual rulers of the city. This pattern, of one or two powerful families dominating a city, was repeated in Milan by the Visconti and Sforza, while of the three other great cities, only Venice remained independent and isolated, more Byzantine than Italian; Naples was ruled by an absolute monarch, and Rome, with the Papal States, was controlled by the Popes created from the great families of Italy.

Although ruthless and often treacherous in their grasp of political power, these new merchant princes were cultivated and educated, with a thirst for all new knowledge and art, and they had wealth enough to patronise artists and scholars on a large scale. They

pursued the ideas of humanism and realism, but with an even greater emphasis on the importance of the individual, and with a greater desire to understand and control the world around them. The study of mathematics, anatomy, botany, astronomy and other secular subjects which they fostered marks the beginning of modern science. In art, extending Giotto's innovations, it helped to create a new language for describing space, solid form, and realistic detail in nature.

To the humanism and realism of 15th-century society was added another stimulus which was to carry man forward into a world of new and dangerous ideas that challenged the dogma of the Church. This was the revival of classical learning which followed the rediscovery of Greco-Roman art and philosophy. New speculation about the world had led to renewed interest in non-Christian learning. With the fall of Constantinople to the Turks in 1453, scholars from the Eastern capital, which had maintained a tradition of classical scholarship, migrated to Italy and settled in the new centres of culture. At about the same time, in the search for new knowledge, Greco-Roman manuscripts which had been preserved in Christian libraries were rediscovered and studied anew. The logic and freedom of thought of the Greek philosophers fascinated the individualistic mind of 15th-century man.

In the practical field of art and design the great programme of palace and other secular building under the new patronage led to the study of the pre-Christian styles of Rome, and the first excavations and measurements of classical ruins. This study was stimulated and clarified by the discovery, at the beginning of the century in the library of Monte Cassino, of the complete manuscript of the treatise on architecture by Vitruvius, the great Roman architect.

This newly acquired knowledge of the ancient past with its different values and greater freedom led naturally to an adventurous and often dangerous speculation about the nature of man and his future. The artist was most responsive to this new climate, and by mid-century he found his status raised from that of mere craftsman to that of an artist-philosopher, playing an important part in the intellectual life at the courts of the merchant princes. In this atmosphere of enquiry, learning and art, the 15th-century artist perfected the language of Renaissance humanism and realism.

PIERO DELLA FRANCESCA

Characteristic of mid-15th-century art, and one of its key figures, was Piero della Francesca (1410/20–92). Equally famous in his lifetime as a mathematician and a painter, he expresses exactly the scientific and intellectual character of the great banking city of Florence, from which he developed his style.

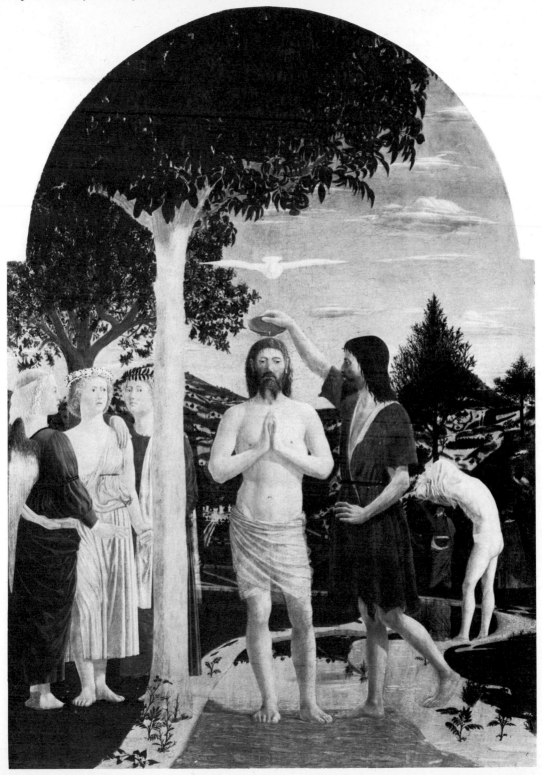

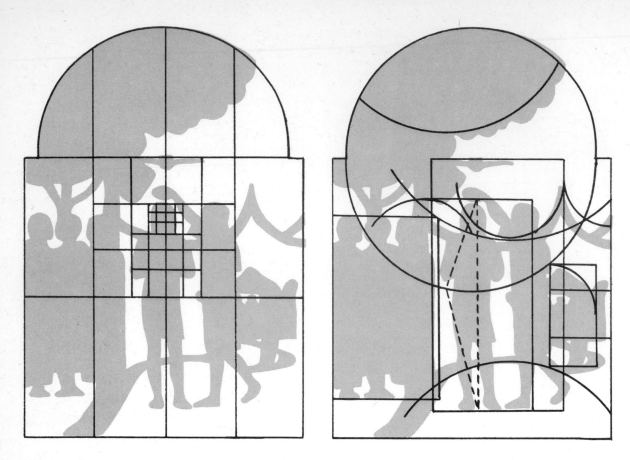

Fig 28a and b. Analysis of
fig 28

An analysis of his 'Baptism of Christ' (figs 28, 28a and 28b) reveals
that the composition is based on a division of the panel into thirds
horizontally, and into fourths vertically, with this same division
being repeated in decreasing scale towards the centre of the picture,
until we find Christ's head framed in a rectangle. There seems to
be little doubt that the geometric basis of his pictorial organisation
was deliberate, since the numbers three and four had special signi-
ficance at the time – three being the number of the Holy Trinity,
and four that of the classical elements earth, air, fire and water. By
combining them, Piero not only expresses the idea of God in the
world in the person of Christ, but also relates, in a typically Florentine
way, classical thought and Christian faith.

Like all paintings this one contains not one, but several patterns
of composition. It seems likely that, having constructed a strict
mathematical scaffolding for his painting he then developed the
composition further on the basis of repeated rectangles, circles and
arcs; such a development might well be more intuitive than the
original scheme of divisions, expressing Piero's own classical sense
of order.

We notice also how Piero introduces space, through the newly discovered method of perspective drawing, in the change of scale from the figures in the foreground to the distant towers in the background.

MASACCIO

If Piero expressed the mathematical idealism of 15th-century Florentine culture, it is Masaccio (1401–28) who extended the realism of Giotto. Giotto had lent new life and solidity to his figures, but he had difficulty in establishing the space between them, so that his pictures remain partly two-dimensional. Masaccio both improved on Giotto's modelling of the figure to give it greater solidity, and also succeeded in creating a pictorial space in which his solid masses could exist with the illusion of real life (fig 29 – facing page 64).

With Masaccio, the new language of space and form was fully established. Other artists were to refine it and use it even more fluently.

TITIAN AND THE VENETIAN SCHOOL

If we compare the 'Madonna and Child' of Masaccio with that of Titian (fig 30 – facing page 65), we notice a number of interesting differences. The intellectual Florentines were mainly interested in shape, volume and space; they used colour only to distinguish one area from another, each area being clearly bounded by an outline (local colour – see Chapter 2). Indeed, Florentine pictures could be regarded simply as coloured drawings, since they were first composed and drawn in monochrome and only afterwards was the colour applied by glazing over the drawing and underpainting.

Titian (1487/90–1576) and the Venetian painters had a different approach in which colour was as important an element as drawing, and its use expressed the essential difference in the cultural climate of Venice from that of Florence. A city of art, music and trade, rather than of science and banking, the main European trading centre for the rich and colourful products of the East, Venice had developed a more sensuous and pleasure-loving attitude to life. These qualities are expressed in her art through a sensuous and poetic use of colour, light and atmosphere.

Moreover, the Venetian painters relied on a direct observation of nature, accurately studying her tones and colours, rather than on the geometry and perspective used by the Florentines. They unified their compositions not by line but by tone and colour (atmospheric colour – see Chapter 2). Thus in Titian's painting, the reddish brown of the kerchief appears in the grey dress, in the flesh colour, in the hair and in the background.

This style, begun in Venice, led to developments in colour in the

succeeding centuries which resulted eventually in the art of the Impressionists, and this late painting by Titian might almost be by Renoir (see Chapter 6).

TINTORETTO

Renaissance art developed a little later in Venice than in Florence. By the time Tintoretto (1518–94) was working there, new scientific ideas about the nature of the universe were gaining ground. In particular, the belief that the world was the fixed centre of the universe was giving way to a new theory of a dynamic universe in which everything, including the earth, was in a state of constant motion. More will be said about the men who originated this theory later in this chapter, but it seems certain that the Venetians with their study of astronomy and navigation were receptive to new explanations of the universe, and it was in Venice that the awareness of this new aspect of reality was first clearly expressed – in the paintings of Tintoretto. His picture 'The Origin of the Milky Way' (figs 31 and 31a) is not only an allegory on an astronomical theme; the whole composition is based on the idea of dynamic movement, with the airborne figures of Jove, the infant Hercules, Juno and the Cupids

Fig 31. *The Origin of the Milky Way*, Tintoretto. Reproduced by courtesy of the Trustees, The National Gallery, London

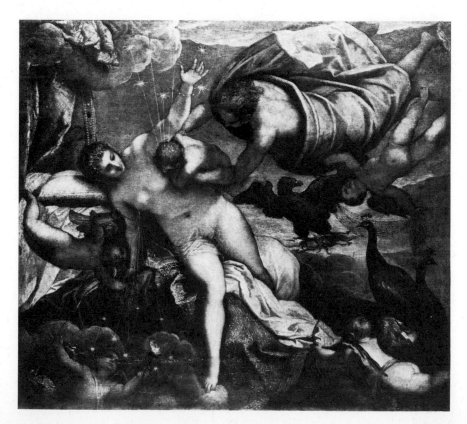

appearing to hurtle through space – a very different universe from the static order of Piero's.

LEONARDO DA VINCI

It is one of the great paradoxes of the Renaissance that, at the time when the economic foundations of the City States began to crumble and they lost political and military power, Italy produced her greatest art. By the end of the 15th century, the period now referred to as the High Renaissance, the mainland of Italy had become a battlefield of foreign armies seeking to bring the riches of Renaissance Italy under their control. However, this was also the age of Leonardo da Vinci (1452–1519), Michelangelo (1475–1564) and Raphael (1483–1520), three artists who took the language of Renaissance art to its greatest heights, using it with a breadth, fluency and power which few of its earlier creators matched.

The turbulent times in which they lived and the breakdown of Renaissance humanist values, affected these artists in different ways. Leonardo, often described as the greatest 'all-round man' of his age, pursued knowledge on a broader front than any of his contemporaries, making major and prophetic contributions to science no

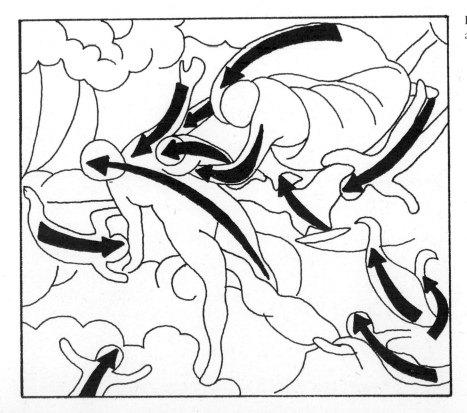

Fig 31a. Composition analysis of fig 31

Fig 32. *Virgin of the Rocks*,
Leonardo da Vinci.
Reproduced by courtesy
of the Trustees, The
National Gallery, London

less than to art. But in the few paintings he has left us he seems to have withdrawn more and more into a world of his own imagination, his pictures becoming darker and darker and more dreamlike throughout his life (fig 32). He expresses in his work the melancholy twilight of the Italian Renaissance and the beginning of an age of emotional instability which was to follow.

His scientific investigations led him to the same conclusion which Tintoretto seems to have reached intuitively, that the understanding of movement is the key to nature, but unlike Copernicus and Galileo he never published his notes on dynamics. However, his awareness of these forces about to be revealed by science, is expressed in his most original drawings of the elements in movement – storms, clouds and flowing water – whilst his strange background to the 'Virgin of the Rocks' suggests the volcanic forces within the earth itself.

MICHELANGELO

From a belief in man and his power to control himself and his environment, the Renaissance moved through a period of depressing strife and disillusion which seemed to disprove the earlier ideals of the 15th century. Leonardo had expressed not only the turbulence of his time, but his awareness of the frightening forces in nature which man yet barely understood and which were still beyond his control.

The foundations of Renaissance optimism were shaken. So it was also with Michelangelo, the development of whose work reflects equally the troubled atmosphere of Italy during his lifetime. Both artists were frustrated in their work by the fact that their patrons were more preoccupied with war than with art. Their most creative works were starved of money due to their employers' expenditure on their armies. Both spent much of their lives working as military engineers.

The early work of Michelangelo expresses the confidence of Renaissance man in his own powers. He represented God in the form of a superman, and man as embodying god-like qualities. The latent power of the individual is conveyed with a Greco-Roman beauty of form and a scale which makes man larger than in everyday life. But, as Michelangelo grew older, the Italy of his youth disappeared, the Church which he served was torn apart by the Reformation, and the difficulties of his personal life increased. Then his work gained an angry power that suffering and frustration lent to his vision. The figure of Moses (fig 33), the central feature of the great tomb of Julius II which, under the Pope's demanding and erratic patronage took up the best years of the artist's life, expresses

Fig 33. Michelangelo's
Moses. Basilica di San
Pietro in Vincoli, Rome

Michelangelo's own feelings of anger, power and brooding anguish.
 Later, after the Reformation, when he seems to have lost faith in
man in this world, his work became more poetic and mystical –
almost medieval in its other-worldly character. The tragedy and
pessimism of the collapse of Renaissance Italy, no less than his own
personal suffering, are echoed in Michelangelo's anguished statement
in which he, like Leonardo expressed the idea of man at the mercy
of forces outside his control. Speaking of his work for the Pope,
'I have wasted my youth, chained to this tomb', and later, towards
the end of his life, 'I am sick of heart and can find no rest.'

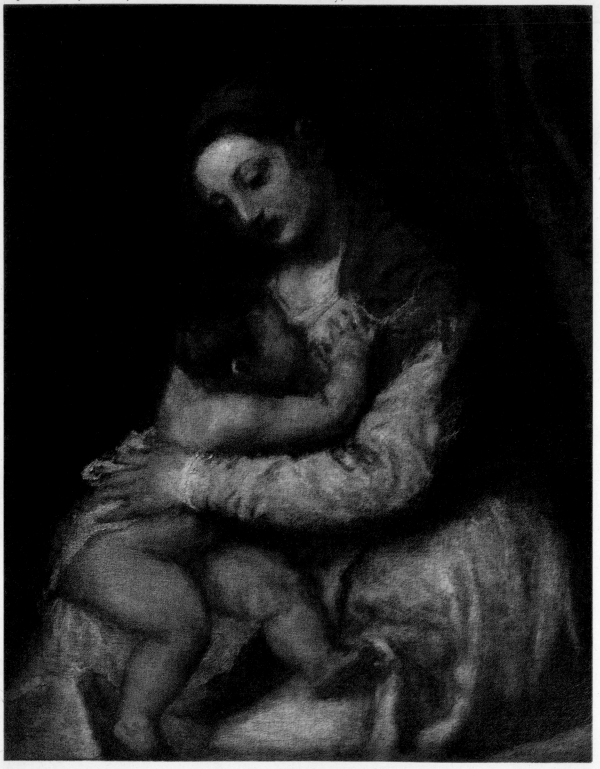

RAPHAEL

The greatest artists in any age are perhaps those who, like Leonardo and Michelangelo, become deeply involved, intellectually and emotionally in the events of their times. But there are others who, especially when faced with conflicts such as those that affected Italy during the High Renaissance, react against events and try to evade or rise above personal involvement by seeking to create an ideal image of what the world might be, rather than what it really is like.

Such an artist was Raphael (1483–1520) whose perfectionist method and technique so clearly avoids any reference to the hazardous state of Italy and his Papal patrons. Perhaps Raphael, who died at thirty-seven, did not live long enough to reach the maturity of Leonardo or Michelangelo, but it is difficult to decide whether his art is the result of a dedicated idealism or merely an escape from the times he lived in.

THE NORTHERN RENAISSANCE – FLEMISH PAINTING

In northern Europe, the centres of the new realism in art were the prosperous manufacturing and mercantile cities of Flanders. Here the pioneer artists were Jan van Eyck and his lesser known brother Hubert.

Northern realism differed from Italian in being much more perceptual, and the Northern artists rarely used the conceptual classic geometry and mathematical perspective of the Florentines. There are a number of reasons for this difference. Classical Greco-Roman art was virtually unknown in the Gothic North, and the Flemish middle-class patrons were, on the whole, less scholarly than their Italian counterparts, relying much more on personal experience and experiment in developing new ideas than on classical philosophy. Furthermore, climate and national characteristics made art a more private and personal matter in the North, with the artist producing small-scale minutely observed work, unrelated to architecture, in the isolation of his studio. Contrast this with the Italians working on a large scale, usually on compositions designed for particular churches or palaces frequently executed under the public gaze. In short, the art of the cold North tended to be introverted and private, whilst in Italy, where life is lived more in the street and communal places, art is more extroverted and public.

The Renaissance artist in the North was valued as an observer of detail and events rather than as a philospher. Van Eyck's painting 'Arnolfini and his Wife' (fig 34) is almost certainly a record of a marriage ceremony, and may well be one of the first pictures commissioned as an eyewitness account of an event by the artist; the inscription over the mirror reads 'Jan van Eyck was here, 1434',

Fig 34. *Arnolfini and his Wife*, Van Eyck. Reproduced by courtesy of the Trustees, The National Gallery, London

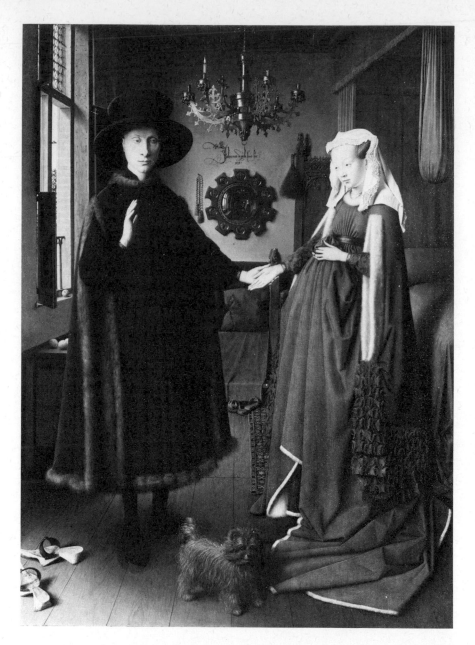

and reflected in the mirror we can see two figures who were probably the witnesses to the ceremony, and one of whom may well be van Eyck himself.

We notice how the treatment of many minute details, such as the rust stains from the nails in the window-frame, the play of light on the brass candelabra, and the worn-down and stained footwear in the foreground, show direct observation rather than conceptual thought. We have already observed in Chapter 2 how van Eyck

uses the newly developed medium of oil-paint to create the illusion of actual textures. He thus leads us imaginatively into the painting through our knowledge of everyday materials gained through our sense of touch.

This art, based on the use of the eye rather than the mind, with its concern for natural colour and the appearance of surfaces, was to lead eventually to 17th-century Dutch painting, and later to 19th-century realism.

GERMAN ART

German art had always contained strong elements of emotion and fantasy, an expression of the introverted and frequently anguished temperament of Nordic man. These can been seen in the expressionist idols of Nordic pre-Christian ritual and in the horrific demons which appear in medieval German art. By contrast with the quiet, observant art of Flanders, German Renaissance art took on a much more dynamic and expressive character.

By the 16th century northern Europe, like Italy, had become extremely disturbed both in religion and politics as a result of the Reformation and the wars which followed it. The conscience of the individual Christian was torn between his sense of direct duty to God and his loyalty to the teachings of the Church. Reformed Christian teaching laid emphasis on personal faith, and German art of this period expresses both the anguish of divided loyalties and the new individualism in belief. Nowhere is this seen more powerfully than in the paintings of Mathis Grünewald (c. 1470/80–1528). In the detail of his 'Crucifixion' (fig 35) the artist's personal identification with the suffering body on the Cross, and the resulting expressionist treatment of the figure and its setting, leads the viewer also to share immediately the physical agony of Christ, and thus focuses the individual's direct relationship with God which was the essence of belief in the 'Reformed' Church. Compare this image with the impersonal and almost totally unemotional 'Crucifixion' by Raphael (fig 5).

BAROQUE ART – REFORMATION AND
COUNTER-REFORMATION

In the 16th century, following the collapse of the independent City States in Italy, three important historic factors served to change the whole cultural climate of Europe, and gave rise to new patterns of patronage in the arts. These were the Reformation, the Counter-Reformation with the growth of absolute monarchy, and the spread of new scientific ideas about the nature of the universe. In Catholic Europe, the Baroque style growing out of Late Renaissance art

Fig 35. *The Crucifixion*,
Grünewald. Staatliche
Kunsthalle, Karlsruhe
(Photo Eva Bollert)

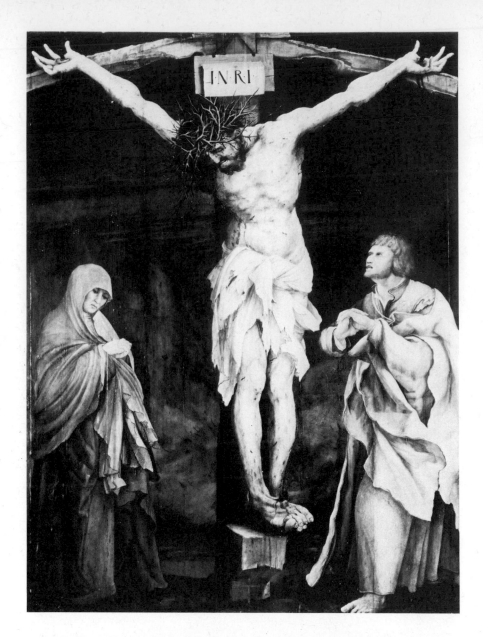

emerged as the artistic language expressing emotional, religious
fervour and the mystical ideas of absolute monarchy. Baroque art
also reflected strongly the new ideas of a dynamic universe, while
in the 'Reformed' countries, middle-class naturalism and the new
theology were shown in a new phase of realism in art.

 The 'Reformed' Church rejected the luxury and ritual of the
Papacy and considered the making of religious pictures and sculp-
tures to be idolatrous, so that in the non-Catholic countries Church
patronage almost ceased and most artists had to turn to new secular

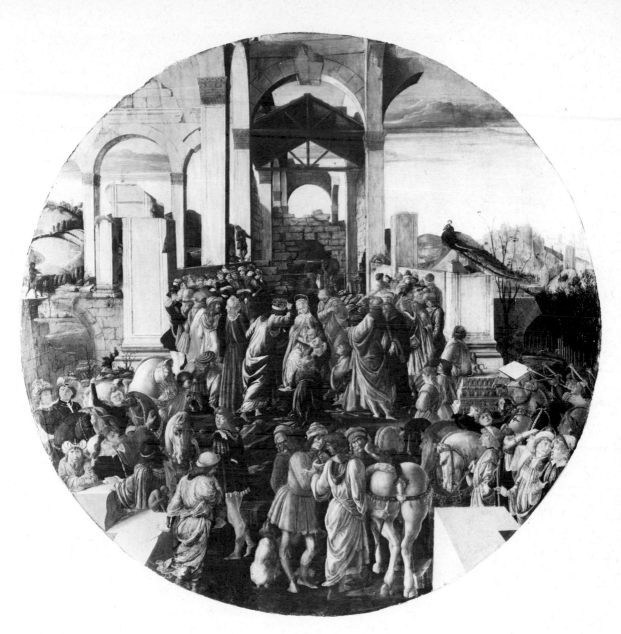

subjects. But even those who were able to continue painting religious subjects were clearly influenced by Protestant ideas. If we compare Botticelli's 'Adoration' (fig 36) with that of the Flemish painter Brueghel (fig 37) we see that Botticelli interpreted the subject in terms of a splendid pageant, expressing at once the courtly life of his Florentine patrons and the kind of regal luxury which the Catholic Church, before the Reformation, accepted as a fit setting for the life of Christ. On the other hand, while there is much dispute about the nature of his patronage, Brueghel's interpretation is much

Fig 36. *Adoration of the Kings*, Botticelli. Reproduced by courtesy of the Trustees, The National Gallery, London

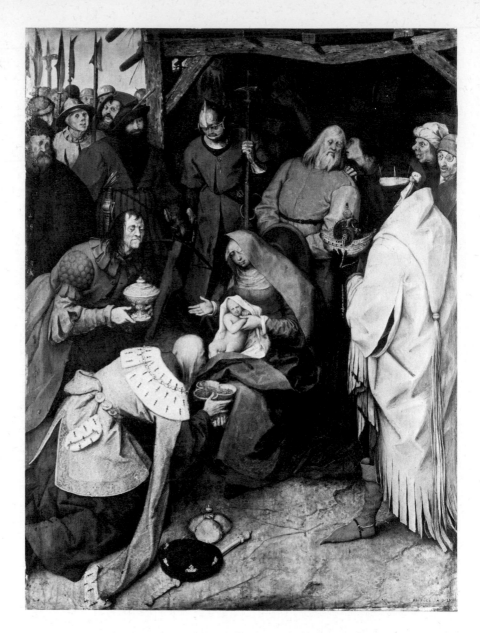

more in tune with Protestant thought. The scene is brought directly into everyday life so that anyone viewing the picture at the time it was painted might imagine it to be an event in his own village. He is not kept at a distance from Christ by grandeur such as Botticelli's, but can identify himself with the ordinary people who crowd familiarly round St Joseph and the Virgin.

The religious upheaval of the Reformation shocked the Papacy into a recognition of its shortcomings, and the Council of Trent (1545–63) was convened to carry out the necessary reforms within

the Catholic Church itself. As a result the Catholic world re-organised itself for a great struggle to win back the lands lost to the 'Reformed' Church. For the Counter-Reformation the Church marshalled all its forces – political, military and evangelical and it found a new emotional use for art in its campaign to recapture the minds and imaginations of men in the 16th century.

At the Council of Trent, the Church redefined the role which art should play in influencing and reinforcing religious beliefs. It rejected the freedom with which 15th-century artists were allowed to interpret religious subjects, it ruled rationalism and humanism to be opposed to religious expression and it required the artist to lay emphasis on revealed truth and spiritual qualities. A new kind of artist was, therefore, attracted to Church patronage, the kind of personality who could identify himself emotionally with the new fervour of the Church, who would turn his back on both the themes of classical philosophy as well as a scientific analysis of the real world. In short, the Church now required, not an art which focused man's attention on this world, but an impressive and dramatic style which would transport him emotionally to an acceptance of the Church dogma and authority. Like other freethinkers at this time, any artist who departed too far in his work from what the Church considered acceptable was likely to be required to explain himself before the Inquisition and to accept its correction.

This expression of powerful religious emotion is most clearly seen

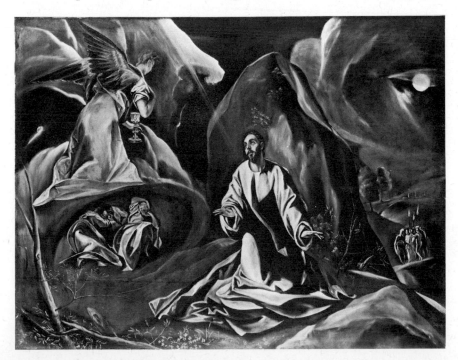

Fig 38. *The Agony in the Garden*, El Greco. Reproduced by courtesy of the Trustees, The National Gallery, London

in the illusionistic decoration and mural painting of 16th- and 17th-century churches which sweeps the viewer, in imagination, upwards to turbulent skies that break through the high domes into the infinity of heaven itself. But it is in the paintings of El Greco (1541–1614) that the religious fervour of the Counter-Reformation reaches its most intense expression in art. In his 'Agony in the Garden' (fig 38) the swirling forms, flame-like rhythms, dramatic contrasts of light and dark, and intense colours, express, through the artist's emotional involvement, the burning mysticism of Catholic faith in 16th- and 17th-century Spain.

THE BAROQUE AND ABSOLUTE MONARCHY

During the 16th century the conflicts between the middle classes and the aristocracy took a new turn. With the economic collapse of the City States in Italy, the middle classes suffered a setback. Feudalism continued to decay, but all over Catholic Europe the strongest rulers began to consolidate and extend their power through complex alliances and through curtailing the power of the nobles in their own territories. The idea of personal power and the divine right of kings to rule, as being the most stable basis for Government, was fostered by the rulers themselves, who supported the aims of the Counter-Reformation and benefited in turn from the unifying power of the Church.

It was Spain, experiencing little of Renaissance humanism in the 14th and 15th century, moving from feudalism and fanatical religious wars with the Moors to leadership of the Catholic world in the 16th, which set the pattern for absolute monarchy. Under Philip II, and with the new wealth following her conquest of South America, Spain formed a powerful alliance with the Pope and dominated Europe during the Counter-Reformation. Later, in France the system of absolute monarchy was fully developed by Louis XIV, the 'Sun King', and the magnificence and extravagance of his rule was copied by lesser Catholic rulers everywhere.

With its grandeur of form and splendour of colour, the Baroque style was wholly suited to creating the architectural environment and to expressing the emotionally inflated ideas of absolute monarchy. The extravagant scale and decoration of Baroque palaces such as Versailles is one obvious expression of the power, wealth and unlimited egotism of the men who believed they were divinely ordained to rule. Another, is the highly mannered portraiture which flourished at these courts, in which the pose, dress and ornaments were designed to present an image of the rulers as figures larger than life and different from ordinary men, as in Van Dyck's portrait 'Phillipe le Roy' (fig 39).

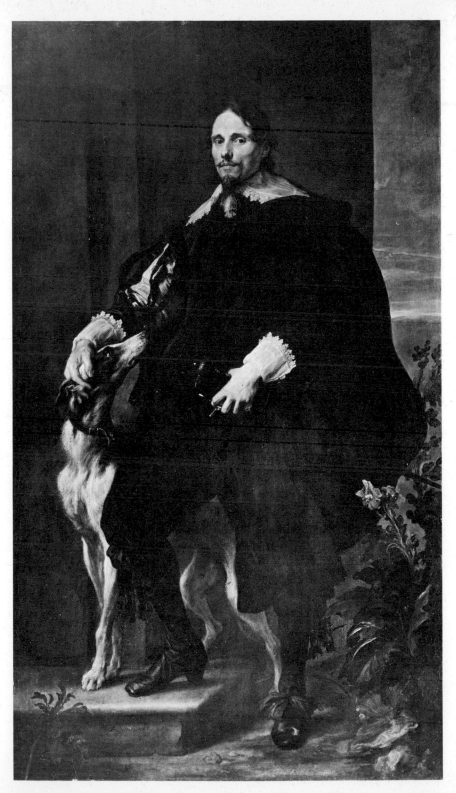

Fig 39. *Philippe le Roy*,
Van Dyck. Reproduced
by permission of the
Trustees of the Wallace
Collection

SCIENCE AND THE BAROQUE

As we have seen, the Baroque style was the product of an alliance between the Catholic Church of the Counter-Reformation and 'absolute monarchy'. But this new art, with its curvilinear rhythms, airborne forms and sense of dynamic movement, expressed another aspect of reality besides that of religious fervour and monarchical self-esteem.

The artists who created the Baroque, following in the prophetic footsteps of Leonardo and Tintoretto, perceived the great changes in scientific thought that were going on around them and that movement was the key to understanding nature. The scientific and philosophical meaning of dynamics became the great theme in man's quest for knowledge in the 16th and 17th centuries and it exercised the minds and imaginations of the artists no less than those of the scientists.

Copernicus, a Catholic monk and scholar, was the first to have published, in 1643, a new and revolutionary theory of the universe, which rejected the old notion that the earth was the static centre round which everything in space revolved, suggesting instead the existence of a heliocentric universe in which the earth is merely a planet, possibly one of many, in perpetual movement round the sun. We must reflect on how dramatically this single novel idea changed man's attitude to nature from the 16th century onwards, and how it seriously conflicted with the established belief of the Church. Not

Fig 40. *Château de Steen*, Rubens. Reproduced by courtesy of the Trustees, The National Gallery, London

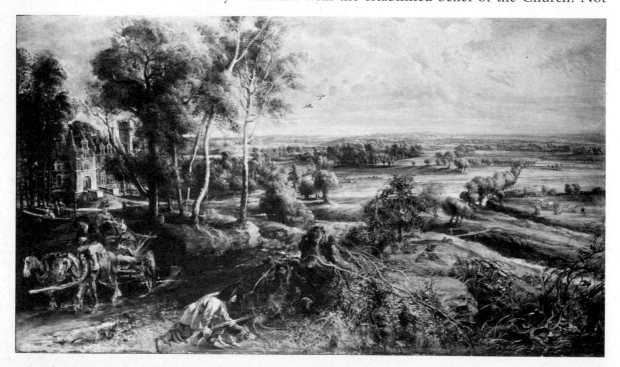

Fig 41. Basilica of San Spirito, Florence, Filippo Brunelleschi. Mansell Collection

only did it open up completely new scientific horizons, which we in our 'space age' are still exploring, but it also challenged the basis of Church dogma – the belief that the earth was the only planet chosen for the existence of life, which it had pleased God to create as the setting in which man would seek salvation. The new theory of the universe implied that there might be other worlds with intelligent life as important as ours and that mankind might not have the sole monopoly of God's will and mercy. This single idea brought about the first serious and direct clash between science and religious belief.

The Church was at first ambivalent in its attitude to the new science. It tolerated Copernicus who died before his work was published, then it condemned and burnt Giordano Bruno who

Fig 42. The Vierzehn-
heiligen, Balthasar
Neumann. Helga
Schmidt-Glassner

vehemently supported and preached the new ideas, following which,
it persecuted Galileo who, in 1632, published his *Dialogue on the
Copernican System*. But, although, Galileo was condemned and
virtually silenced by the Church, the validity of his ideas gradually
forced recognition from the Catholic thinkers, and so became to a
great extent accepted as part of Church theology.

This partial acceptance and the further spread of a knowledge of
dynamics, through the work of such men as Gilbert, Stevinus and

Kepler, contributed to the new cultural climate and influenced, as surely as did religion and secular power, the dynamic forms of Baroque art.

Rubens (1577–1640), who worked under the patronage of both the Church and the Catholic rulers, was not only an artist, but a scholar and a friend of philosophers. There can be little doubt that he was familiar with the ideas of his contemporary, Galileo. All the painting of Rubens expresses the idea of motion as a universal power, and in his Late Baroque landscape (fig 40), we are presented with a sweeping panorama in which light, movement, space and energy are united in a new vision of nature.

The great changes that had taken place in man's ideas and their expression in art between the beginning and the end of the Renaissance can be summed up in the comparison of two churches (figs 41 and 42). The mathematical precision and symmetry of Brunelleschi's San Spirito make it a typical expression of the Renaissance idea of a static balanced world, an idea which persisted up to the 16th century. Neumann's Vierzehnheiligen, on the other hand, built between 1743 and 1772 in the Late Baroque or Rococo manner shows the Renaissance style transformed by new ideas of movement and light into a dynamic and fanciful composition of flowing lines. Its style marks both the end of Renaissance tradition and the beginning of a new age.

The stability of Early Renaissance art was to inspire a last revival of Greco-Roman classicism with the birth of the Neo-Classic style in the 17th and 18th centuries. After that the forces which were foreshadowed in the turbulence of the Baroque swept away the old values in a new age of change and revolution.

5

The Age of Revolution

The history of Europe from the 16th to the 19th century is one of conflict and upheaval in every sphere of life, starting with Luther's revolt against the Papacy, which ended the power of medieval religion, and culminating in the Industrial Revolution, which ended the static pattern of craft-based society and pitched man into the perplexing mobility of the modern technological world. It is an age of transition in which all the old values of life are challenged and new ideas are born.

No longer is society held together by the bond of a single system of belief. New movements and philosophies follow each other in rapid succession as man's philosophic and scientific awareness of reality expands, and he struggles to create a society capable of controlling his newly acquired knowledge. This bewildering tempo of change is experienced in art as elsewhere in life, and is demonstrated by the ebb and flow of new styles which appear during these three hundred years, as the language of art was expanded and adapted to new conditions.

The main styles following the Baroque were Realism, Neo-Classicism and Romanticism.

REALISM

We have seen how art in the Catholic countries, after the Reformation, took on a strong emotional and anti-intellectual character. In the 'Reformed' countries, by contrast, a very different art emerged which expressed the practical theology and realism of Protestantism.

Luther had been the great figure of the Reformation in the 16th century. But, by the 17th century, the emotionalism and conservatism of Luther's ideas had been replaced by a mature and sensible, if no less demanding, interpretation of Protestantism. In developing a theology suitable to a modern commercial and industrial society it was John Calvin who had the greatest influence. Calvin accepted and understood the realities of the world of commerce – hard work, thrift, frugality and business success – all these typically middle-class characteristics he found possible to accept as

a part of Christian virtue. He viewed the achievement of high moral standards in these practical terms, and saw them as being the main aim in life. But, despite his responsibility for the burning of Servetus (with whose medical theories he disagreed), Calvin accepted science as being on the whole, a good thing benefiting man.

On the other hand, he condemned ceremony, pageantry and the use of religious images. The Church councils set up under his influence, although democratically elected, had the power to supervise private affairs, and to exclude from communion those citizens whose private lives did not come up to their standards of sombre virtue.

Calvinistic Protestantism could be said, therefore, to be a new interpretation of Christianity for the middle class, realistic and often liberal in its aims, but tending to conformism and narrow puritanism in practice and behaviour.

Calvinism had a profound influence on Protestantism in Holland, France, Scotland, England and North America and brought about a radical change in artistic style. Religious subjects, pagan classical themes and allegory were banned, individual imagination was held in check and the artist was left with portraiture, landscape and still life, subjects which involved, not flights of fancy and emotion, but a realistic and straightforward observation of nature through the senses.

Realism in art was reinforced by the ideas of the 17th-century philosophers, Locke, Hume and Berkeley who emphasised the interdependence of mind and senses in apprehending reality, rather than the classical belief in abstract thought as the main road to knowledge.

Another important reason why scientific realism became the main element in Protestant culture was that, while both Catholic and Protestant Churches were opposed to new ideas which conflicted with dogma, the latter did not seek to control science. The net result was that in the 'Reformed' countries and especially in Holland, a liberal attitude to science emerged. Thus, in Holland, which became the great centre of lens-grinding and the manufacture of scientific instruments, the direct observation of nature was aided by the new climate of scientific experiment, especially in the field of optics and light.

Every aspect of the everyday world was given consideration in this new realistic vision. Never before in history could a mere backyard (fig 43) have been considered worthy of artistic treatment. In their search for new ways of precisely conveying the visible aspects of nature, Dutch artists, like de Hooch (1629–84) and Vermeer (1632–75), not only refined the illusionistic effects of

Fig 43. *Woman and Maid in Courtyard*, De Hooch. Reproduced by courtesy of the Trustees, The National Gallery, London

oil-paint, but it is probable that they also used some system of lenses and mirrors to achieve a greater accuracy of observation.

The realism of Dutch art reflects also the influential ideas of the philosopher Spinoza, one of the many intellectual refugees who found asylum in the liberal climate of 17th-century Holland. The basic ideas of his philosophy were – the unity of mind and matter, that God and creation are one and the same thing, that God exists in all things and that happiness is attained through control of the emotions by reason. The work of Vermeer would seem to express these ideas precisely; to him everything is worthy of being painted; all things in his pictures are treated as being equally important, while the calm, balanced organisation of his interiors expresses a vision of life in which his emotional responses are carefully controlled by his mind.

The characteristics of Dutch painting are also the product of a new kind of patronage. The Dutch used paintings to decorate their homes and the subjects they chose reflect their national pride, new prosperity and the middle-class values by which they lived – portraits, tidy towns and domestic interiors, landscapes which frequently show their industrious farming and fat herds of cattle, or seascapes with great merchant sailing ships. Some patrons preferred flower pieces or still lifes, others bought pictures of tavern scenes or other

Fig 44. *Jacob Jacobsz Trip*, Rembrandt.
Reproduced by courtesy of the Trustees, The National Gallery, London

'low life' subjects. Each had his preference of subject, and with this we find the early growth of specialised collecting. Pictures were rarely commissioned directly, with the exception of portraits, so that artists had first to paint them and then sell them competitively on the market like any other product. The smaller size of Dutch houses and the lower prices paid by the new kind of collector led the artists to concentrate on small-scale canvases in quantity rather than on the single large painting; this has given 17th-century Dutch art the name of 'the Little Style'. Thus, the artists were compelled by economic circumstances to conform, to a great or lesser extent, to the simple and humdrum taste of their patrons.

If this concentration on ordinary everyday things in small paintings seems to lend an unambitious air to Dutch art, it is compensated for by one great exception – Rembrandt (1606–69) who brought to painting one of the most profound visions in the whole history of art, for he lifted Dutch realism to the same plane as the work of Giotto, Michelangelo and Leonardo. It was Dutch humanism and the liberal cultural climate in which it flourished, which made possible the art of Rembrandt, but it was the artist's own unique genius which caused him to transcend the limitations of Calvinist

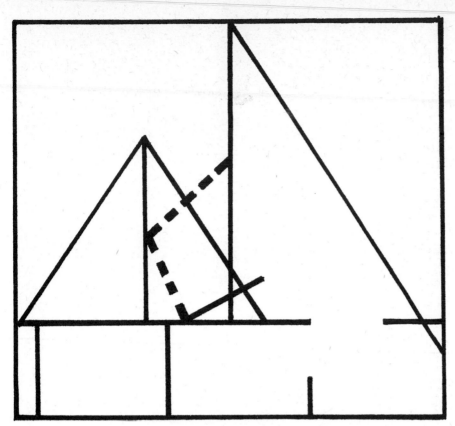

Fig 45a. Analysis of
fig 45

society and to achieve in his work an intellectual integrity and depth
of emotion which is universal and timeless.

 In his later portraits such as that of Jacob Trip (fig 44) Rembrandt
developed an insight into humanity, its tragedy, frailty and mor-
tality, which he communicated through an expressionist style which
combined a masterly control of paint texture with a subtle but
dramatic use of light and dark.

 The ideas which permeated Dutch art were also the basis of the
English and French realism of the 18th century. Nowhere was the
difference between the middle-class and aristocratic ways of life
more clearly expressed than in the two main styles of painting, one
realist, the other a continuation of the Baroque Court art practised
in 18th-century France.

 Chardin (1699–1779), a middle-class painter inspired by the Dutch
style, painted domestic scenes in which the bourgeois ideals of
honesty, simplicity and rationalism were expressed in compositions
that yet have a classical monumentality and dignity (fig 45). His
paintings found favour with patrons of his own class.

 By contrast, the work of Fragonard (1732–1806), who had been a
pupil of Chardin for a short time, found favour mainly with

Fig 46. *The Swing*,
Fragonard. Reproduced
by permission of the
Trustees of the Wallace
Collection

aristocratic patrons, including Madame du Barry. He specialised in
light-hearted, and often erotic themes (fig 46) painted in the Rococo
style. This cleavage in French art expresses the conflict between the
two classes that was eventually to lead to the French Revolution.

An analysis of these two pictures (figs 45a and 46a) shows that
their respective ideas are not just contained in the subjects chosen, but
are expressed even more strongly through their visual organisation.
Chardin's balanced and close-knit composition reflects the new
middle-class vision of a strong, stable and orderly society, while the
fragile structure of the Fragonard, in which the forms lack weight
and barely holds together, reflects the wistful decadence of a class
which was indeed rapidly falling apart.

Fig 46a. Analysis of
fig 46

NEO-CLASSICISM

Realism, in the Dutch manner, was not the only style opposed to
the Baroque and Rococo of the old aristocratic order. The Neo-
Classic style which came into existence in the 17th and 18th cen-
turies was a product of the ideas of the wealthier and more educated
middle classes in France and of the liberal aristocracy and upper
middle classes in England, all of whom were opposed to the extreme
forms of absolute monarchy. Theirs was a culture based on the
spread of classical learning and on the modern scientific knowledge
which followed the invention of mechanical printing, as well as on
travel and study in the centres of Renaissance art. Thus it combined
enthusiasm for science with admiration for classical philosophy and

the social order of the ancient world. This learned and logical approach to reality led to the period being called the 'Age of Reason'.

The greatest contribution to the ideas of Neo-Classicism were made by the French philosopher Descartes, by the painters Poussin and Claude, and by Isaac Newton's theories of universal order, even though they were often opposed to those of Descartes.

DESCARTES

Born and educated in Catholic France, Descartes (1596–1650), however, settled in Holland where the intellectual atmosphere was more sympathetic to original thought. From his speculations he constructed the first complete system of modern philosophy, basing his method on the Greek belief that knowledge is acquired purely by use of the mind. He was fascinated by mathematics as a clear process of thinking, and he believed that all problems concerning the universe could be solved by logical reasoning. Starting from simple self-evident truths he constructed a system of ideas which he hoped would be a parallel with the logical mechanism of nature. Descartes also combined algebra with geometry to create co-ordinate geometry by means of which all paths, curves and surfaces which occur in nature could be represented algebraically. In short, he attempted an explanation of man and the universe which accorded with middle-class ideas in the Age of Reason.

POUSSIN

Nicolas Poussin (1594–1665), like Descartes, spent the greater part of his working life in exile from his native France. He painted in Rome and numbered among his patrons many from the educated French middle class. It can be assumed that neither of these men was in sympathy with the absolute monarchy of Louis XIII and Louis XIV.

Poussin combined his Baroque training with the study of Italian Renaissance art, especially the paintings of Titian. In his early mythological paintings, notably in the Bacchanalian subjects, he developed a style in which the dynamic movement of the Baroque is strictly controlled by the composition. By contrast with the extreme emotion of the Baroque which is expressed in compositions which overflow the confines of the picture, Poussin's dancing rhythms form a 'closed circuit' within the canvas and seem to suggest the idea of emotion contained by the intellect – an idea shared by the new rational thinkers of his time.

In his later work Poussin reacted against the Baroque and went on to create a new kind of classical composition which expressed both his own mature ideas and the values of the intellectual middle

class. 'Painting', he said, 'deals with human actions, and above all with the most serious and noble actions.' From his study of the ancient classical world Poussin saw in the Golden Age of Greece and Rome the model for an alternative to the mysticism, ostentation and intrigue which characterised the self-centred world of absolute monarchy, that of an ideal world of order, justice and law in which passions were disciplined by intelligence and a sense of duty and in which art flourished as it had in ancient Greece. Poussin selected noble themes from mythology which conveyed the virtues of duty, self-discipline and sacrifice as the foundation of a just society. These themes reflected precisely the sentiments of the French middle class who, suffering the repressive rule and taxation of the monarchy, were seeing in political terms a vision of a new society based on reason and equality – the vision that fired the imaginations of those who eventually brought about the French Revolution.

These late compositions of Poussin were constructed with a mathematical logic and a clarity of drawing by which all natural forms were idealised and every part fitted with absolute precision. In other words, he not only expressed enlightened middle-class ideas but also created a logical and intellectual equivalent of nature which expressed in visual form ideas very close to those of Descartes. In landscapes such as 'The Burial of Phocion' (fig 47) the pictorial space is described by a system of vertical and horizontal marks (fig 47a) which, if extended would form a three-dimensional network throughout the space – a kind of pictorial equivalent to co-ordinate geometry.

CLAUDE

Another important contribution to the Neo-Classic expression of scientific philosophy was made by Poussin's compatriot, Claude (1600–82), who also lived and worked in Rome.

One of the principal subjects of scientific investigation in the 17th century was the phenomenon of light. The Dutch scientist Huygens believed that light consisted of impulses or waves moving through a medium which filled the whole of space. (Descartes had also suggested the existence of an invisible substance, filling space.)

Claude, with a more intuitive and poetic approach to nature than Poussin, painted ideal landscapes in which space is described almost as a concrete phenomenon, by the light flooding through it from the back of the picture (figs 48 and 48a). The source of light in a Claude landscape is always situated towards the centre of the painting, in contrast to Poussin who, being concerned with the solidity of form in space, always arranged the light to come from the side of the

Fig 47. *The Burial of Phocion*, Poussin. Reproduced by courtesy of the Earl of Plymouth

Fig 47a. Composition analysis of fig 47

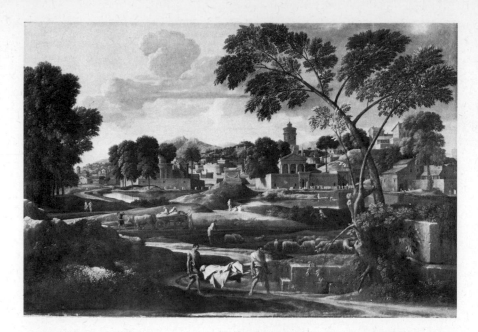

picture to emphasise modelling. Claude's trees, buildings and other objects are seen as dark shapes silhouetted against this light from the centre, and the receding areas of the landscape are described by alternating light and dark tones running across the picture. The total effect is to emphasise the presence of light filling the space.

With his concern for the pictorial importance of light, Claude follows in the footsteps of the Venetian painters and, with them is one of the forerunners of Impressionism.

Fig 58. *Bridge at Sèvres*, Sisley. The Tate Gallery, London

Fig 59. *Autumn at Argenteuil*, Monet. Courtauld Institute

NEWTON AND NEO-CLASSIC ORDER

In England, after the formation of the Commonwealth and the subsequent restoration, the liberal society of the landowning class who controlled power and wealth under the new system of constitutional monarchy, also combined rational thought and scientific

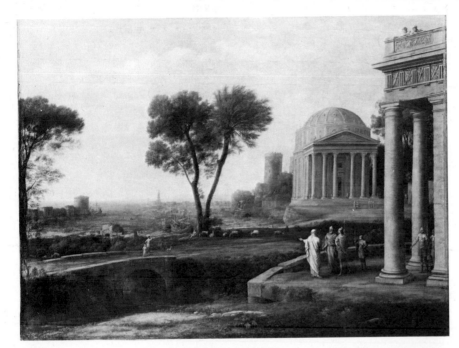

Fig 48. *Aeneas at Delos*, Claude. Reproduced by courtesy of the Trustees, The National Gallery, London

Fig 48a. Composition analysis of fig 48

curiosity with a serious study of classical culture. They too had a vision of a stable and well-ordered society as an alternative to the emotionalism and chaos of the religious wars of the 17th century.

Newton's explanation of the universe as a beautifully constructed machine moving predictably according to fixed laws, caught the imagination of the educated and led them to seek a similar pattern and order in political organisation and social behaviour. With this idea they combined an Arcadian vision of a classic Golden Age derived from the Grand Tour, the study of Renaissance and Roman art and from the poetic inspiration of the Roman Campagna as interpreted in the paintings of Claude and the Roman school of the 17th and 18th centuries.

The result was a style of elegance and classical formality, not only in art, but also in manners and behaviour. In art, painting and sculpture counted less than architecture and, therefore, the ideals of Neo-Classicism in England are better seen in the work of architects such as Inigo Jones, Wren, Gibbs, Kent and Adam, and a host of other designers and master-craftsmen who created the churches, public buildings and above all the country- and town-houses of their patrons. These all combined classic proportion and decoration with rational planning and construction.

A more poetic aspect of English Neo-Classicism is seen in the great style of the 18th-century landscape gardening in which all the elements of a Claude painting – ruined temples, groves, rivers, bridges and lakes of the Roman Campagna – are reconstructed into an ideal landscape evocative of the Golden Age.

At the same time the moral aspirations and realism of the Commonwealth were preserved by an important section of the urban middle class in England. Their sympathies lay more with Dutch than Italianate culture, and their anti-aristocratic and Puritan traditions are best expressed in the work of William Hogarth (1697–1764).

Hogarth's series of paintings 'Marriage à la Mode' and 'The Harlot's Progress', which he translated into the new democratic medium of engraving, looked at the luxury and pretensions of aristocratic society with the cold eye of a realist and the moral judgment of a Puritan.

ART AND THE FRENCH REVOLUTION

In the Catholic countries, as absolute monarchy declined, became decadent and finally lost touch with modern reality, the Baroque style lost its power and gradually dwindled into the over-refined and theatrical style of Rococo. The painting of Watteau (1684–1721) is the last great expression of courtly elegance, a kind of melancholy dream of aristocratic life (fig 49) which was rapidly fading, and we

Fig 49. *La Gamme D'Amour*, Watteau. Reproduced by courtesy of the Trustees, The National Gallery, London

have already seen how Fragonard (fig 46) expresses an even more advanced phase of the declining French court.

Both the elements of realism and rationalism which we have noted in the paintings of Chardin and Poussin, are combined in the work of Jacques-Louis David (1748–1825). This particular combination was to become the art of the Revolution which was finally to overthrow the absolute monarchy.

Having been trained in Rome, David adopted the ideals of Neo-Classicism and eventually developed a severe realistic style strongly influenced by Poussin. Like Poussin, but with even more direct reference to the revolutionary ideas of middle-class France, he painted subjects from Roman history which expressed admiration for classical republican virtues – a sense of duty, loyalty and self-sacrifice of the citizen in the service of the State.

In 1783 David joined the revolutionary Jacobin Club and in 1792 became a Deputy of the Convention, being at the same time appointed Official Artist of the Revolution. It was in this capacity that he was commissioned to record the death of the revolutionary, Marat, assassinated by Charlotte Corday (fig 50). In this, perhaps his most famous painting, the beautifully disciplined placing of the shapes, combined with the detailed descriptive drawing, expressed both the idealism and the brutal realism of the Revolution.

David lived through the period of chaos and disillusion which followed the Revolution. In 1798, he met Napoleon, and falling completely under his spell, was appointed Painter to the Emperor in 1804. From the ideas of the Revolution he now turned to expressing the cult of the hero. Once more, art was in the service of absolute power, and the pendulum again swung away from classic to emotional art. The last works of David are either romantic portraits emotionally inflating the image of Napoleon or else descriptive records of his hero's achievements. David's rapid transition from one style to another is a dramatic example of how different demands of patronage coupled with changed political and social conditions can bring to the fore quite different aspects of the artist's personality.

THE ROMANTIC MOVEMENT

The Age of Reason, dominated by the ideas of Newton and the rationalist philosophers, had created the vision and hope of a world in which science and technology would solve man's economic problems, while at the same time the well-ordered society would give men equality and justice.

Science and rationalism promised a new Golden Age.

The reality did not match the dream. The final outcome of the Age of Reason was a twofold upheaval – firstly, the French Revolution with its aftermath of terror and then the new restrictions of individual freedom under Napoleon, and secondly, the Industrial Revolution which destroyed the old familiar patterns of living and in its early phase created visual squalor and social injustice.

By the end of the 18th century it became clear to the more imaginative people that rationalism was failing to solve the problems of mankind, and that the mechanistic age it was bringing into existence threatened to swamp individual freedom and imagination. There followed among artists and other creative individuals an anti-scientific reaction which had already been expressed in the Romantic philosophy of Jean-Jacques Rousseau (1712–1778). He believed that science and virtue were incompatible and praised the beauty of unspoilt nature. Rousseau held that man is born naturally good, and is only corrupted by institutions. His was a different vision of the

Golden Age – one in which man retained the freedom of the 'noble savage' and the innocence of childhood.

Basically, Romanticism was a revival of 'instinct' which had been repressed in the Age of Reason. Against the excessively inhibiting order and balance of classicism it advocated adventurous movement, violence and change. The theory behind Romanticism equated the elemental forces of nature with the tempestuous emotions of the human heart.

The supremacy of nature over man's invention and human heroism; the inevitability of death – these became the tragic emotional themes of the Romantic movement. Romanticism dominated all the arts in the early 19th century – literature, music and visual expression – but because its themes were most easily and adequately expressed in words romanticism was primarily a literary movement. It found its most powerful expression in Germany in the writing of Goethe and Schiller, and in England in the poetry of Wordsworth, Shelley, Byron, Coleridge and Keats, as well as in the work of the Romantic novelists.

'Romantic' painting was often based on literature, as in the case of Eugène Delacroix (1798–1863) who took many of his subjects from the great writers, but whose original painting technique, with its free handling of colour, provides yet another link between the Venetians and Impressionism. Perhaps the most characteristic and influential of the French Romantic painters was Géricault (1791–1824), despite the brevity of his life. A liberal, opposed to the restoration of the monarchy in 19th-century France, Géricault was a man of great sensitivity and passionate feeling. He was fascinated by extreme emotional states of mind, and painted a series of disturbing portraits of different kinds of mental patients. In his painting of a horse (fig 51) every brush stroke expresses the animal's terror, and the dramatic use of light and shadow captures the tension of the storm.

We have already observed, in defining Romanticism, that it occurs in ages of upheaval and change. Nowhere in the early 19th century was the turbulence of a changing world more concentrated than in Spain, where the Peninsular War coincided with the life of one of the world's greatest artists, Francisco Goya (1746–1828).

An artist of mercurial temperament, Goya was caught up in the tragedy of Spain, torn between his admiration for progressive France and loyalty to his own country. The personal anguish which he felt is expressed in dramatic paintings and prints which combined an uncompromising realism with an expressionist use of tone and drawing. His work has a powerful satirical content, characteristic of that type of Romantic artist who expresses not only personal feeling, but being out of sympathy with the events of his time, con-

sciously condemns the society in which he lives. In his painting 'The Bewitched', (fig 52) a priest, terrified by demons in the form of donkeys, pours oil into a lamp held by the devil. We are not only immediately moved by the sense of terror and confusion which the sinister light and dark conveys, but we see a specific reference to the confusion which reigned in Spain at the time – where ignorance and the passions of war, symbolised by the ghastly animals, can blind man to the difference between good and evil.

England, during the 19th century, was free from the wars and revolutions which afflicted the Continent, but she suffered nearly as much from the disruptive effects of the Industrial Revolution, which everywhere seemed to be destroying the beauty of nature and the old values of life.

In the reaction from industrial ugliness and the mechanisation of life, English Romanticism turned in two directions, firstly to a

Fig 51. *Horse Frightened by Lightning*, Géricault. Reproduced by courtesy of the Trustees, The National Gallery, London

Fig 52. *The Bewitched*, Goya. Reproduced by courtesy of the Trustees, The National Gallery, London

revival of medieval art and legend – a purely native vision of the Golden Age which 19th-century England chose to believe existed before Renaissance values reached her shores. This resulted in the Romantic history painting of the Academicians and in the revivalist styles in art and design. Secondly, and much more significantly, other artists turned to themes of nature as an escape from man-made chaos. This last approach inspired the work of England's two greatest painters, Turner (1775–1851) and Constable (1776–1837).

Turner, an admirer of Claude, was obsessed by the dynamic elements in nature, and in many of his paintings (fig 53), he confronts the heroic but puny struggle of man, here symbolised by the tiny engine, with the titanic forces of storm and flood. The poetry and drama of his painting is heightened by an atmospheric, and often abstract, use of light and colour.

Constable, who was influenced to some extent by the new science of meteorology, which led him to make an analytical study of cloud formations, none the less ignored the realities of the Industrial

Fig 53. *Rain, Steam and Speed, The Great Western Railway*, Turner. Reproduced by courtesy of the Trustees, The National Gallery, London

Revolution completely, and painted nature with the same purity of form which characterises Wordsworth's poetry. He added greatly to the language of painting through finding new ways of conveying the effects of atmospheric change and light in landscape (fig 54).

By their innovations in the use of light and colour both Turner and Constable became the latest forerunners of Impressionism. At the time of Turner's death a new generation of artists was already born who were to challenge the old methods and values of Renaissance Academicism, and who were to make the breakthrough into this first great style of the modern movement.

6

Impressionism and Post-Impressionism

PRELUDE TO THE MODERN MOVEMENT

We come now to that part of our study which is certainly most relevant to understanding the role which art plays in our own lives, but which, paradoxically, may prove the most difficult of all for many people – the art of our own time – that complex development of styles which has come about in the past hundred years, and what is now generally referred to as the 'modern movement'.

The difficulties which many people experience in approaching modern art are understandable. They result less from any lack of artistic sensitivity than from a general lack of understanding of the kind of new world we live in. The changes which have taken place in every aspect of life in the last century have been so rapid, and often so complex and specialised, that general education has lagged sadly behind, and has failed to give us a coherent understanding of the cultural climate in which we live. Indeed, most formal education, at least until recently, conditioned us to think in terms of the cultural patterns of the past so far as art was concerned, while over-specialisation in scientific and technological training precluded an overall grasp of the new cultural pattern. The result is a degree of prejudice and misunderstanding about modern art which never arises in our study of even the most esoteric art of the past.

It is, therefore, advisable in order to clear the air to say something generally about the origins of the modern movement before we examine its styles in detail. Even the most superficial examination of modern art will indicate that it represents the most fundamental change in man's consciousness of reality in the whole history of art. Our most fruitful approach, therefore, is possibly to begin by asking quite simply why such a great change took place at this point in history?

The answer, of course, lies mainly in the nature of artistic creation in the evolution of man's consciousness.

We have seen in previous chapters how, as ideas change, so do the forms of art. The change which took place in art in the 19th century differs only from previous transformations of style in that it happened more suddenly, and that it reflected a much deeper and

wider change in the cultural climate than had ever occurred before.

In the last hundred years there has been an explosion of ideas which has by now almost completely destroyed the old cultural patterns. In every branch of science and philosophy we have been presented with new ideas about ourselves and the world which have led us to abandon nearly all the theories and beliefs of the 18th and 19th centuries.

The Industrial Revolution, which followed the application of modern science to technology, rapidly destroyed the old system and values of handicraft, and opened up possibilities of creating new forms with new materials and methods. Moreover, it created a mobility in society – an actual fluctuation in the movement of populations, as well as rapid social and political change – which made all the old patterns of living irrelevant. Since the 19th century a new relationship between man and nature has been created; society must find new patterns of living, and science must create a new language to describe its discovery of the invisible world of the atom. It is not surprising that art also has had to abandon the old language of the past, and to create new images to express the artist's apprehension of modern reality.

As will become clear in the following pages, the speed and complexity of developments in modern art places great demands on our understanding, since we still tend to be conditioned to the less volatile and more clear-cut standards of the pre-industrialised age. The ever-changing face of art was often masked in the past by academic rules and formulas, because styles replaced each other gradually. But today the speed of change is such that no established rules are relevant. The first requirement, therefore, in coming to terms with modern art is that we should abandon all preconceived ideas of what art should be, and maintain a flexible attitude of mind in approaching even its strangest manifestations.

The modern movement, then, was born primarily out of the need to create a new artistic language for our times. The actual circumstances in which it began, however, relate directly to the state of art in the 19th century. Traditional art had reached a point of decline – artificial, empty and out of touch with reality. The modern movement can thus be understood also as a reaction against the state of 19th-century academic art.

In England, academic art was seen at its worst. Nothing new was being added to the language of visual expression. Old techniques derived from the past became debased into mere illustration and story-telling, wholly lacking the qualities of visual form. The content of Victorian art was equally superficial or irrelevant – visions of medieval England, sentimental literary subjects often embodying

the narrow morality of Victorian religion, or nudes whose classical titles ill concealed their real purpose – that of being the first 'pin-ups' of the industrial era. Apart from the work of Constable and Turner, and with a few other minor exceptions, there was no art which truly reflected the realities of the scientific age which was coming into being.

France suffered less than England from the impact of the Industrial Revolution. With a deep and unbroken tradition dating back to the 12th century, the mainstream of art continued more vigorously than elsewhere in Europe. None the less, academic art in 19th-century France was also reaching a dead end.

19TH-CENTURY REALISM

Two main styles dominated the artistic scene in France in the first half of the century. The classical style, led by Ingres and derived from Raphael, was associated with the monarchist movement. Romanticism, which came to represent republican ideals, was led by Delacroix, and owed its techniques to the Venetians and to Rubens. In the hands of Ingres and his followers, Classicism became an empty idealisation of form, devoid of feeling and utterly remote from the realities of everyday life. On the other hand, Romanticism which had originally been so directly involved with revolutionary ideas, as in the work of Goya, became more and more exotic and theatrical, equally out of touch with the mainstream of life.

A number of younger artists felt the restrictions of these two official styles. Of these the most important was Gustave Courbet (1819–77) who reacted equally against both the classic and romantic flight from reality. Courbet was a Socialist, and he proclaimed that *Realism* was the style which expressed democratic ideals. He declared that everyday subjects, depicted without idealisation or fantasy, were the only ones an artist should be concerned with. Although much of his work retains a strong romantic quality, he endeavoured to represent the *material existence* of his subjects as completely as possible. We can refer here again to his painting (fig 18) as a typical example of how he tried to convey the total physical reality of objects.

Another artist who reacted against the classic and romantic styles was Courbet's contemporary, Corot (1796–1867). He aimed at depicting nature as accurately as possible by representing the exact amount of light reflected from each area. Corot was probably the first artist to insist on painting landscapes on the spot instead of in the studio. In later life he changed his approach and produced many sentimental and romanticised studies of wooded landscape which became highly popular. However, his earlier work, such as his

painting of Avignon (fig 55), as well as that of Courbet, can be regarded as an important step towards Impressionism.

Another artist who forms a major link between Realism and Impressionism was Édouard Manet (1832–83). Often described against his own wishes as an Impressionist, his development was in fact greatly influenced by the 17th-century Spanish painter, Velazquez. The latter, a comparatively isolated artist, spent most of his working life painting the gloomy court of Philip IV – subject-matter which he probably found so boring that he seems to have concerned himself more and more with the perfecting of his technique than with what he painted. One of his innovations was to arrange his subjects so that the light fell full on them instead of from the side as was customary. In his painting (fig 56) the shadows of the legs can be seen going straight back into the picture. This meant that Velazquez had to use very subtle modulations of tone, equivalent to the slight variations in the degree to which surfaces at different angles reflected light, in order to give his forms depth and solidity.

Manet adopted this technique and used it to represent everyday subjects similar to those of his idol, Courbet. There is, however, a very significant difference between his work and that of Courbet. Whereas the latter attempted to represent every aspect of the material reality of the object, Manet isolates one factor, that of the reflection of light, and allows this to dominate his painting. His work thus gains in luminosity and brilliance (fig 57), but as can be seen by comparison with the Courbet, it is relatively flat and insubstantial. While he never became an Impressionist, Manet's concern with light links him closely with them and he was influenced by them in his later work.

Fig 55. *Avignon from the West*, Corot. Reproduced by courtesy of the Trustees, The National Gallery, London

Fig 56. *Philip IV of Spain in Brown and Silver*, Velasquez. Reproduced by courtesy of the Trustees, The National Gallery, London

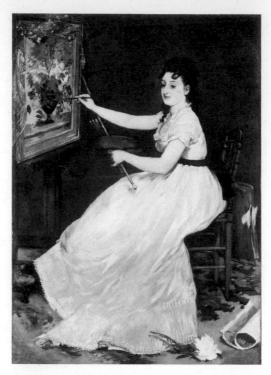

IMPRESSIONISM

Impressionism can be seen as both an end and a beginning in the history of European painting. It marks the end of European naturalism, or perceptual art. Philosophically, it extended the realism of Courbet and Corot, and a number of Impressionists, notably Pissarro, were close to Courbet in their social and political beliefs which laid emphasis on the importance of the material world. But by refusing to idealise, romanticise or even compose, except in the most elementary way, the Impressionists pushed the tradition of perceptual representation to an extreme (fig 58 – facing page 88).

On the other hand, by following Manet in painting only their visual sensations, while ignoring all qualities of the subject other than the reflection of light from its surfaces, they were heralding the abstract movement. The later paintings of Monet, who died in 1926 when abstract painting was well established, are in fact almost abstract. This is clear from a comparison of Monet's landscape (fig 59 – facing page 89) with those of Rubens (fig 40), Poussin (fig 47), Claude (fig 48) or Constable (fig 54).

Figures 60, 60a and b will help to explain how Impressionism was the first step which led to abstraction. We see things by the reflection of light from their surfaces; if the artist is concerned only with representing his visual sensations, he is not painting the object but the *light* which is reflected from it. Courbet and most of the

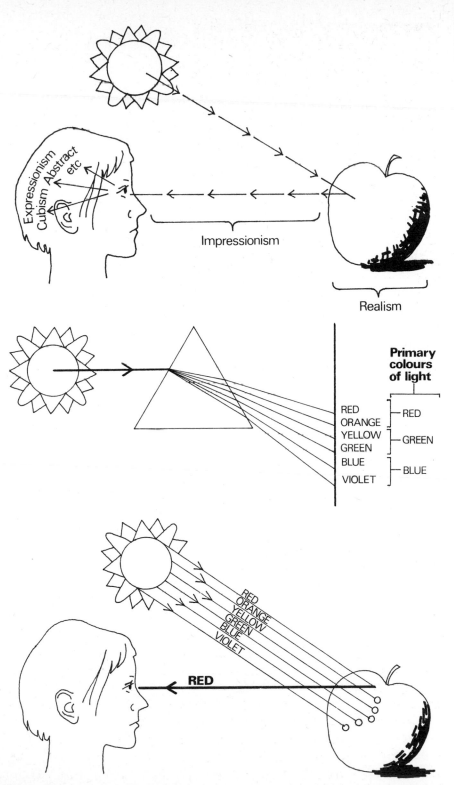

Fig 60, 60a and b.
Principles of
Impressionism

Expressionism
Cubism Abstract
etc

Impressionism

Realism

Primary
colours
of light

RED
ORANGE
YELLOW
GREEN
BLUE
VIOLET

RED
GREEN
BLUE

RED
ORANGE
YELLOW
GREEN
BLUE
VIOLET

RED

other painters in the realist tradition, as far back as van Eyck, were trying to represent the *object itself* by combining the evidence of all their senses, particularly sight, touch and muscular effort (weight), with a certain amount of conceptual thought, all in one image. Monet wished to paint only the sensation of light seen reflected from the object without any other associations with it. He once said, 'I wish that I had been born blind and then suddenly regained my sight so that I could begin to paint without knowing what the objects are that I see before me.' He would then have had no emotional or intellectual reaction to things, and would not connect the visual with any other sense.

To the realist, light was a means of revealing the object; in Impressionism the light comes between the eye and the object, and often seems to obscure it, as can be seen in the paintings (figs 58 and 59).

There seems to be little doubt that the invention of the camera, which was in general use by the 1850s, greatly influenced Impressionist ideas. The impersonal image resulting solely from registration of light, informality in composition, and above all, the ability to seize a moment in time; each of these qualities seem to be aimed at in the Impressionist technique – direct observation of light, rejection of composition, and a swift execution which aims to capture the sensation of the moment as spontaneously as any manual technique can. Indeed, the Impressionists' other great preoccupation, colour, may have been partly stimulated by the recognition that the painter still had sole control over the one element of perception that the camera was, as yet, unable to command. What is significant is that light and colour became the real subjects of Impressionist painting, and the artist's involvement with these elements corresponds very closely with 19th-century ideas about their scientific nature. It was believed that light consists of waves travelling through a substance called 'ether' which filled the whole of space. The effect of the Impressionist technique is to give the light a peculiar vibrating quality and the actual texture of the paint seems to suggest that the most tangible material thing in the painting is the light-filled space itself. Both Claude and Turner (see Chapter 5) foreshadowed this development.

Their endeavours to render as accurately as possible the visual experience of colour and light led the Impressionists to observe colour in nature more accurately than any painters in the past had ever done. Their observations coincided with current scientific theory. They discovered the phenomenon of simultaneous contrasts, which had already been expounded by the French chemist, Chevreul; that is to say that areas round or next to a strong primary

colour will tend to take on a tint of that colour's complementary hue, especially noticeable if the adjacent surface is grey or restrained in colour. For example, a strong area of orange will create a contrasting bluish tint in surrounding surfaces. The Impressionists observed actual instances of this: shadows cast next to greenish-yellow foliage were not black, as rendered in academic tonal paint, but had a warm violet/red tint. Since they observed that there is no black in nature, they eliminated it from their palette and used the principle of contrast more accurately to render their visual sensations.

Their technique went even further than this in its relation to scientific theory. It had been established by Newton that white light consists of a combination of all the colours, as can be proved by passing a beam of white light through a prism. The different wavelengths of light are refracted at different angles, giving us the spectrum effect of a rainbow (fig 60a). The Impressionists, by applying their colour in small, broken touches, rather than by mixing it on the palette, and thus allowing the eye of the viewer to mix the colours optically (e.g. small separate brush strokes of blue and yellow seen together appear as green), approximated to the nature of light itself. The effect could only be approximate, however, since the mixture of colour in light differs essentially from its mixture in pigment.

We observe an object to be a particular colour because its surface absorbs all the wavelengths of light except those that are reflected back to the eye (fig 60b). The painter's pigments act, of course, like any other surface; that is to say their colour effect is the result of a *subtractive* process. What we see when we look at a red apple, or patch of red paint could be described as 'minus orange, yellow, green, blue and violet'.[1] Light, on the other hand, works by an *additive* process; if we add coloured lights we get more light; if we add coloured pigments we get less light; the result is that the primary colours of light (i.e. the minimum basic colours from which all others are derived) are different from the primaries of pigments.

The additive primaries of the colour photographer are thus blue, green and red; the subtractive colours of the painter are yellow, an impure red, and impure blue. This can be tested by mixing green and red pigment, when a coloured grey, darker than either, will result, and by mixing red and green light (either by mixing light rays or by spinning a disc painted with red and green stripes) when the result will be a yellow brighter than either. Thus the Impressionists could never achieve a completely true effect of light by using prismatic colour; but they came as close to it as any painters ever could.

[1] In fact, however, no natural red is completely pure, and it would be more accurate to describe it as minus varying amounts of the other colours.

The Impressionist concern with colour and light accounts to a great extent for their choice of subject. They chose only scenes where these elements were prominent – sunlit streets or landscapes, often with water and the added light reflection it gives; outdoor scenes in which colour predominates – flower gardens, regattas, open-air restaurants, dances and fêtes. Rarely did they attempt indoor scenes or winter landscapes, with the notable exception of Monet's snow scenes in which the quality of light reflected upwards from the ground is particularly arresting.

There is a further important point implicit in the diagram. If we shine a coloured light on the apple it will change colour; in a blue light, for example, it will appear nearly black since the surface will absorb most of the light. Does the apple in fact have a colour? To what extent are any of our perceptions of an object true to its objective existence? The question of how or whether we can ever know the reality of the external world was one which was beginning to concern scientists at the end of the 19th century. It was, as we shall see, beginning to concern artists as well.

It should be emphasised here that the Impressionist approach to colour was for the most part intuitive rather than scientific, and their innovations in colour were the result of artistic experiment and direct observation of nature rather than the conscious application of theory. For a short time the aims of some half-dozen painters (notably Pissarro, Monet, Sisley, Renoir and Morisot, with marginal contributions by Boudin, Manet and Degas) were close enough to give them the cohesion and force of a revolutionary movement. This culminated in the first Impressionist Exhibition in Paris in 1874. Its great achievement, in the face of strong public opposition, was to shatter for ever the preconceived notions of academic art, and, through the liberation of colour, to establish a springboard for the modern movement.

THE CRISIS OF IMPRESSIONISM

However, after the 1870s these painters began to go their own ways. By the 1880s many of them began to realise, despite their efforts to achieve objectivity, just how subjective their painting was, and how transitory were the effects they were trying to capture.

Many of them began to realise that they had sacrificed too great a measure of truth to reality in order to achieve merely the partial truth of their visual sensations. They had abandoned the object for light and colour, and lost touch with the structure of reality – contour, volume and space. And furthermore, with their overriding concern with sensation, they had withdrawn from intellectual or emotional involvement in nature. The realisation of the limitations

of Impressionism caused a crisis among the young artists, and each sought to solve the problem in his own way.

Renoir visited Italy in 1881 and rediscovered the elements of form which had made the Renaissance great. In 1883 he said, 'I have wrung Impressionism dry. Impressionism is a blind alley as far as I am concerned. If a painter works direct from nature he looks for nothing but momentary effects. He does not compose and becomes monotonous.'

There followed a period of almost classical figure drawing in which he rediscovered volume and space. Later he was to return to the colours of Impressionism, but in his late work colour expresses a more earthy response, with the female nude at the centre of a joyous sensuous world.

Monet, perhaps the purest of the Impressionists, took a different direction. By degrees he carried light beyond the merely sensual to a point where it became the theme of an emotional and mystical vision, akin to music and almost abstract in form. With progressively failing sight, he spent the latter part of his life painting his lily pond at Givency. These last paintings, veils of colour and light, have had a strong influence on more recent abstract artists.

Others of the Impressionists, and a number of younger artists influenced by them, tried to apply the effects of colour and luminosity in a more objective way. Of these the most outstanding was Seurat (fig 61 – facing page 112) who set out to make Impressionism scientific rather than intuitive. He applied his colour in dots, the mixture and proportions of the colours used being carefully calculated and prepared before application. (From the technique, his style is often referred to as Pointillism, or, from the historic viewpoint, as Neo-Impressionism.)

However, because of the problems arising from the differences between coloured pigment and coloured light, the overall effect of Seurat's painting is often dull and greyish, compared, for example, with the work of Sisley (fig 58) and Monet (fig 59). He also diverged from Impressionism in that he carefully composed his pictures, using many traditional methods, especially a classic use of the Golden Section proportion in the divisions of his canvas.

Had he not died young, at a point where he was beginning to concern himself more with form than colour, he might have been one of the great modern classic artists in the next phase of the modern movement. As it was, his style carried on by lesser artists like Signac and Cross, was to play an important role in the development of Fauvism and the work of Matisse. However, the period following the crisis in Impressionism was to be dominated by three great artists, Van Gogh, Gauguin and Cézanne.

POST-IMPRESSIONISM

The realism of the Impressionists was too shallow, too uncommitted, to satisfy the vision of artists in the latter part of the 19th century. The climate of the times, social conditions on the one hand, scientific developments on the other, made it inevitable that art should take two main directions – a new emotional involvement and a more analytical approach to reality.

These two trends, one romantic, the other classic, continue the revolt against academic art which more and more distorted the artist's role in society, while progressively losing touch with the modern world. The artist was faced with a crisis in patronage. If he conformed to the superficial and sentimental values of middle-class patronage at the expense of personal integrity, then he found himself elevated to a position far above that of artists in the past, so that many 19th-century artists not only received titles, in the tradition of the academics, but also became as wealthy as their patrons. If, on the other hand, the artist refused to conform and expressed himself in a way which ran counter to conventional notions of art, he was treated as a rebel and outsider and deprived of patronage. The 19th century is the first period in history when the creative artist becomes unemployed.

The Impressionists were the first to suffer in this way, but it is the art of Van Gogh and Gauguin which most deeply reflects the changed social position of the 19th-century artist. With their shared insistence on individual emotion as the main element in art, they are the archetypal figures of modern art, Van Gogh in his complete rejection by society, Gauguin in his total revulsion against the bourgeois values of Western civilization.

By contrast, the work of Cézanne represents the classic aspect of modern art. Working also in isolation, but primarily concerned with formal ideas, it was he who brought painting back to a concern with structure and opened the way for an art in harmony with modern scientific ideas.

VAN GOGH

Vincent Van Gogh (1853–90) was a man sensitive to the point of mental instability. He had a deeply religious attitude to life and his strong feelings of love for humanity led him on an agonising search for identification with and service to society. His life up to 1883 is a tragic saga of failure and rejection in many attempted roles – missionary, teacher, student for the ministry and even as art dealer and shop-assistant. It was only after this period that he took up painting, devoting himself to it with a kind of apostolic fervour.

After a period of dark toned painting, possibly influenced by

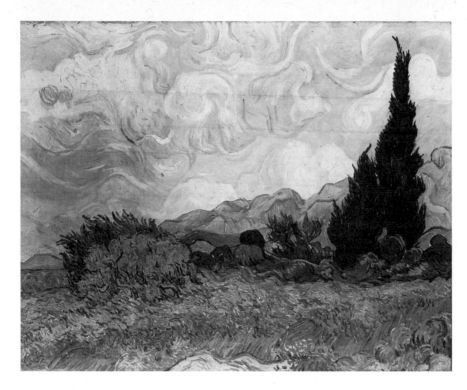

Rembrandt, he discovered the Impressionists in 1886, and it seemed as if their colour was a revelation which was at last to give him an outlet and release for all the suffering and pent-up emotions of his earlier life. Working in Arles in 1888 he painted his greatest pictures, and in a letter to his brother Theo, he describes the strange elation, a kind of heightened awareness, with which he worked. 'I have a terrible lucidity at moments these days, when nature is so beautiful I am not conscious of myself anymore, and the picture comes to me as in a dream.'

In these paintings he combines the heightened colour of Impressionism with writhing forms and dynamic brush strokes to express his strong emotions. His work is nearly always symbolic both in colour and subject. In the painting 'Cornfield and Cypress Trees' (fig 62), the golden cornfield symbolises life, and the dark cypress trees death; through the whole landscape a wind seems to blow, stirring everything into motion, even, one feels, the distant mountains. Is this also symbolic of an anguished soul that was never at rest?

During 1889 there followed a period of gradual mental breakdown until, having painted a few last tragic pictures, which express his final agony of mind, he committed suicide in 1890. Van Gogh is characteristic of that kind of artist who finds release through his

work by a process of unburdening. This highly charged mode of
expression we have already noted as characteristic of the Nordic
vision (see Grünewald – Chapter 4). This extreme kind of romantic
art is today called 'Expressionism'. It reflects one important aspect
of the present human condition – the isolation and alienation of the
individual, and especially the artist, in modern society. Van Gogh
can be regarded as the father of modern Expressionism.

GAUGUIN

Paul Gauguin (1845–1903) like Van Gogh was a latecomer to paint-
ing. He did not take up full-time painting until he was thirty-five,
when he gave up a successful business career. In many ways, how-
ever, he was the opposite of Van Gogh. From being an accepted
and respected member of society he chose to become an outsider,
rejecting Western art and civilization. Although trained in the
Impressionist technique he soon reacted strongly against its im-
personal visualism and sought to begin both his life and his art all
over again from a simple and unsophisticated starting-point. With
this aim, he became the first of many modern artists to search for
the basic meaning of art in primitive societies and in non-European
traditions. He first of all studied Egyptian and Eastern art, stained
glass and primitive art, and at one time led a movement called
'Synthetism' which attempted to unite all these influences.

In escaping from the sophisticated art world of Paris he first went
to Brittany in the hope of finding a simple, natural way of life, but
eventually left Europe and settled in Tahiti. Here he hoped to find
a society close to the sources of life in which he could evolve a direct
and primitive form of expression. Gauguin's great problem, of
course, was that, as a knowledgeable and sophisticated European, he
could never become a true primitive artist. However, he under-
stood and absorbed the elements of non-European art to an extra-
ordinary degree. He observed that Eastern art, for example, is not
concerned with describing the physical existence of things but with
expressing the essence of nature – the forces of life which underlie
appearances. This was what he hoped to capture through a more
direct and intense use of colour and simplified forms. He understood
also the exotic use of abstract/symbolic colour, and evolved a style
in which he organises his flat areas of colour for emotional, rather
than descriptive effects. He never hesitates to alter the colours of
nature to this end, substituting, for example, red for the green of a
tree. Gauguin said that he wished by colours to express 'a certain
long lost barbarian luxury'.

In his painting 'Nevermore' (fig 63 – facing page 113) a Tahitian girl
lies on a bed with a bird with figures symbolising evil spirits in the

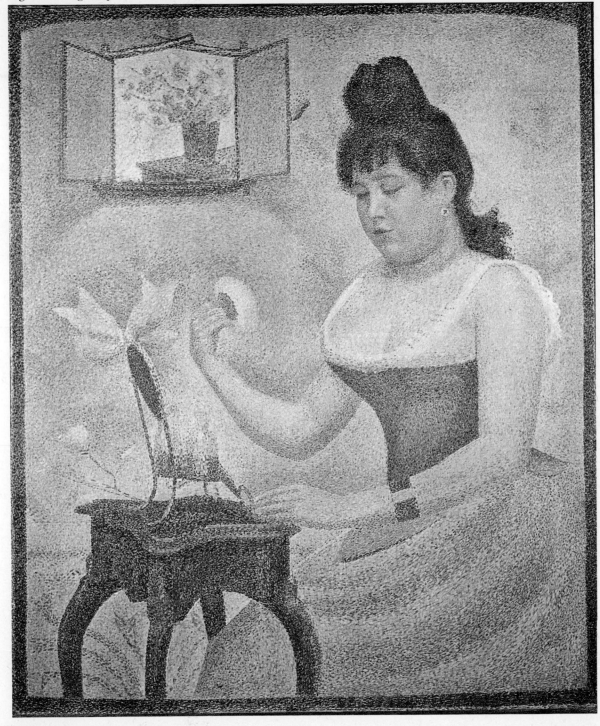

Fig 61. *Young Lady with Powder Puff*, Seurat. Courtauld Institute

Fig 63.
Nevermore, 1897,
Gauguin.
Courtauld
Institute

Fig 65. *The Pool
of London*,
Derain. The Tate
Gallery, London

background. Notice how the colours intensify each other, the sombre blue with the yellow in the foreground, the patches of red against the blues and purples of the background. Gauguin's great contribution to modern painting was the liberation of colour from the restrictions of natural appearances so that artists could henceforth use it in any way which served their ends.

While working at Pont-Aven in Brittany, Gauguin had attracted a group of followers who shared his desire to develop a more personal art out of Impressionism. This group developed ideas which were to be enormously influential in 20th-century art. Among these ideas was the realisation (by no means obvious at that time) that a painting is essentially a two-dimensional object which is one of the key ideas in modern art. It was one of this group of followers, Maurice Denis, who stated this important fact. 'Remember', he said, 'that a picture, before being a horse, a nude, or some kind of anecdote, is essentially a flat surface covered with colours, arranged in a certain order.'

In 1888 Serusier made a tiny painting (fig 64) on a cigar-box lid, under Gauguin's direction. In it the landscape is translated into flat areas of colour, parts of which are non-naturalistic, giving an overall effect which is almost abstract. Serusier's friends were so impressed with this painting that they called it 'The Talisman'. It seems to be at least twenty years ahead of its time.

THE FAUVES

From the work of Van Gogh, Gauguin and the Symbolists there emerged, therefore, two important principles which became essential to the subsequent development of modern art. The first was the liberation of colour – the establishing of colour as an autonomous element in expression no longer limited merely to describing its appearance in nature. The second was the recognition of the reality of the resultant work of art as an object having an existence in its own right, independent of objects in nature. (See also Cézanne, page 115.)

This combination of the abstract use of colour and recognition of the painting as an autonomous object was carried a step further by a short-lived movement called 'Fauvism' (a term derived from the French word 'Fauve' (wild beast), which was applied to the style by an insensitive and depreciating critic) which flourished from 1905 to 1908. These artists, notably Matisse, Derain, Braque, Marquet, Vlaminck and Dufy, endeavoured to create a new artistic language of the 20th century. Although they still painted everyday subjects, they used intense colours applied in flat areas quite unlike colour as observed in nature, and they often distorted the proportions of their

Fig 64. *Le Talisman*,
Serusier. Collection
particulière: Photographie
Giraudon, Paris

subjects in order to create exciting two-dimensional patterns on the
surface of the canvas, as can be seen in Derain's painting 'The Pool
of London' (fig 65 – facing page 113). In their use of colour, separating
it from nature, the Fauves were, therefore, moving further towards
abstraction, although they did not reach the next logical step of
abandoning subject-matter altogether.

In trying to get back to the first principles of art, Gauguin was
not alone in studying pre-Renaissance and non-European styles. One
very potent influence was the Japanese print which came to be
imported in large numbers to Europe in the 19th century (fig 66 – fac-
ing page 136). These works, because they were printed from wood-
blocks, were carried out in flat areas of colour. European perspective

was not used and the shapes were organised in a highly decorative way. This, combined with a taut linear style of drawing, gave a clarity and directness of expression that was lacking in overworked academic styles.

Manet, the Impressionists, Gauguin, Van Gogh and the Fauves were all influenced by this style. Its unconventional (by European standards) reconciliation of space and surface helped the modern artist to see and make pictures in a new way.

Matisse, the leader of the Fauve movement, and Dufy, a much lighter talent, were the only two members of the group to continue painting in that style after the break-up of the movement in 1908. Matisse continued throughout his long life to experiment with colour and pattern, and in 1910 he was particularly stimulated by an exhibition of Near Eastern art held in Paris and especially by the elements of Persian manuscript illustration (fig 67 – facing page 136). Having many of the qualities of the Japanese print and other Eastern art, Persian illustrations and miniatures are particularly two-dimensional in character, the composition forming an overall design like a tapestry or carpet on the surface of the painting. This two-dimensional quality is further enhanced by a use of intense decorative colour, no doubt deriving from Muslim techniques in ceramics and enamelling, which makes no concession to atmospheric perspective or modelling of figures in the round.

Matisse adopted the drawing and colour of Persian painting, as in his 'Odalisk' (fig 68), exploiting colour combinations never seen before in European art, using patterns to make areas advance or recede, and often contradicting the accepted spatial effects of colour (see following notes on Cézanne's use of warm and cool colours) – thus the use of red as a background colour.

Matisse himself declared that his aim was to do no more than give pleasure. However, it is arguable that in his use of shape and colour he went much further than this. He was the first artist to reconcile colour and drawing with the flat surface of the canvas, at once rejecting all the main elements of academic painting, while opening up new possibilities for the expressive use of colour and shape. He was, in fact, one of the most important influences on artists of the 1960s.

CÉZANNE
While the liberation of colour was being achieved by Van Gogh and Gauguin in a primarily romantic way, the search for a new artistic language was being pursued in a more classic or analytical manner by Paul Cézanne (1839–1906).

Of all the Post-Impressionists, Cézanne was probably the most

Fig 68. *Odalisk with Red Trousers, 1922*, Matisse. Modern Art Museum, Paris: Cliché des Musées Nationaux

influential because his work foreshadowed so many of the developments of 20th-century art, architecture and design. It would not be an exaggeration to say that it is essential to understand his work in order to understand the greater part of 20th-century painting. Starting like Van Gogh and Gauguin as an Impressionist, Cézanne, too, soon became dissatisfied with the deficiencies of this method, and especially with its disregard for structural form. Working alone at Aix-en-Provence for the last twenty years of his life, he aimed as he once said, 'to make Impressionism as solid and enduring as the old masters'. To do this he began to use the colour principles of Impressionism to create space and volume rather than sensations of light. The principle on which he based his technique was that of the spatial effect of colours (fig 69).

As a rule the warm colours of the spectrum seem to come forward while the cool hues recede. Likewise intense colour advances and greyed tones of colour recede; light and dark tones generally have a similar spatial effect. Cézanne seems to use all these effects of colour and tone, often combining them in a contradictory manner – thus in one painting an intensely blue vase will appear to advance closer than a dull red background. But, basically his method was to split up his forms into advancing and receding facets, each rendered in an appropriate spatial colour. He applied each facet as a flat brush

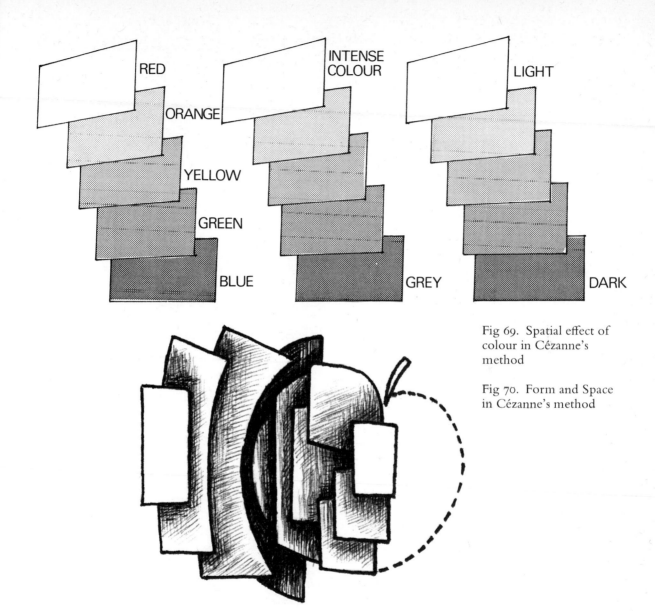

Fig 69. Spatial effect of colour in Cézanne's method

Fig 70. Form and Space in Cézanne's method

stroke, or patch of colour, (fig 70) and this created a problem when it became necessary to make the curved surface of a form, such as an apple, turn in space. In order to give this effect, Cézanne used similar patches of appropriate colour to make the background appear to curve round behind the form. The way in which Cézanne made space appear to curve round his masses gives the impression that each object in the painting exists in its own 'pocket' of space, as if the space were specially hollowed out to accommodate it. That is to say that the objects exist, not in a generalised space or 'perspective box' as in Renaissance painting, but in a space which is relative to

Fig 71. Translation of three-dimensional space to two-dimensional surface in Cézanne's method

each mass. It could be said, therefore, that in breaking with the traditional way of rendering space Cézanne was the first painter to give visual expression to a new idea of *relative* space. This innovation in art is of special significance in view of parallel developments regarding the nature of space which were taking place in science at the end of the 19th century. The subsequent development of Cubism was greatly dependent on Cézanne's new visualisation of space.

We have already noted that the recognition of the work of art as an autonomous object was an important principle implicit in the work of Gauguin and his followers. It was Cézanne, however, who most clearly established the importance of this in modern art. The problem of translating a three-dimensional reality into an image on a two-dimensional surface has existed as long as painting itself. Since the Renaissance the solution has been the use of tone and linear perspective to create an illusion of three dimensions on the canvas. In reacting against academic art, the modern artist has been forced to reconsider the whole nature of painting, and a part of this reappraisal has been the acceptance of the basic fact of the two-dimensional nature of the canvas, and with this the recognition of the work of art as an object existing in its own right independent of external reality. That is to say, the work of art has its own laws and logic which are different from the laws of nature. The task of the artist is then seen to be that of translating the laws of nature into the laws of art. The reality of the picture surface and the autonomy of the finished work as cardinal principles of modern painting are embodied in Cézanne's method in two ways. His technique of applying paint in flat patches meant that each area could be viewed either as lying flat on the plane of the canvas, or seen in conjunction with the surrounding patches as having an existence within the pictorial space. Secondly, his abandonment of Renaissance perspective meant that surfaces could be tilted (fig 71) and brought nearer to the picture plane. In the painting illustrated here 'Still Life with

Cupid' (fig 72 – facing page 137) we notice how the floor of the studio seems almost vertical so that the distant apple seems to be as accessible as those in the foreground.

Cézanne's rejection of Renaissance perspective at the end of the 19th century, conforms very closely with developments in physics. The concept of a space-filling, wave-carrying ether had had to be dropped since there was absolutely no way of proving its existence; the whole problem of the nature of light and how it travels through space was thus once more the subject of speculation. It was partially solved when, at the beginning of the 20th century, Einstein suggested not a new way of thinking about light but a new idea of space. This involved the idea of space curving round masses (fig 72a and see notes on Cubism and Relativity – Chapter 7). In order to describe such a space a new geometry was necessary, and this in fact had already been invented by the German mathematician Riemann, in the 19th century.

Euclid's geometry is based on the idea that the angle-sum of a triangle is two right angles, that parallel lines never meet in infinity, and that the shortest distance between two points is a straight line. It was shown by Riemann and others that perfectly logical geometrics could be built up on the assumptions that the angle-sum is less or greater than two right angles, that parallel lines meet in infinity, and that the shortest distance between two points is a curved line.

Renaissance perspective is, of course, based on Euclidian geometry; Cézanne's perspective is clearly non-Euclidian (cf. fig 72 and fig 43) though his imagery could be said to comply with scientific ideas in another way. Faraday and Maxwell had shown in the 19th century, that the forces of electricity and magnetism operated not directly at a distance on objects, but in a field through the intervening space, and it seemed likely that gravitation also operated in a similar way. Thus an object could be said to influence all the space round it. This idea seems to be clearly illustrated by Cézanne's new way of relating solid forms to the curving space surrounding them.

In his more complicated paintings he often uses several axes round which to construct the painting. In his 'Card Players' (fig 73 – facing page 160) the pictorial space seems to curve round the monumental figures, and is divided by a line running through the barely seen bottle on the table and the knees under it (fig 73a).

In his landscapes, the construction is inevitably different from his figure compositions and still-life studies.

His rejection of Renaissance perspective is often more obvious in the landscapes where he appears to use multi-viewpoints, as if when painting, he imagined himself moving about in space from

Fig 72a. Composition
analysis of fig 72

Fig 73a. Composition
analysis of fig 73

left to right across the picture plane in order to paint each object as seen frontally, then backwards or forwards into the landscape in order to bring distant objects close up. However, as in all his pictures, it can usually be seen that every spatial colour facet is related to one particular feature, for example his favourite and often painted mountain, the Mont-Sainte-Victoire.

It was Cézanne who finally carried modern art forward into a new conceptual phase. Although he looked at nature in a perceptual way, through the application of a new pictorial logic he translated his perceptions into conceptual images. These images embody ideas of space and structure which lead directly to the next phase of the modern movement.

The new ideas in physics which began in the 19th century eventually meant the abandonment of Newton's science. In art, Cézanne's abandonment of Renaissance methods was equally revolutionary.

7
Cubism and Classic Abstraction

The new ideas of space and volume which science had begun to explain in the 19th century and which Cézanne explored intuitively in his work, were dramatically developed at the beginning of the 20th century. The scientist, probing below the surface appearances of nature, proceded beyond the chemical analysis of matter and the hitherto unseen world of the microscope to uncover the basic physical nature of all structure – the molecule and the atom – revealing new dimensions of reality, no longer capable of verbal description but demanding the new abstract language of mathematics.

The artist also, pursuing his intuitive exploration of reality, becomes more and more concerned with aspects of reality beyond the scope of visual perception. Abandoning the arbitrary effects of perceptual art – the accidents of light and atmosphere and the limitations of one fixed view point – he seeks to grasp the total reality of things and to find new images for the universal relationships – the pattern and structure that unites all things. He too is constrained to invent a new conceptual abstract language.

In science and in art, exploration of reality becomes a process of 'making visible the invisible'. To understand this is the key to understanding the art of the 20th century.

CUBISM
Cubism is the first great style in the development of modern conceptual art. It contained three basic ideas which gradually emerged as it developed. The first was to paint objects from several different

Fig 74. Multi Viewpoint Image

Fig 75. Volume and Space – Positive and and Negative Images

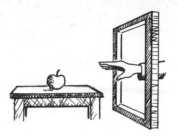

Fig 76. Picture Surface
and Space – Cubist
extension of Cézanne's
method

viewpoints at once. This was by no means a new approach, as can
be seen from our observations on Egyptian, Byzantine and medieval
art in previous chapters. It is one which is also frequently encoun-
tered in Primitive art. Essentially, it is a conceptual idea arrived at by
combining a series of perceptions, akin to the understanding of an
object which is built up from reading the plan, elevation and section
on an engineer's or architect's drawing. If you take an apple and
turn it over in your hand so that you look at it from the top, side and
bottom, your mental image of it will be something like that indi-
cated in the diagram (fig 74). 'I paint objects as I think them, not as I
see them' – Picasso.

The second idea was that it is impossible to conceive a complete
image of an object without considering the space that the volume
occupies as well as the volume itself. If you can imagine a part of the
apple disappearing, you may be able to visualise an apple-shaped
space remaining (fig 75). Convex then becomes concave, positive
space becomes negative, volume becomes anti-volume. Or, as
another example, the form of an egg could be shown either by filling
the emptied shell with solid plaster to give a positive image in volume,
or equally valid, by casting plaster round the egg, when a negative
image in space would be registered in the plaster. In fact the idea of
replacing convexities with concavities, or volumes with spaces, has
been much used by sculptors who were influenced by Cubism. 'I
was unable to introduce objects until after I had created spaces' –
Braque.

The third idea in Cubism is also one with which we are already
familiar – that of relating the whole image to the surface of the
painting. This, as has been pointed out, meant abandoning Renais-
sance perspective which, as Braque said, 'does not allow one to take
full possession of things'. The idea that everything in the picture
should be, as it were, within reach ('to touch things, not merely to
see them' – Braque), was very important to the Cubists (fig 76). It was
essentially a style in which the artist *feels* his way through space.
Braque saw space as something 'tactile, I might almost say manual'.

Cubism developed through several stages between 1907, when
Picasso painted the first Cubist picture, and roughly 1920 when the

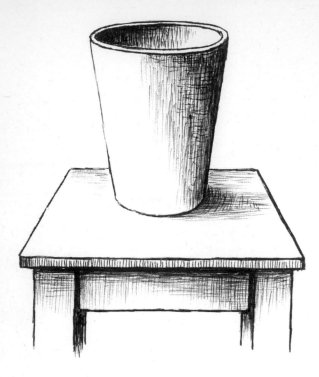

Fig 77. Traditional perceptual image

Fig 78a. Facet Cubism

Fig 78b. Analytical Cubism

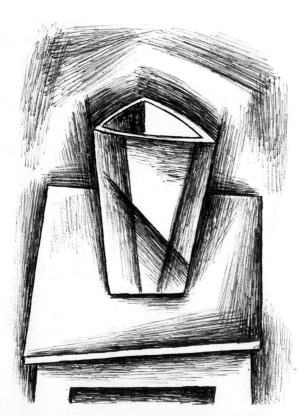

various artists who had taken part in the movement began to go their own ways. These stages have been given names by art historians, but it is important to remember that the whole movement was one of intuitive experiment, rather than conscious theory. The theory, as outlined here, came later, and the historical development of Cubisn is actually by no means as logical and clear-cut as these diagrams may suggest. They should be regarded simply as an attempt to isolate and condense the main elements of Cubism as an aid to understanding its development.

Starting from an academic viewpoint, let us imagine the feelings of an artist faced with the problem of depicting a beaker standing on a small table. Traditionally he would create an illusion of what he sees by using linear perspective to suggest space and tone to suggest volume (fig 77). Visually, the surface of the painting disappears as a result of this illusion.

The earliest phase of Cubism, known as 'Facet Cubism' might have led the artist to treat the subject as seen in fig 78a for example. Picasso and Braque inspired by Cézanne would have broken the object and its space into large facets, each symbolising a different angle of view, but at the same time related to the surface of the

Fig 78c. Hermetic Cubism

Fig 78d. Synthetic Cubism

canvas. The top of the table tilted up, bringing it closer, and the beaker is shown both as seen from the side as well as looking down into it. The ellipse at the top is changed into a triangular shape, again suggesting different viewpoints. Sometimes in these Early Cubist paintings, facets are seen to overlap, which already suggests a quality of transparency that allows one to see the object in terms of space as well as volume.

During the next stage, known as 'Analytical Cubism' (fig 78b), the artist, as it were, dissected objects and rearranged the parts. Here the fragments of three, or perhaps four, views (side, three-quarter side and top, top and bottom), treated as transparent facets, are incorporated in one image. The space in which the object exists is also treated in facets so that both the object and space seem to be solid and spatial simultaneously, and the whole image appears to be within touching distance.

Analytical Cubism resulted in extremely complex pictures, and this led the artists to simplify the organisation of their paintings in the next phase, known as 'Hermetic Cubism', which indicated a self-contained, or self-sufficient image (fig 78c). Here the facets are all adjusted so that they lie parallel with the picture plane, like transparent sheets of glass arranged one in front of the other, symbolising different depths in space. Here and there on these planes or layers of space, fragments of the object seen from selected angles, might be drawn. The resulting form was becoming more and more a reconciliation between the reality of the object and the reality of the flat canvas. It was at this stage that Picasso and Braque began sticking actual materials – newspaper, wallpaper, etc. – on to their canvases (collage). This had the effect of making the image appear to emerge through the picture plane outwards into the world of the viewer. Fragments of lettering, introduced into their compositions, had the same effect. Thus a new kind of contact between pictorial space and real space was achieved.

The last coherent stage of development is known as 'Synthetic' or 'Flat-pattern' Cubism (fig 78d). Here the starting-point for the image is really the canvas itself ('there was no question of *starting from* an object; we *went towards* it' – Braque) on which a synthetic symbol is conceptually created, which refers to, or stands for, the object and its spatial qualities, rather than representing it.

The development of Cubism, as diagrammatically explained in the preceding illustrations, can be seen in all its subtlety in the four paintings – 'Fruit Dish' by Picasso (fig 79), Facet Cubism; 'Mandolin' by Braque (fig 80), Analytical Cubism: 'Composition with Ace of Clubs' by Braque (fig 81), Hermetic Cubism – (note the use of wood graining which refers to an actual wood table in the com-

position, but which has the visual effect of projecting these areas beyond the picture plane. This kind of 'Spatial ambiguity' derives from Cézanne, and later becomes a key idea in modern art). 'Still Life, 1916' by Diego Rivera (fig 82), Synthetic Cubism (note again the use of collage round the still life, making the space appear more solid than the bottle in the middle, which seems to exist as a void).

Cubism thus represents a further move away from the representation of purely visual experience in art. Yet at the same time it could be described as an attempt to achieve a more complete image of the 'real' object. The point here is that ideas about what is real have been constantly changing throughout man's history, and it is significant that our thinking about the nature of reality underwent certain fundamental changes in the first twenty years of this century. For example, certain developments in technology came about at this time which were to have a profound effect on our lives today. In 1909 Ford made the first popular motor car; in the same year Blériot proved, by flying the Channel, that the aeroplane could be a practical means of transport; Marconi had already made radio a revolutionary means of communication with his invention of the radio valve in 1906, while the telephone was by this time commonplace to many people. By the turn of the century, cinematography was widespread and public film shows were common; steel and reinforced concrete had been used in new ways to span spaces

Fig 79. *Fruit Dish, 1908/9*, Picasso. Collection, the Museum of Modern Art, New York. Acquired through the Lillie P. Bliss Bequest

Fig 80. *Mandolin, 1909/10*, Braque. The Tate Gallery, London

Fig 81. *Composition with Ace of Clubs*, Braque. Modern Art Museum, Paris: Cliché des Musées Nationaux. Rights reserved A.D.A.G.P.

Fig 82. *Still Life, 1916*, Diego Rivera. The Tate Gallery, London

beyond the previous capacity of architecture. The new century opened with a kind of technological explosion.

It will be seen that all these advances were concerned in some way with time, space or movement, or with all three. Take, for example, the experience which one has when telephoning someone a thousand miles away, distant in space but simultaneous in time, at once far and near, a relationship quite outside man's experience before the 19th century. As a result people were beginning to think in a new way about the relationship between these concepts. In science also, new ideas were being introduced which were to change fundamentally the old Newtonian idea of time and space as separate aspects of reality.

In 1905, Einstein, who had been much concerned with the problem of how light moves through space, published his *Special Theory of Relativity* which proved that observations of time, length and mass are relative to the velocity of the observer, and that, since everything in the universe is in a state of motion, there can be no absolute idea of time and space which would be true for all observers. This led him to suggest that both time and space as we know them are subjective constructions of the human mind, and do not correspond with nature which, he suggested, exists in a four-dimensional

'space–time continuum'. That is to say, time can now be regarded as a further dimension of space.

The parallel here with Cubism is obvious. A Cubist painting is the result of combining subjective views of the object, experienced in subjective time, into one simultaneous, objective image (fig 83).

In 1916 Einstein published his *General Theory of Relativity* in which he pointed out that there is no way of distinguishing between the effects of acceleration and of gravity (a fact which we have all experienced when a fast elevator speeds up or slows down). This led him to suggest that the geometry of space is determined by the distribution of masses within it; that, for example, the movement of a satellite round a planet is caused by the curvature of space round the larger mass, that all space is curved in some way, and that it is impossible to conceive of space without objects.

Here too, the similarities between these ideas and the discoveries of the Cubists are evident. The space in a Cubist painting exists only in relationship with objects; it is curved, in the sense that the effect on the viewer is that of moving round the object within the picture, rather than that of viewing it from one fixed point of view; and space and volume seem to be interchangeable.

One further possible link between Relativity and Cubism is now clear. It is virtually impossible to visualise a four-dimensional space, in terms of our ordinary experience of the world. For the scientist it must ultimately be expressed in the abstract terms of mathematics. For the artist it can only be adequately expressed in a form of near-abstract symbolism. At this level, reality ceases to be perceptual, and becomes entirely conceptual.

CUBISM AND MACHINE AGE DESIGN

Cubism was probably the most far-reaching and influential artistic movement of the 20th century, not only in its effects on painting and

Fig 83. From subjective apprehension to objective image

sculpture, but also in its influence on all the other visual arts. It was, moreover, paralleled by equally revolutionary developments in music and literature (Stravinsky, Schoenberg, Joyce, and Eliot) which occurred at roughly the same time.

In the 1920s two painters who had been much influenced by Cubism, Ozenfant (fig 84) and Jeanneret, developed from Cubism the theory of 'Purism'. This stated that art should concern itself with 'constant universal forms' of which there are two kinds – organic, those that belong to nature and have evolved for specific purposes and conditions (the formation of plant and animal life – leaves, eggs, bones, etc.), and mechanical, those developed by man for his own purposes. These two artists suggested that in creating his

mechanical forms, man should emulate the functional economy and efficiency found in the universal forms of nature.

This idea, applied to architecture and design, led to the theory of 'Functionalism' which was pioneered by Jeanneret who subsequently, as Le Corbusier, became one of the great pioneers of modern architecture (figs 85 and 86). As Le Corbusier realised, architecture, that is the organisation of relationships between actual masses and space in terms of human movement and activity, is a much more

Fig 85. House at Garches – Le Corbusier and Pierre Jeanneret. From *Modern Architecture* by J. M. Richards – Penguin

Fig 86. Villa Savoye at Poissy, interior – Le Corbusier and Pierre Jeanneret

adequate and natural vehicle for expressing the ideas of Cubism than is the flat surface of a canvas.

The development of steel, glass and concrete in modern building technology had already gone a long way towards abandoning old concepts of architecture and creating a new language of design. The rigid division of exterior from interior, characteristic of traditional solid-walled building, was replaced by a skeletal structure which allowed light and space to flow through the building. Le Corbusier lifted the mass of the building off the earth, supporting it on piles so that space flowed underneath it; he developed the use of light screen walls independent of the load-bearing structure to create a new relationship between outside and inside, with overlapping and transparent planes which immediately recall the experiments of Analytical and Synthetic Cubism. He introduced natural forms such as trees to fill some of the interior spaces of his buildings, and his development of courtyard and roof gardens created a subtle interrelationship of natural and man-made forms. And in his organisation of the interior, he replaced the old rigid arrangement of rooms, as a series of separate boxes, with new relationships of space as functionally designed areas flowing or unfolding one into the other; that is, architectural space conceived in terms of movement within and through it. Le Corbusier was not alone in pioneering these Cubist and Functional ideas. Independently and in different ways the new ideas of mass, space and movement were developed by others of his contemporaries such as Lloyd-Wright, Gropius, Mies van der Rohe, and Buckminster-Fuller.

In painting, Cubism led, in the main, towards greater abstraction. There was, however, one painter, Fernand Léger, who seems to have understood and identified himself with the vision of the new Machine Age as it appeared to those architects and designers who were attempting to create a new human environment. Or perhaps it would be more correct to say that he tried to reconcile humanity with a machine-made world. From early work with Picasso and Braque, Léger subsequently became concerned with a style of painting which expressed an age in which the machine had replaced nature as the most important factor in our environment. From Cubism, he evolved simplified cylindrical forms related to and contrasted with flat areas of colour (fig 87), a style which was at once humanistic and classical, a 20th-century development of the tradition of Poussin, David and Ingres.

While many contemporary artists may appear to have gone beyond Cubism or even to have abandoned it, it would be yet true to say that the principles of Cubism remain the basis of the new idiom of Machine Age design which is still in an early phase of its evolution.

Fig 87. *Two Women holding Flowers*, Léger. The Tate Gallery, London: Rights reserved S.P.A.D.E.M., Paris 1969

CLASSIC ABSTRACT ART

In painting, perhaps the most important development from Cubism was classic abstract art. If we look again at Cubism we can see that as it develops the actual object becomes less and less important while the relationships of the object to space, and through space to other objects, gain in importance. 'Let us forget things and consider only the relationships between them' – Braque.

The Cubists themselves, however, never completely forgot the object. It was for the next generation of painters, like Mondrian and Malevich, and sculptors like Brancusi and Gabo – all influenced by Cubism – to make the next step of finally abandoning the object altogether and creating a completely abstract art, that is, an art of pure relationships (fig 88).

Here again, this new step in art could be said to correspond to a new development in our understanding of reality. Science had begun to suggest that reality extended, in both a microcosmic and a macrocosmic way, far beyond the range of our senses, and that nature, in these ranges of reality, did not at all correspond with what we know of it within the very narrow range of our sense perceptions.

About 1910 the physicists Rutherford and Bohr suggested that the atom was not a compact particle of matter, but a kind of planetary system with a nucleus equivalent to the sun, and with electrons revolving round it at distances comparable, on that scale, to those of

Fig 88. The disappearance
of the object

the planets from our sun. In 1919 Rutherford succeeded in splitting
the atom by knocking particles out of it, and thus transformed one
hitherto immutable element into another.

Meanwhile Max Planck, investigating the properties of sub-
atomic particles, had put forward the idea of the quantum (a discrete
package of energy) to describe the way electrons discharge energy.
Subsequent developments of this theory led to the idea that the
various fundamental units of matter – electrons, neutrons, protons,
etc. – would have to be regarded as having the properties of both
waves and particles.

Einstein had suggested, in the meantime, that mass and energy
should be regarded as equivalent, and produced the famous equation
$E = MC^2$ to describe this. Furthermore, it became clear at about this
time that we could never truly 'know' what a particle was really
like, or even where it was at any particular moment, since any
investigation of it inevitably changed it and its position.

Since then, it has become obvious that this is a principle which
applies to any scientific investigation; we can never know the true
nature of any phenomenon, but only its relation to other phenomena.
We don't know what a thing 'is', but only what it 'does'. Reality
thus becomes a system of relationships rather than of objects.

'To define a thing is to substitute the definition for the thing itself'
– Braque.

'Nothing is more misleading than clear and distinct ideas' – de
Broglie (physicist).

Fig 89. *Composition with Red, Yellow and Blue*, Mondrian. The Tate Gallery, London

Mondrian is the most important of those modern artists who seem to have understood reality intuitively in terms of ideal relationships. After working for a time as a Cubist, he gradually began to simplify his paintings into isolated marks on the canvas, then into complexes of vertical and horizontal lines and finally into canvases divided by vertical and horizontal lines with a few rectangles painted in the primary colours (fig 89). He himself said that he was now concerned, not with the surface irregularities of nature, but with the universal harmonies of proportion which lie behind the surface.

The relationship of his work with the philosophy of Plato (Chapter 3) and with the ideas of modern science is evident. The object has disappeared, leaving only a system of relationships – subtle, more dynamic, because of its asymmetry, but conveying the same feeling of universal truth as did the Golden Section of the Greeks.

Malevich, at the centre of a highly original modern movement in Moscow, made a clean break with representational art, and went

straight to abstraction, producing, from 1913 onwards, composi-
tions in which coloured squares and rectangles, dynamically related
to each other and to the rectangle of the canvas, suggest less the
harmony of nature than the energy inherent in all matter.

The idea of a geometrical abstract art of precise relationships
remains an important aspect of art today, but it has been developed
subtly in new directions since the pioneering work of Mondrian and
Malevich. In the painting by Joseph Albers (fig 90 – facing page 161)
both colour and proportion are important, but they seem to interact
on each other so that the image fluctuates before our eyes, suggesting
perhaps the ambiguity of perception, an aspect of modern art which
will be examined again in our observations on Op art.

Fig 66. *Maple Leaves on Tsutata River*, Hokusai. Reproduced by courtesy of the Trustees of the British Museum

Fig 67. King Hormuzd reproving his Son, Persian MS. 18188, f. 431b. Reproduced by courtesy of the Trustees of the British Museum

Fig 72. *Still Life with Cupid*, Cézanne. Courtauld Institute

8
Expressionism

If the classic tendency in modern art, characterised by developments from Cubism to mathematical abstraction, expresses the universal realities of the scientific age, it is the style of Expressionism which most significantly reflects the human condition in modern times.

We have already commented briefly on the nature of Expressionism in Chapter 4, and in the paragraph on Van Gogh. It is a form of art which, unlike most modern styles, is based not upon theories, technical experiment or research, but on the artist's own individual, spiritual and emotional experience.

Expressionism is outside any stylistic discipline, the artist relying on a very personal handling of line and brush stroke, and on distortions of form and colour – a kind of personal 'handwriting' which gives maximum emotional intensity and individuality to his expression.

Distortions are used, as in the work of Van Gogh, either symbolically (e.g. heightened yellow, symbolising happiness) or to express states of mind (twisted tree forms expressing personal anguish). In fig 91 note how distortion changes the character of the bottle, giving each image a different meaning. Elongation gives it delicacy and a 'spiritual' quality, compressing it makes it heavy and 'earthy'; bending it makes it fluid and unreal.

Fig 91. Expressionist distortion of the object

Fig 92. The expressive-
ness of lines of different
character

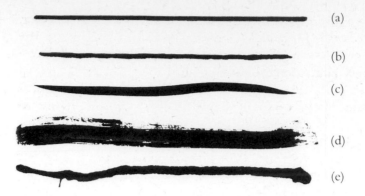

(a)

(b)

(c)

(d)

(e)

Each line, brush stroke, or mark in modelled clay contributes to the emotional meaning of the Expressionist image. In fig 92, we see how five different kinds of line suggest different states, depending on how and with what they are drawn:

(a) with a ruler – firm, definite, uncompromising.
(b) slowly, and freehand – intensity, concentration.
(c) quickly, with panache – free, graceful.
(d) violently and quickly – anger, force, violence.
(e) accidentally, by dribbling the ink – chance, indeterminancy.

Expressionism is not a movement or a grouping of artists, but rather is it a temperamental tendency in all art – an extreme form of Romanticism.

We have already noted that it is characteristic of Northern peoples; an expression, perhaps, of man's anxiety when he is in conflict with the forces of nature. Indeed, a study of the influence of climate on art might show that Expressionism tends to appear wherever man must struggle against external forces, for it can be seen as a strong element in the art of peoples who live in the difficult conditions of the Equatorial zones no less than in the bleak countries of the North.

The proposition that Expressionism is the product of conditions of stress seems to be further borne out by the fact that it appears also in all regions at times of social, political and spiritual upheaval, as for example the work of El Greco during the Counter-Reformation, or Goya during the traumatic period of war and revolution which attended the collapse of Absolute Monarchy.

The significance of Expressionism in modern art is that it has become the characteristic expression of the isolated individual in modern society. Our century has often been referred to as the 'age of anxiety' to indicate the wholly novel human conditions in which the individual, deprived of the support of communal, social and religious belief, is thrown on his own resources, to cope as best he

can with an age of unprecedented unrest and change. Expressionism as already referred to in Van Gogh's work becomes, for the modern artist, a process by which he unburdens himself of the loneliness, fear and anxiety engendered by his isolation.

Philosophically, Expressionism corresponds with Existentialism and particularly with that of Jean-Paul Sartre. Thus, if God does not exist, there is only one being whose existence comes before its essence; that is – man. According to this philosophy, then, man is nothing else but what he makes of himself; he alone is responsible for what he is. Therefore, he lives of necessity in a condition of anguish, abandonment and despair – anguish because of his responsibility for himself and the human race as a whole, abandonment because he has nothing to depend upon outside himself: he is condemned to be free. And he suffers despair because he must limit himself to that which is within his will or within the sum of probabilities. ('One need not hope in order to undertake one's work.') Nothing can save man from himself.

The Existential attitude to life is typical of many modern artists for whom it represents the only acceptable position for the individual in relation to the modern concept of the universe. This position seems to be further intensified by the peculiar social and economic isolation of the modern artist, who can no longer rely for spiritual support on the kind of creative patronage which existed in the past.

The artist thus becomes an outsider, and is often forced into the position of revolutionary, critic or inquisitor; he becomes a disruptive force in society, his work being disturbing and abrasive. Hence the persecution of modern art by authoritarian régimes and reactionary establishments, and the violent criticism directed at it by all those who fear to abandon the safe world of their preconceptions. It is worth noting that in recent years the official or conventional attitude of opposition to modern art has changed somewhat, and on the principle that 'if you can't beat it, buy it', modern art has become the prestige symbol of the 'progressive' establishment figure. This situation only deepens the dilemma of the artist who jealously guards his freedom from authority and who resists being compromised by accepted values. (See also note on Pop art – Chapter 9.)

The nature of Expressionism cannot be explained by generalisation, nor reduced to an artistic theory; its essence is in the individuality of each artist's work. It can be appreciated and understood, therefore, only by reference to specific examples of which the following are characteristic.

Van Gogh and Edvard Munch (1863–1944) may be regarded as the pioneers of Modern Expressionism. Munch, like Van Gogh,

Fig 93. *The Sick Child*,
Edvard Munch. The Tate
Gallery, London

was a typically isolated figure, reserved, nervous, neurotic and
melancholy. His mother and two sisters died of tuberculosis, and the
theme of his painting, 'The Sick Child' (fig 93) and other similar
pictures, probably derives from the saga of family illness which cast
a shadow over his life. His childhood was also disturbed by a
domineering father, and this, together with the early death of his
mother, probably led to a life-long feeling of insecurity. He was
obsessed by visions of tragic women, death and the terrible forces of
nature. Note, in this painting the dramatically simplified shapes,
the disturbing, unbalanced composition, and the way in which the
light seems to emanate from the child's face suggesting a burning
fever. A peculiar psychological twist is the way in which the child
seems to be comforting the mother.

Munch's work aroused scandals throughout his life, and his
paintings were confiscated as 'degenerate' by the Nazis in Germany,
where he worked for a considerable period of his life. He died in
isolation during the German occupation of Norway.

Chaim Soutine (1894–1943) was a Lithuanian Jew who worked

in France from 1913 onwards. Another isolated artist, ignored throughout most of his life, he died in hiding from the Nazis. He always worked under great nervous strain, and his portraits, still lifes and landscapes contain extreme distortions which express his feverishly passionate nature. In his painting (fig 94) the restless instability which was part of his nature transforms the stability of the earth, trees and buildings into a paroxysm of furious restless movement, which is accentuated by the expressiveness of the brush strokes.

The French tradition in art, including modern French painting, has been perhaps the least susceptible to Expressionist tendencies. Georges Rouault (1871–1958) is, however, an outstanding exception. Beginning his career as apprentice to a stained-glass artist, he

Fig 94. *The Road up the Hill*, Soutine. The Tate Gallery, London: Rights reserved S.P.A.D.E.M., Paris 1969

later associated with the Fauves, but in his subsequent development
he diverged altogether from the aims of such artists as Matisse. An
intensely religious man, he used the themes of clowns, prostitutes,
judges and religious subjects to express his sense of the tragedy of
mankind and his horror of persecution, cruelty and stupidity. As
can be seen in his painting (fig 95) he developed a technique of thick,
rich paint texture in which the abstract colour of the Fauves is
intensified by the dramatic use of heavy, black outlines, reminiscent

of medieval stained glass. Like all Expressionists, his handling of paint is extremely personal.

Expressionism has always been associated with German art, although, of course, not all German artists were Expressionists. However, many of the most important German artists have been Expressionist in character, a fact which may be associated with

Fig 96. *Cupid complaining to Venus*, Lucas Cranach. Reproduced by courtesy of the Trustees, The National Gallery, London

Fig 97. *The Painter's Father*, Albrecht Dürer.
Reproduced by courtesy of the Trustees, The National Gallery, London

national temperament, or with the alternations of authoritarianism, war and anarchy which have characterised German history.

This tendency, as we have already noted, became particularly marked in the 16th century during the period of spiritual and social upheaval which accompanied the Reformation. Lucas Cranach (1472–1533), a Court painter, was also a friend of Martin Luther, and even his mythological Court paintings such as 'Cupid complaining to Venus' (fig 96) show a peculiarly Germanic distortion in the strange elongations of the figure, whose pose seems to be at once graceful yet awkward. This 'clumsiness' gives the image an emotional intensity often lacking in the perfection of classical idealisations.

The same qualities can be found in the work of Albrecht Dürer (1471–1528) who, although much influenced by the Italian Renaissance, produced portraits such as 'The Painter's Father' (fig 97)

Fig 98. *Vagabonds, 1910/15*, Emil Nolde. Wallraf Richart Museum, Cologne

which are directly opposed to the idealisation of the sitter in typical Italian portraits of that time. Dürer was a contemporary of Grünewald (see Chapter 4) and also knew Luther, and, as can be seen from his religious engravings, he was very much affected by the conflicts of the Reformation.

This tendency towards Expressionism recurs in an even more personal way in the work of many modern German artists. Emil Nolde (1867–1956), like many Expressionists, was first influenced by Impressionism and then reacted against it. He was associated with the Brücke, a group of young artists who, like others throughout Europe at the beginning of the century, were breaking free of the restrictions of academic art, and were pioneering new methods, in their case primarily of an Expressionist character. Nolde later left the Brücke, and became an isolated and solitary artist, working on themes which combined a personal religious vision with a tragic and ironic view of humanity. In his 'Vagabonds' (fig 98) man is shown as a grotesque, clownish wanderer. Nolde uses intense modulated contrasts of colour, here, for example, red and green, to create extremely disturbing effects. Nolde was bitterly attacked by the Nazis who even forbade him to paint.

The specially searing note of fear and anguish which runs through all Modern German Expressionism would appear to be directly connected with premonitions of disaster and the actual events leading up to the First World War, and even more obviously with the catastrophic conditions and despair which Germany suffered after the War. While many of the Expressionists seem to have been isolated and uninvolved in immediate events, although by no means left in peace by the authorities, others like George Grosz, the great satiric cartoonist, and the painter Max Beckmann, clearly felt themselves to be involved more directly in the post-war life of their unhappy country. Beckmann (1884–1950) was, in his own words, 'trying to encompass man, monster of such terrifying convulsive vitality, in a structure of planes and lines'. Many of his works of the 1920s depict a nightmare vision of post-war Germany as a masquerade of clowns, cripples, criminals and prostitutes. In his painting, 'Family Picture' (fig 99), with the artist himself lying on the bed to the left, he depicts his own family in this vein, as if to say without compromise that even the closed circle of the family is not immune to the forces of fear and destruction which affect society in general – a microcosm of tortured humanity. The enclosed space creates a feeling of claustrophobic tension between the characters, and the distortion of the figures, with their large heads and squat bodies, gives the opposite effect to the spiritualised elongations of Gothic art. His art, like that of many others, reveals, and warns us against,

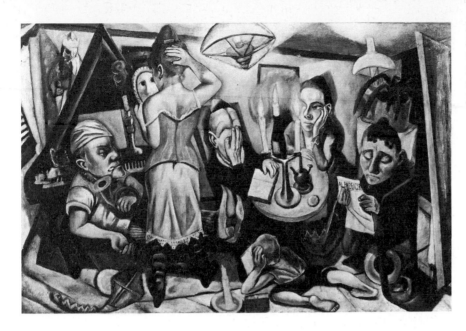

Fig 99. *Family Picture*, Max Beckmann. Collection the Museum of Modern Art, New York. Gift of Abby Aldrid Rockefeller

the negative forces in each of us. But, while art always reflects life and helps us to live more fully, it cannot of itself effect a change in human behaviour in the face of such forces as opposed it in the Germany of the 1920s. Beckmann's premonitions proved only too true. Destructive forces prevailed and Beckmann himself had to flee from the Nazis in 1936. He died in New York.

The debacle of Fascism may be regarded as the final paroxysm in which the old world reached its death-bed, although there are still sinister indications that neither Fascism nor the old world have yet expired. In the first half of the 20th century there was, in every capital in Europe a Nero ready to fiddle while Rome burned. The Austrian Empire, last stronghold of monarchy grown decadent, died to the sound of the waltz. Vienna at the beginning of the 20th century became yet another centre of revolutionary intellectual activity. Here Oskar Kokoschka (b. 1886) studied and worked from 1904, painting and writing, a central figure in the new art movement. At this time it was not only the artist who was turning his eye inwards expressing in new ways the workings of the human mind and the 'storms of the human heart'. In Vienna, Freud and his associates were formulating the new science of psycho-analysis, and it is striking how the portraits of Kokoschka have the same penetrating psychological insight into his sitters (fig 100 – facing page 184) as Freud sought in his work. This insight is expressed in typical Expressionistic distortions. Kokoschka applied the same imaginative vision to his still lifes, landscapes and paintings of animals. Significantly, having regard for the part which Austria had played in the cataclysmic

Fig 101. *Head VI*, Francis
Bacon. Arts Council of
Great Britain

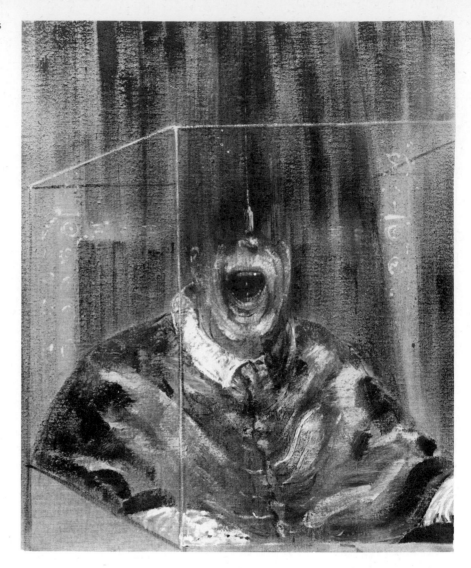

wars of the 20th century, he also painted large allegorical composi-
tions in which he expressed his concern for the political tragedies of
modern man. Like so many of the best Germanic artists, Kokoschka
became a refugee in the 1930s.

Possibly the greatest living exponent of Expressionist painting is
the British artist Francis Bacon, whose images express, more than
many others, the Existentialist anguish of modern man. Sometimes,
as in his painting 'Head VI' (fig 101), parts of his figures seem to
dissolve into space, suggesting the ephemeral nature of human
existence. Often his subjects are businessmen, popes, cardinals, men
of power, who, with their open mouths, screaming or laughing,
seem to exist in a kind of private nightmare of anxiety. In many of

his paintings, the figures are enclosed in a space frame suggesting caged animals, or objects in a museum. With their undercurrent of horror and violence, Bacon's images touch the rawest nerves of our awareness, confronting us with the darker forces of personality which exist in every individual. Another British artist, Roland Piché, is the sculptural equivalent of Bacon. In works like his 'Sunset and Deposition in Space Frame' (fig 102) organic shapes, suggesting limbs and internal organs are often contrasted with actual space frames in such a way that the spectator has an almost visceral feeling of humanity enclosed by a geometrical structure.

Figurative imagery is necessarily a major part of a style which is

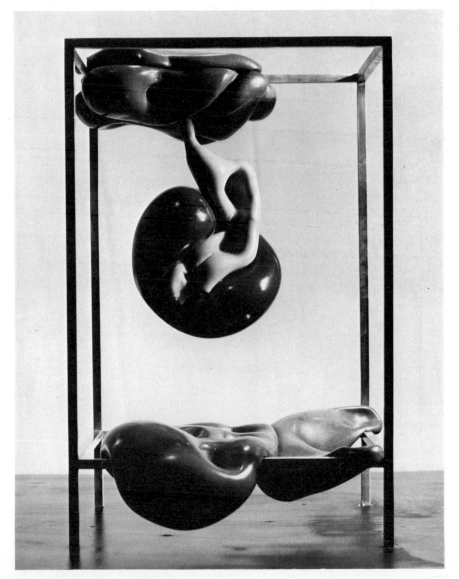

Fig 102. *Sunset and Deposition in Space Frame*, Roland Piché. By courtesy of Marlborough Fine Art (London) Ltd

so directly concerned with the human condition. None the less, there developed a form of abstract Expressionism parallel with the development of the classic abstraction which followed from Cubism. In 1910, Wassily Kandinsky (1866–1944) the Russian painter then working in Dresden, painted the first entirely non-representational pictures. These were very different from the geometrical abstractions of such artists as Mondrian and Malevich. Whereas their work derived from Cubism, Kandinsky's early abstracts were much more closely related to Fauvism and figurative Expressionism. As in classic abstraction, Kandinsky abandoned the object, but aimed at an emotional rather than an intellectual use of abstract imagery. In his painting 'Battle' (fig 7a), for example, the composition consists of freely applied, brilliant patches of colour and loose, wandering lines. His method of painting seems to have been largely improvisatory and spontaneous, and Kandinsky himself said that what he was trying to do was to express great cosmic forces which govern the

Fig 103. *Agony, 1947,* Arshile Gorky. Collection the Museum of Modern Art, New York. A. Conger Goodyear Fund

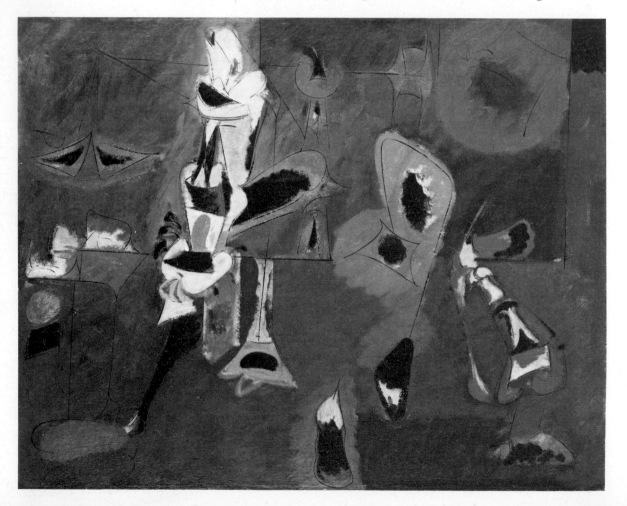

universe. His aim may be compared with that of Mondrian who, it will be remembered was concerned with the inner order of nature. What the comparison shows perhaps, is two basic ideas about nature, the one as an ordered set of mathematical relationships, the other as a dynamic clash of vital forces in which irregularity is the essential characteristic. It is worth noting that the abstract nature of music played an important part in the development of Kandinsky's art, and he envisaged a kind of painting in which the organisation of abstract shapes, colours and lines would be visually analogous to the organisation of the abstract sounds in music.

In the 1920s Kandinsky abandoned his early abstract Expressionist style for a more geometrical one, and no one followed his spontaneous style until it was revived in the 1940s in America by Arshile Gorky (1905–48), an Armenian who had settled in the United States in 1920. Gorky, after early work in the style of Cézanne and Picasso, became influenced by the improvisatory methods of Surrealism (see next chapter). He produced a remarkable series of paintings which were essentially Expressionist and spontaneous, before his death by suicide in 1948. Paintings like 'Agony' (fig 103) from this series, although abstract in form, contain suggestions of organic shapes, flowers, plants, creatures, and seem to have the same kind of cosmic vitality as the early Kandinsky's.

In the late 1940s and 1950s a number of American painters, of whose work the painting by James Brooks (fig 104) is typical, developed the abstract Expressionist style of Gorky. It rapidly spread all over the world and soon became one of the most remarkable phenomena of modern art. One of the few rules of the style was that all painting should be improvised. Thus each action performed by the painter in making his work is related only to the cumulative effect of previous actions. 'The act of painting, in itself and for itself, is the real subject of the painting', and the finished work is a visible history of the actions and the way the artist felt when he did them – hence the other name given to this style, 'Action Painting'.

This method of painting crystallised a significant difference between the work of the old Masters and that of many moderns. Whereas in the past, because the artist was usually working for a commission, the actual act of painting was a journey to a known destination, the modern painter often embarks on a voyage of exploration with no idea of what the work is going to look like when it is finished.

In 'Action Painting' the value of each mark depends upon its uniqueness as also does the value of the complete work (see diagram in Chapter 2). It is perhaps significant that this extremely personal form of Expressionism should originate in America at a time when

Fig 104. *Boon, 1957*,
James Brooks. The Tate
Gallery, London.

the pressures of press, radio, television and advertising – the 'hidden persuaders' of the mass media – were becoming greater and greater. It could perhaps be regarded as an American, and later world-wide, protest of individualism against conformism; it corresponded in many ways to the beatnik movement of the same period.

It follows from the improvisatory method that all technical procedures are permissible and that the less conscious the method, the more spontaneous the result will be. Thus, accidental effects were welcomed by the Action painter – splashes, streaks, blobs and dribbles of paint are characteristic of this style. Jackson Pollock, for example, painted his pictures by dribbling the fluid paint on to a canvas laid flat on the floor, a method which combined some control in the actual movement of the hand holding the can of paint with unpredictable results as to where the paint would actually fall (fig 105).

The use and exploitation of random, accidental effects in art may well correspond with certain 20th century concepts in science (fig

106). In 1927 the physicist Werner Heisenberg put forward the 'uncertainty principle' based upon the fact that locating electrons in time and space can only be achieved by applying the laws of probability. (Sir James Jeans likened the problem to that of locating one fly inside a cathedral. One could not predict where it would be at any moment of time. If, however, the inside of the cathedral was filled with millions of flies one could predict that each cubic foot would contain a certain number of insects. If one can imagine all those flies leaving tiny smoke trails the effect would be not unlike a Jackson Pollock painting.) The 'uncertainty principle' suggested that chance governs the behaviour of electrons, and many scientists have since suggested that Heisenberg's principle applies not only to subatomics but is intrinsic to the whole universe – an idea which plays havoc with traditional ideas of particular causes producing particular effects. It may well be that the intimate details of the cosmos have a kind of fuzziness which science will never be able to clarify or overcome.

Fig 105. *Number 23, 1948,* Jackson Pollock. The Tate Gallery, London

It could be suggested that one of the reasons why Action Painting

Fig 106. Relation of
accidental effects in art
to the Principle of
Uncertainty in science

made such an impact was precisely its implication of a new kind of
form – that significant patterns could be made from random effects
and that this corresponded with the new climate of thought created
by modern science. Certainly a pattern such as that in fig 106, made
by the chance dropping of black strips on to a white surface, may
have more significance for us today than it would have had for a
man of Isaac Newton's time.

A further implication of the spontaneity of Action Painting may
be deduced from the work of Franz Kline. Over a long period
Kline's Action Paintings consisted of dramatic black marks on a
white surface (fig 107). Although he himself has denied being
influenced by Oriental calligraphy, the similarity between his
images and Eastern brush drawing is often remarkable. This fact

Fig 107. *Meryon, 1960*,
Franz Kline. The Tate
Gallery, London

may be explained by the influence which Zen Buddhism has had on
a number of the Action Painters.

Zen is a form of Buddhist belief and practice which is concerned
not with reality, but with transcending it through reaching and
activating those parts of the mind or self of which one is normally
unaware. By this method the individual believes that he can trans-
cend the self and achieve awareness or oneness with the universe, or
a full awareness of being.

Certain Western psychologists have reached conclusions which
are very similar to the Zen way of thought. They suggest that the
unconscious mind may have a quality of understanding which
cannot be achieved by the conscious mind, and that in certain
circumstances we may be able to tap these unconscious sources (see

Fig 108. *The Universe*,
Sengai. Idemitsu Art
Gallery, Tokyo

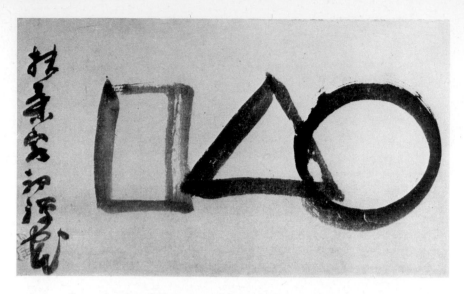

note on Jung in the following chapter). Sengai was a Zen Buddhist
monk (1750–1837) who was famous both for his understanding of
human nature and for the spontaneous drawings in which he
captured his awareness of life. In this example of his calligraphy
(fig 108) the circle represents the infinite, the triangle the human
intellect, and the square, which doubles the triangle, indicates how
the doubling process may proceed infinitely until we have what the
Chinese philospher calls 'the ten thousand things, that is, the universe'.

Action Painting by by-passing conscious creativity seems to use
essentially unconscious sources, and thus may reveal to us dimensions
of reality not readily accessible to the conscious mind.

9
Dada and Surrealism

One essential ingredient in much European art is that of fantasy. At certain times it seems to become the predominant element in artistic expression. Like Expressionism, it seems to be symptomatic of conditions of stress, and the periods in history when it appears are perhaps those when the conflict of ideas has been so great that artists and their public have tended to withdraw into a private world of their own imagination.

While the creation of these worlds of fantasy might appear at first sight as a means of escape from immediate reality, they nevertheless seem to reflect, in strangely reversed images, the very contradictions from which they are withdrawing. One such period, which we have already mentioned in relation to Expressionism, was that immediately before the Reformation, when the spiritual conflict must have been almost intolerable for sensitive individuals. An artist whose work reflects this very clearly is the Flemish painter Hieronymus Bosch (1450–1516). His work consists of fantastic moral allegories in which he uses symbols from folklore, alchemy, witchcraft, mystical religious writings, and possibly from some of the heretical religious sects which flourished in the Middle Ages. In the detail from a panel representing hell (fig 109) from his triptych, 'The Garden of Earthly Delights', the damned soul is shown with a body like a broken eggshell inside which something like a travesty of the Last Supper appears to be taking place. The legs of the grotesque figure turn into tree trunks supported on boats locked in a frozen sea. His hat, in the form of a table or platter, supports a bagpipe in the centre, round which a procession of lost souls dance, partnered by devils. The ears and knife are probably a reference to the medieval Church's suspicion of music as a source of temptation. Other artists in the past who have shown similar qualities of fantasy in their work were Leonardo, Brueghel, Fuseli, Hogarth, Goya and Blake.

The 20th century might well be regarded as a period equalling that of the pre-Reformation in its apparently insoluble neurosis-creating contradictions. Certainly fantasy has become an outstanding feature of modern art. It appears with new force and originality

Fig 109. *Garden of Earthly Delights*, detail of right-hand panel, Bosch. Prado, Madrid

Fig 110. *Sleeping Gypsy*,
Henri Rousseau.
Collection the Museum of
Modern Art, New York.
Gift of Mrs Simon
Guggenheim

in the 19th century in the writings of Lewis Carroll, Edgar Allan Poe and Edward Lear, and it played an important part in the work of other Symbolist writers and painters at the end of the century. But possibly the first modern painter to exploit fantasy to a really significant extent was Henri Rousseau (1844–1910), a so-called 'naïve' artist. This term is usually applied to the self-taught 'non-professional' artist whose simple vision of life is supposed to be a kind of peasant's 'Garden of Eden', untainted either by deep emotion or intellectual aspiration. Rousseau was much more than this. His child-like vision was very 'knowing', and he developed his self-taught technique to a high degree of professionalism. Often, as in his 'Sleeping Gypsy' (fig 110), there is a dream-like feeling which is emphasised by the meticulous clarity of his technique. As we are drawn hypnotically into the painting we wonder if it is we, rather than the sleeping figure, who are dreaming.

Rousseau, despite obvious connections with the Symbolists, may appear to be a rather isolated artist in his time. But, in fact, his work has strong psychological links with other 'fin de siècle' art. A similar withdrawal into the world of fantasy is to be found in the Art Nouveau movement, especially in the meticulous and haunting illustrations of Aubrey Beardsley, and the dream symbolism of painters like the Dutch artist, Toorop. Indeed, the Art Nouveau style, although now regarded as being mainly concerned with design and the decorative arts, can also be seen as the first unified style whose imagery derived directly from the workings of the artist's subconscious mind. It thus foreshadows the subsequent development of Surrealism.

Fig 111. *Uncertainty of the Poet*, Chirico. Sir Roland Penrose: Photograph John Webb, F.R.P.S.

However, Art Nouveau which suffered from many of the weaknesses of the aesthetic (or Art for Art's Sake) movement, produced little painting of significance. It remained for individual artists to continue Rousseau's exploration of the dream world. Already, in the period before 1920, several artists were independently developing a kind of dream-painting. Marc Chagall (b. 1897), a Russian Jew, had arrived in Paris in 1910, where he quickly absorbed the influences of Fauvism, Expressionism and Cubism. Armed then, with a style which combined abstract colour with a conceptual organisation of form, he began to produce paintings based on Russian and Jewish folklore, dream memories of his childhood and poetic fantasies of his life with his wife, Bella.

Another important exponent of fantastic art was Giorgio de Chirico, an Italian born in Greece in 1888. For one period of his life

Fig 73. *Card Players*, Cézanne. Courtauld Institute

Fig 90. *Departing in Yellow*, Albers. The Tate Gallery, London

he seems to have been the embodiment of that melancholy and inward-turning spirit which settled on the classical countries of the Mediterranean, especially Italy, as the influence of Renaissance humanism declined in the modern world. In Paris, de Chirico began to paint what he called 'metaphysical' paintings in which he combined everyday objects in surprising ways, creating an atmosphere of melancholy and mystery. The feeling of extreme tension created by the recognition of familiar objects, but juxtaposed so as to arouse vague premonitions of some impending horror or disaster, is partly achieved by strange jumps in time, perhaps typical of Italy where the layers of the past overlap the present as in few other countries. In his 'Uncertainty of the Poet' (fig 111) the classical statue and arcades combine with the organic form of the bananas and the modern railway engine to give this disturbing effect. To the Freudian (see page 169) the symbolism would appear essentially sexual, the bananas and railway standing for the male, the torso and rounded arcades for the female. The short period during which de Chirico produced these significant works spans a period of extreme tension covering the First World War, and thus perhaps indicates how such specific conditions can release latent forces in a particular kind of romantic artist. For in the 1920s de Chirico abandoned this type of painting and ceased to have any significance as a modern artist.

Paul Klee (1879–1940), the Swiss painter, arrived in Paris at about the same time as de Chirico and Chagall. He began to develop a kind of miniature art of fantasy which seems to have been based on the technique of automatic doodling. He subsequently described and systematised this method at the Bauhaus, where he taught from 1921 to 1933. Here he also developed pedagogical ideas which have since had a profound effect on the teaching of art.

His method seems to have been to take a certain formal device as, for example, wandering pen lines (fig 112), some of which fall and some of which rise. This basic device he would develop until he found an image emerging which he would then complete with conscious additions. Thus, the subject of the work would only emerge gradually in the process of drawing. His work is often extremely witty (note here the surprised can-opener fish), and has had a profound influence on modern art, not least on contemporary graphic and humorous artists.

In one of his writings, Klee describes the artist as the trunk of a tree which, drawing his inspiration from roots underground, is the medium through which life flows to blossom into leaves, or works of art, at the top. Compare this with the notes on Jung's theories of the subconscious which follow later in this chapter.

These various tendencies towards fantastic art seem to have been

Fig 112. *They're Biting!*, Paul Klee. The Tate Gallery, London

brought to a head by the First World War. In 1916, the movement called 'Dada' was founded in Zürich, and within a few years it had attained world-wide significance. Switzerland during the First World War became a refuge for some of the most sensitive intellectuals, poets, writers and artists in Europe. These men shared an attitude of profound anarchic disgust with the stupidity which had led to the holocaust of the war. They were against all the traditional values of patriotism, religion, duty and culture, which far from creating a stable and humane society, seemed to them to have led to the release of all man's most disruptive and aggressive forces.

Fig 113. *Bicycle Wheel*, 1913–1951, metal and wood, 60 inches high, Marcel Duchamp. The Sidney and Harriet Janis Collection. Gift to the Museum of Modern Art, New York.

They set out deliberately to undermine, by every possible means, all these values. As artists and poets they realised, however, that their own language of expression, as exemplified in established art forms, was itself compromised by association with just those ideas and institutions to which they were opposed. Thus Dada (the name is said to have been chosen at random by the poet Tristan Tzara from a French dictionary), was founded as an essentially *anti-art* movement.

Marcel Duchamp (1887–1968) has by now become one of the legendary figures of this movement. Even before the founding of Dada, Duchamp had been ridiculing traditional artistic values by

Fig 114. *Haarnabelbild,
1920*, Kurt Schwitters.
Lords Gallery

Fig 114. *Haarnabelbild,
1920*, Kurt Schwitters.
Lords Gallery

suggesting that simply by choosing an object the artist could claim it as a work of art, as for example with his bicycle wheel mounted on a stool (fig 113). This, which was one of what he called his 'ready-mades', was, in fact a demonstration which proclaimed the right of an ordinary everyday object to be regarded as art. In 1919 he reversed the process by exhibiting a reproduction of Leonardo's 'Mona Lisa' with a moustache drawn on it, thus signifying that a work of art could be demoted to the level of a common object. The title, written below it, is obscene if pronounced in French, a deliberate attempt no doubt to debunk all the false veneration given to this picture by would-be art lovers and connoisseurs. Many years

later Duchamp distributed to his friends a similar reproduction, without a moustache, and bearing the title, 'LHOOQ Shaved'.

Next to Duchamp perhaps the most important Dadaist was the German, Kurt Schwitters (1887–1948), who developed the idea of making works of art out of the rubbish which other people threw away (fig 114). Similar in some ways to Duchamp's ready-mades, these works, often extremely tasteful in their relationships of shape, colour and texture, were declarations of both the democracy of art and the aristocracy of objects. They were, of course, very different in intention and effect from the Cubist collages of Picasso and Braque.

In 1915 Duchamp began work on his masterpiece (fig 115). He ceased work on it in 1923 having, as he said, 'brought it to a stage of incompletion'. This is a composition on glass ('canvases', he said, 'have dusty behinds'), executed in wire, foil and oil-paint. It has been defined as 'a mystical-mechanical epic of desire' and André Breton described it as 'human love seen by one from another planet who cannot make head or tail of it'. It is possibly one of the most

Fig 115. *The Bride stripped bare by her seven Bachelors*, Marcel Duchamp. Philadelphia Museum of Art

Fig 116. *Freud's picture of the mind*

important works of the 20th century, and one of which the full potentialities have yet to be discovered. It lies in the field of modern art like some strange monument which will only reveal its full story to the archaeologists of the future. Having finished work on it, Duchamp, who never repeated himself and who in a few short years had foreshadowed nearly every significant art movement of the next fifty years, virtually ceased to produce art, and devoted himself to chess. Or so it was assumed by the world at large; but after his recent death it was discovered that he had, in fact, been working secretly on a major work over the years. Perhaps this was Duchamp's final ironic dada joke – to produce art in secret. About the same time Tristan Tzara, one of the founders of Dada, announced its end by declaring, 'the true Dadaist is against Dada'. Dada had made its points and established a bridgehead for a new anti-rational approach to art. Its anarchic spirit was now to be replaced by the more organised forces of Surrealism.

PSYCHOLOGY AND MODERN ART

In the meantime the writings of Sigmund Freud had been making a considerable impact during the first decades of our century. Freud had formulated a new theory about the working of the human mind, although he was careful to point out that what he was doing was simply to relate and expound certain truths which had been known or instinctively felt by thinkers and artists in the past.

However, the clarity and broad sweep of his ideas were to be of tremendous significance to modern artists, and, at a time when they were being met with much public ignorance and opposition, Freud's theories provided philosophical justification for many of the new artistic experiments.

Briefly, the basis of Freud's theory was the proposition that the mind is far more complex than had been hitherto realised, in that it consists not only of the conscious mind, that part of which we are normally aware, but that there is also a vast area of mind which he called the 'subconscious', which was possibly the mainspring of all activity and thus affects all our conscious thoughts and actions. Freud's picture of the human mind may be likened to an iceberg (fig 116), only the tip of which is above water and is influenced by surface conditions. The larger part is under the surface, and the overall movement of the visible part is thus, in fact, propelled by unseen forces.

Freud described the mind as having three main parts (fig 117):

The ID which is the subconscious part, and which contains all primitive instincts and desires. This, he described as the source of all psychic energy and he believed that one of the main motivations of this energy was sexuality.

The EGO, or conscious mind which controls our awareness of reality – the part with which we consciously think and plan. The Ego includes the ideas of reality conveyed to us by our senses.

Fig 117. Id, Ego and Super-Ego

Fig 118. Jung's view of the mind

The SUPER-EGO, the last part of the mind to develop in human growth, roughly corresponds with what we normally call conscience. The Super-ego controls our actions so as to ensure conformity with what is socially acceptable.

It will be seen from this division of the mind that between the Id and the Super-ego conflict rages in the field of the Ego, and, according to Freud, most forms of mental illness arise from this conflict.

Freud's theories opened up a whole new field of exploration which is yet in an early phase. Another explanation of the structure of the mind was put forward by Freud's pupil, C. G. Jung (fig 118). According to Jung, the individual consists of a *persona* which is that that part of personality that develops in accordance with the demands of society. This development usually involves the suppression of another part of the personality which he called the *shadow*. Beyond the shadow, lie the various levels of the unconscious which contain the accumulated knowledge and experience of man's past like layers of geological strata. Below some level, these strata are shared by all individuals, and at this level Jung postulated the existence of a *collective unconscious*. Embedded, as it were, in the strata of the collective unconscious are what Jung described as the *archetypes*, i.e. collective symbols of human experience. To Jung, the most important step in the development of human personality was what he called *individuation*, a stage at which persona, shadow and collective unconscious should come to terms. Jung thus regarded the subconscious as a source of wisdom and knowledge.

The theories of the early psychologists have since been expanded, modified and inevitably opposed by other theorists. At the present time psychological research continues in a state of ferment and speculation, but has at least reached a stage where the most positive and imaginative theorists and practitioners are attempting to relate and extend the work of such pioneers as Freud, Jung, Adler and Kline.

All interpretations of art in terms of these theories must, therefore, necessarily remain tentative and speculative for the time being. None the less, Freudian and Jungian psychology does suggest explanations of the nature of artistic creation and the work of art which cannot be ignored (fig 119). The main significance of their ideas in relation to art lies perhaps in the nature of dreams. To the Freudian, a dream is often the emergence of part of the Id, in which socially unacceptable urges are frequently disguised symbolically in some respectable, everyday form. To the Jungian, a dream may be interpreted as a happening which is part of the collective uncon-

scious, often some archetypal symbolism, which in the guise of our everyday experience is bringing us some message of wisdom or solution to some dilemma in our conscious life. A large part of the process of psycho-analysis consists of the interpretation of dreams.

In general the unconscious mind may be regarded as the ultimate source of artistic inspiration. In Freudian terms, the artist is an individual who suffers from the conflict of Id and Super-ego with a peculiar intensity. Through his expressive skill which is an essential part of any artist's personality, he is able to create a kind of visible solution to his internal conflict with which the viewer in turn can identify himself, sharing it as a solution to his own conflict.

To the Jungian, the artist is a person who is in some way in close touch with his unconscious (as though there are faults in the strata so that different levels are in contact) and who is endowed with the physical talents to give a visible form to the archetypal wisdom arising from the unconscious. Thus, the value of the artist's work is as a part of the process of Individuation.

The three parts of the mind which Freud described might be linked with three aspects of the work of art: the Id with the unconscious imaginative content, the Ego with the subject-matter or obvious content, and the Super-ego with the form and composition of the work which may be seen as being synonymous with the organisation which society demands. An intriguing fact which merits reflection is that in much modern art the imaginative content, the obvious subject-matter and the form seem to be one and the same. Furthermore, many works of art seem to be intelligible in

Fig 119. The subconscious as the source of artistic inspiration

both Jungian and Freudian terms. A striking example is provided by Henry Moore's reclining figures (see fig 10) which can be viewed, not only as described above, but also as Jungian archetypal earth-mother images, combining as they do in one form the idea of the female figure as well as that of landscape.

SURREALISM

In 1924 the poet André Breton published the 'Surrealist Manifesto' and the Surrealist movement was founded. It is significant that Breton had been a doctor in the French army in the First World War and was among the first doctors to have experience of the application of Freud's psycho-analytical method to the stress illnesses of war. The primary aim of the 'Surrealist Manifesto' was the exploration, utilisation and liberation of the subconscious mind. Surrealism was not only an artistic movement, but a fundamental philosophy of life having wide social and political implications. It was defined by André Breton as 'the revolt of the psyche against the authority of reason; at the same time it is an appeal to reason to liberate man from the oppressors – the family, the church, the fatherland, the boss'.

It demanded from its supporters the utmost personal dedication to its principles and, like many such revolutionary movements, it was ultimately torn by dissension, schisms, expulsions and ex-communications. Its impact on 20th-century culture, however, has

Fig 120. *Bottled Moon*, Max Ernst. The Tate Gallery, London: Rights reserved. S P.A.D.E.M., Paris 1969

been enormous. The freeing of the imagination from conventional modes which was its main aim has inspired and enriched popular literature, notably science fiction, and has had a liberating effect on popular forms of entertainment, as for example in the comic work of the Goons and the Beatles in Britain. It has also had an overwhelming influence in the art of the film and in graphic advertising.

In a more general sense the Surrealist aim of liberating the subconscious has contributed to the permissiveness of social behaviour in the 1960s, and in various ways it is the main idea underlying the contemporary 'hippy' or underground movement. 'Do your own thing!' might well be a Surrealist slogan.

One of the most important Surrealist painters is Max Ernst (b. 1891) of whom Breton said that he had 'the most magnificently haunted brain in Europe'. Having started as a Dadaist, Ernst's great contribution to Surrealism was the invention of various techniques to achieve accidental effects on the canvas which, rather like Klee's development of random drawing, would suggest to the subconscious, images which would then be developed consciously. These techniques included frottage, the impressing of textures such as woodgrain on the canvas or paper in the manner of brass rubbings, the application of oil and water causing random markings, and an original use of collage effects. He probably used a mixture of these methods to achieve the complex textures of the dream landscape in his 'Bottled Moon' (fig 120). Ernst's work frequently includes sexual symbols, but also as it does here, contains suggestions of primeval scenes or even extra-terrestrial landscapes, which might be understood in Jungian terms.

The Spanish painter Joan Miró (b. 1898) developed another form of Surrealism, more akin perhaps to the work of Klee. It has been described as 'the poetry of the unutterable, of the unreal, of germinations and beginnings'. His paintings are made up of shapes and signs reminiscent of Child and Primitive art and strongly suggest Jung's archetypal symbols. But Miró's symbols are also often clearly erotic and seem to accord with Freud's ideas of subconscious motivation. For all their apparent child-like simplicity, Miró's primitive life forms and strange creatures (fig 121) have a tremendously witty vitality which strikes strange and diverse chords of the imagination. Forms like these which carry multiple meanings are typically Surrealist.

Yet another form of Surrealism is the meticulously painted dream image. In this method the strange juxtapositions of objects are given added impact through an intensely clear and obsessively detailed delineation of the forms – a kind of parody of our visual sense, as if the artist is insisting that we accept the conceptual images of the

Fig 121. *Women, Bird by Moonlight*, Joan Miró. The Tate Gallery, London

unconscious as part of the conscious perceptual world. René Magritte, the Belgian artist (1898–1958), is possibly the most haunting exponent of this kind of work. In his 'Time Transfixed' (fig 122) the composition probably results from an unconscious thought-link between the objects and the ideas they suggest – the mirror (space), the clock (time), the railway engine (movement through space and time), the smoke and the fireplace. This 'automatic' method of evolving a theme or composition by letting each successive thought suggest the next was characteristic of writers, painters, film-makers and musicians who belonged to or were associated with the Surrealist movement – James Joyce referred to it as the expression of the 'stream of consciousness'. By literally translating such associa-

tions into images, Magritte presents us with a strangely disturbing picture. The Freudian interpreter would probably translate it into erotic terms, the engine standing for the male and the fireplace for the female.

Perhaps the most obvious example of a 'Freudian' Surrealist is Paul Delvaux, another Belgian artist (b. 1897). Delvaux was influenced by both de Chirico and Magritte. He is obsessed with the strangeness of nude and clothed figures, especially the female, which he paints in dream-like settings of moonlit classical temples, haunted streets and squares, and empty rooms. In 'Venus Asleep' (fig 123) the timeless silence in which the eternal beauty sleeps seems about to be shattered hysterically by the entrance of death, here symbolised

Fig 123. *Venus Asleep*, Paul Delvaux. The Tate Gallery, London

by the familiar expressionistic device of the skeleton. The eroticism of life here confronts mortality in a dream vision of the dead past.

One of the greatest of modern sculptors, Alberto Giacometti (1901–66) made a number of Surrealist sculptures before he developed the style of elongated Expressionist figures for which he is now famous. His 'The Palace at 4 a.m.' (fig 124) is probably the best known of his Surrealist works. Both the title and the form itself evoke a strange vision of a great formal building filled by the dreams of its sleeping occupants.

Surely one of the most disturbing Surrealist objects ever made is the fur-covered teacup (fig 125) by the Belgian woman artist Meret Oppenheim. The impossibility of using it as an utensil makes it a characteristic Surrealist demonstration of anti-rationalism and anti-functionalism, while its weirdness is made more disturbing by its obvious Freudian implications.

The Spanish painter, Salvador Dali (b. 1904) appeared in Paris in the 1920s as a flamboyant fanatic of Surrealism, and became one of the leaders of the movement until his expulsion by André Breton. He described his painting as 'hand-done colour photography of concrete irrationality', and proclaimed the method of 'paranoic-critical activity', by which he alleged that he was able to induce in

Fig 124. *The Palace at 4 a.m.*, Alberto Giacometti. Collection the Museum of Modern Art, New York

Fig 125. *Fur Teacup*, Meret Oppenheim. Collection the Museum of Modern Art, New York

Fig 126. *The Persistence of Memory*, Salvador Dali. Collection the Museum of Modern Art, New York

himself a state of hallucination so that ordinary objects became transformed into something else. In his 'Persistence of Memory' (fig 126) the starting-point for the transformation might well have been a somewhat far-fetched pun 'Montre ta langue' (show your tongue). The patient shows a soft tongue which immediately suggests the phrase 'la montre molle' which can also mean 'the soft watch'. So the watches are painted like soft tongues. But, in order to function, a watch should be a rigid mechanism, so that the soft watches are also symbols of impotence.

While he was undoubtedly an artist of great talents, Dali's weakness seems to have been a combination of undisciplined exhibitionism and calculated commercialism which soon earned him the contempt of sincere adherents of the Surrealist movement. In recent years he has become an establishment figure, the darling of café society, lending 'prestige' to its pseudo-patronage of modern art. Perhaps an artist of Dali's temperament cannot survive the rapid changes and pressures of modern society. Whatever the reason, his work today seems as anachronistic as did Ingres's Neo-Classicism at the height of the Romantic movement. If we recall Breton's 'Surrealist Manifesto', Dali's subsequent support for the Spanish Government and the Church is clearly a betrayal of all Surrealist principles.

The true successors of pre-war Surrealism are the Neo-Dadaists, and some of the Pop artists of our time whose work is discussed in our final chapter.

10
The Contemporary Scene

Although the proliferating movements of post-war art may seem to be bewildering and confusing, they can in fact be understood with as little difficulty as the art of the past, if we bear in mind the following points.

In the first place the basic nature of art has not changed. It remains, as it always has been, a visual language for the expression of ideas, a language which has developed from the past and has changed only in order to cope with new patterns of thought and new ideas about the world.

In the second place there is today, as there always has been, an internal development in art of such a nature that each art movement can be seen as a reaction against the preceding one. The pendulum swings unceasingly back and forth between classic and romantic, perceptual and conceptual, abstract and figurative, and perhaps between other poles of expression as well. The only difference which may be possible to discern today is that it swings faster than in the past.

Thirdly, of course, all modern movements can be related to some section of contemporary social, philosophical or scientific ideas. The fact that for many people contemporary art remains unintelligible does not invalidate this point. As the composer Edgar Varese has said, 'Contrary to general belief, an artist is never ahead of his time, but most people are far behind theirs.' The solution to this lag in public understanding, as already suggested, clearly lies in providing a new kind of liberal education relevant to the task of understanding the complexities of our age.

In studying the various styles of modern art, as they are dealt with in this last chapter, it should be borne in mind that while it is convenient to put artists into distinct categories, many of them seem to relate to more than one movement. Art obstinately refuses to fit into pigeon-holes.

NEO-DADA
Much post-war art can be described as Neo-Dada, and as such can be related to the anarchic activities of the original Dadaists of

1916–22. That is to say, it can be regarded as a renewed and deliberate attempt to undermine existing artistic values. This latest manifestation of 'anti-art' goes far beyond the 19th-century and 20th-century reaction to academic art, which is by now virtually a dead issue. It reacts not only against those modern styles which have become accepted by the establishment, but calls into question the whole artistic situation at the present time. It can be seen as a revolt against established taste and by implication against all ideas and codes associated with that taste.

The attitude underlying Neo-Dada and much Pop art can be thought of as expressing a general widespread anti-authoritarianism and anti-conformism which have grown up in post-war years. In a most obvious way it expresses the artist's attempt to escape from the compromising situation of being accepted by the establishment. It is one of the basic dilemmas of the contemporary artist that he desires success in order to live and work, yet at the same time fears and mistrusts it because of the doubtful conditions in which it must often be achieved. To the artist and to those few who have bothered to learn its language, art remains as ever an indispensable process of living, but to present-day society in general art has become a commercial commodity, a product which represents a good investment, whilst bringing prestige to its owner regardless of whether it is understood or not. Apart from this purely materialistic motivation in contemporary patronage, the frantic buying of modern art (albeit mostly by established or 'gilt-edged' artists) by businessmen, institutions and public galleries might also be interpreted as a subconscious attempt to absorb and monopolise dangerous forms of expression which may threaten just those values by which the affluent modern patron lives. For the widespread attitude of rejection which is found amongst most contemporary artists is only part of the wider culture of the post-war generation who are in revolt against the moribund attitudes of established institutions. This emerging culture embraces the principle of change as an essential part of creative living and rejects the negative and destructive forces of war, political expediency, and the 'rat-race' ideal of success. Indeed, this new spirit hardly seems to be concerned with rejection any more, but by-passes the old world of preconceived ideas and false absolutes as being simply irrelevant. It proposes an alternative world, not the static utopias of the old-style philosopher and politician, but a world which is created in the process of living, which is achieved by abandoning preconceived ideas and taking a fresh look at *everything*, a new world of reality based on the acceptance of relativity and constant change. It is significant that this new awareness has most recently been expressed where the young are in

greatest danger of being conditioned by the old, in the revolutionary and regenerating activities which are taking place in the universities and art schools.

The acceptance of creative dialogue and social change as an alternative to the dogmatism of static institutions is the most significant element in the new cultural climate. If we think of the principles which were pioneered in the main styles of modern art – Cubism and relativity, Expressionism and 'existential self-creation'; Surrealism and the new freedom of the subconscious – we can perhaps begin to recognise an emerging society which in its rejection

Fig 127. *Torso, 1962,* Harry Kramer. The Tate Gallery, London

of absolute values, its emphasis on individual responsibility and its unselfconscious permissiveness of behaviour, strives to live out these principles in a new expression of human freedom. In this context art must inevitably take on a new character, and in redefining it, we may have to question and perhaps discard many of the values which we assumed were hitherto inseparable from it – its exclusiveness, its permanence, its established techniques, its very role in society.

Neo-Dada is one of the post-war styles which repudiates accepted artistic standards and forces us to see and think about reality in a new way. In Kramer's construction (fig 127) which the artist himself describes as 'show business', the shape of the torso is described in wire, within which is an eccentric movement of wheels turning in different directions and at different speeds powered by an electric motor. The image transports us far from the Renaissance 'man and nature' to a world in which the artist confronts us with a disturbing and novel image, commenting ironically perhaps on the dehumanisation of man by the machine, or on the possibility of machines becoming 'human'.

In Pol Bury's construction (fig 128) the objects on the shelves appear to be immobile, but on contemplating the composition for some time one becomes aware that some of the shapes are no longer resting on the shelves. In an apparently impossible way some have risen while others have fallen. The movement is so slow and slight that one doubts in fact whether it has happened – one's conventional perception of reality is undermined and one doubts the evidence of the senses. An unusual combination of slight movement in extended time plays a big part in this mind-jerking image.

The sculpture by Cesar (fig 129) is an exact scale model, $16\frac{1}{4}$ inches high in red polyester of the artist's own thumb. Both size and the shiny plastic material make this a thoroughly disturbing work. It poses the question of just what happens to our sense of perception when the scale of common objects is suddenly and radically changed, a recurring idea in Surrealism and science fiction. By using a 'cheap' plastic material normally associated with cereal packet toys and such, the artist shatters another of our preconceived ideas and demands a new appraisal of the physical character of the work of art as an object.

ASSEMBLAGE
Closely related to Neo-Dada, and particularly to the Dada work of Kurt Schwitters, is a form of post-war art which consists of putting together objects and fragments from real life to make a meaningful composition. This is commonly called 'Assemblage'.

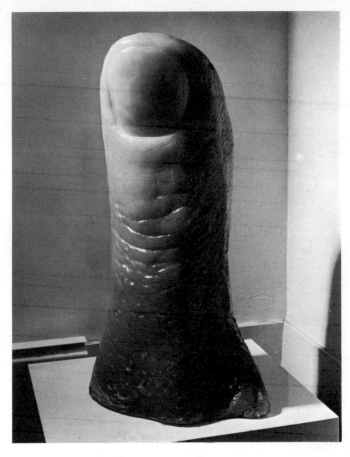

One of the most important artists working in this medium is the American, Robert Rauschenberg. In his 'combine paintings' as he calls them, apparently disparate things are assembled into remarkably subtle compositions. Varying amounts of paint usually applied in an Action Painting manner serve to unite the pieces. In such work, like his 'Trophy I (for Merce Cunningham)' (fig 130) one becomes aware on studying it that the various objects in it are related in a number of different ways. Apart from the formal relationships of shape, texture and colour, each item seems to carry a message like notices on a noticeboard, and these messages are linked to each other across the composition. Thus, in this work, which is dedicated to the dancer in whose company Rauschenberg worked for a time, the 'caution' sign on the left can be linked with the photograph of the dancer, the pieces of wood to the boards of the stage, the fragments of lettering to the sign, and to the idea of a theatre and so on. Rauschenberg's work makes scarcely any reference to nature for both in its materials and images it is inevitably related to the litter and débris of urban life.

Fig 128. *16 Balls 16 Cubes on 7 Shelves*, Pol Bury. The Tate Gallery, London

Fig 129. *The Thumb of Cesar*, Cesar. Hanover Gallery

His work is of particular interest and importance because it so clearly exemplifies a principle of composition which is typical of the organisation of much modern work and which differs essentially from the system on which the works of the old masters were composed. To grasp this difference is to understand one of the most important facts about the world in which we live – how the media by which knowledge and ideas are communicated have changed fundamentally from the Renaissance to the present day, thus altering our processes of thought and apprehension.

In Rauschenberg's work we will find that both the formal relationships and the association of ideas which they express form a kind of complex visual network across the area of the canvas (fig 131). If we compare this approach to composition with that of Van Eyck (fig 131a) despite certain common elements we find a very significant difference in the organisation of the two works. They are similar in that each contains many different objects each of which carries its own symbolic message. In the Van Eyck, however, the symbolic meaning of each object depends upon, and is related to, the two human figures, and the event of their marriage, this being clearly the central theme of the picture. The composition as it were radiates from them. In Rauschenberg's composition, however, although everything is interrelated, nothing is pre-eminent, everything seems to have equal significance. This difference might be seen immediately as expressing the decline of humanism from a point where man was considered the most important entity, to our modern scientific world where man must be reconciled to the role of being but one infinitesimal part of the vast universe which we now explore. In Van Eyck's painting the man makes the event and, therefore, is more important than it. But which is considered more important today, the event of landing on the moon or the man who makes the landing? The achievement will be an impersonal technological one the product of the interrelated ideas and activities of many individuals rather than of individual genius and endurance.

Furthermore, this difference between the organisation of modern works and those of the past may well correspond to changes which have taken place in patterns of thinking in the past few hundred years. It has been pointed out by Marshall McLuhan that the invention of printing led to a linear manner of thinking in which consecutive ideas were related to each other in a causal way (fig 131b). With the development of scientific observation and the systematic categorisation of information, thinking developed in what we might call a tree pattern where several ideas might be developed from one, as with Newton's elaboration of the theory of gravity or Darwin's theory of the evolution of the species. It has now become obvious,

Figs 131, 131a and b.
Comparison of linear,
tree, and lattice com-
position in traditional and
modern art

however, that in many fields of contemporary thought, phenomena can only be understood as a complex lattice pattern of interrelationships. This new pattern results inevitably from the development of varied modern electronic media, such as the computer, which can give us, as McLuhan says, 'instant information on everything'. In our contemporary urban environment we are in fact constantly 'bombarded by information' in a variety of ways – television, radio, the press and advertising in all its forms – and, as in a Rauschenberg painting, we ourselves must select and create the interrelationships between all the information that is available to us. The understanding of reality in the modern world becomes then not so much a task of

Fig 100. *Portrait of Carl Moll*, Kokoschka. Osterreichische Gallery, Vienna

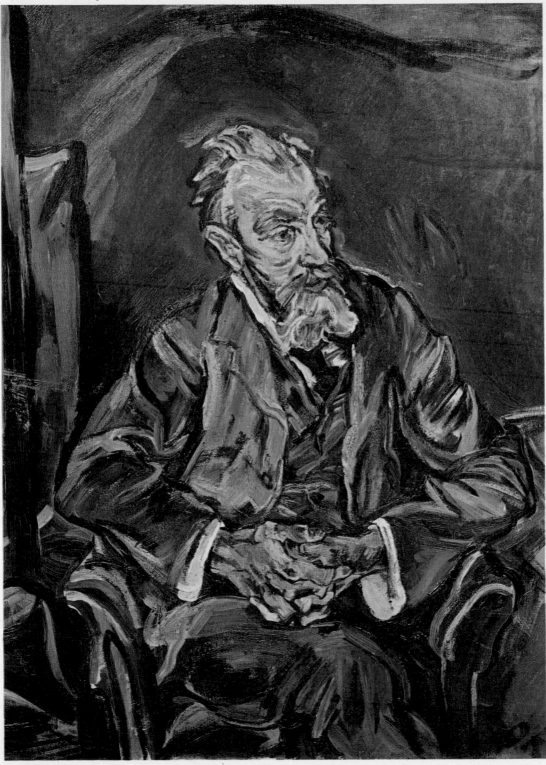

Fig 147. *Orange and Violet*, Michael Kidner. The Tate Gallery, London

memorising great numbers of facts, as was necessary in the scholarship of the past (the computer is rapidly freeing the mind of this burden) but a creative process of making significant relationships between different areas and forms of knowledge.

An important and predictable characteristic in the communication of contemporary ideas is the progressive breaking down of the old hard and fast divisions between the arts. No longer are there clearly defined borders between sculpture, painting, graphics, cinema or even between the different media of sight, sound and movement. A similar dissolving of frontiers between different areas of science is also evident. In a world which accepts change it devolves more and more on the individual to create and re-create his own pattern of reality from the myriad messages which are continuously conveyed to his senses. The process of creating a coherent pattern from many sources of communication can be clearly seen in such recent art forms as Merce Cunningham's ballets in which music, sounds, projected images, décor and the movement of the dancers often

Fig 132. *Black Wall, 1959*, Louise Nevelson. The Tate Gallery, London

seem to be proceeding independently of each other, and thus the audience is involved in making their own individual patterns from the diversity of the media.

One more example will suffice to demonstrate the lattice-pattern organisation in contemporary art. The assemblage compositions (fig 132) of the American artist, Louise Nevelson, consist of walls of wooden boxes within each of which is a smaller composition of wooden objects – pieces of furniture, handles, mouldings, etc. – in some ways similar to Giacometti's Surrealist sculpture. Here also, the relationships created by both the form and content of the small compositions create a network within the whole structure.

The use of non-art materials to make a work of art is not of course new. It probably began in modern art with the Cubist collages or perhaps with Duchamp's 'ready-mades', but it can also be found in much primitive and prehistoric art. It raises the whole question of the relationship of art to reality. In traditional art, one may say that the artist's experience of reality is translated through the medium of paint, stone, metal or other material into an illusion of that reality which is the basis of the work of art. In much contemporary work, however, and particularly in assemblage, bits of reality itself are often the medium from which the work of art is created. Instead of art representing reality, reality now represents art. Thus a new relationship between art and reality is created (fig 133). Similar developments can be seen in contemporary music, as for example Cage's accompaniments for Cunningham's ballet, where real sounds are often used by composers in the theatre where the audience is often involved in the action of the play, and in 'happenings' where real events become art. This 'interchangeability' of art and reality relates directly to what has been said above about the development of communications and the new interrelationship of different media. As McLuhan puts it, 'the medium is the message'.

Fig 133. Reality – Media – Art

POP ART

In the late 1950s and early 1960s a reaction set in amongst many younger artists against Action Painting. It seemed to them that the style had become so introverted and personal that it had ceased to have any connection with the real world. And because it was essentially committed to nothing outside the artist himself it seemed to become precious and meaningless to others. There can be little doubt also that because the technique of Action Painting relied on absolute spontaneity and necessarily repudiated the traditional disciplines of painting, it opened the door to many exhibitionists who commercialised its possibilities by sensational demonstrations

Fig 134. *Zero through Nine*, Jasper Johns. The Tate Gallery, London

of the technique. The reaction against Action Painting had much in common with the reaction of late 19th-century painters against the non-involvement of Impressionism. In order to get back into close touch with reality many of these artists began to use familiar and well-worn images from everyday life. Perhaps because they were at the centre of this reaction some young American artists such as Jasper Johns began to use numbers, maps, targets, letters and flags as the formal basis for their paintings (fig 134) still using the touch and personal paint quality of Action Painting, but relating it now to predetermined and universally accepted images which left little room for formal manipulation. The aim which sustained this new involvement with reality was not one concerned with the traditional creation of the illusion of everyday objects, but rather with that of posing the question, 'Is this a real object or is it a painting?' This was perhaps a more direct way of posing the question which is also implicit in Rauschenberg's work, (already discussed). That the same question was also exercising some of the original Action Painters is indicated, for example, in the late work of de Kooning who modified the principles of Action Painting and began to make images based upon standardised 'pin-up' female figures, including Marilyn Monroe.

The introduction of this kind of imagery into so-called 'fine art' may prove to be as big a turning-point in artistic expression as was Cézanne's rejection of traditional form or the Surrealists' revelation of the subconscious. From its beginnings in the 19th century, modern art has inspired and influenced the growth of new forms in modern environment, from architecture to the ephemeral images of advertising. By the 1960s these forms and images had become the accepted currency of everyday visual experience – new urban building, advertising, cinema, TV and popular entertainment. It occurred to some artists that here was the real cultural expression of modern life as close to the experience of the man in the street as were the scenes and situations painted by, say, the 'genre' painters of 17th-century Holland.

While the movement which initiated this new kind of painting was strongest in America, similar developments were taking place elsewhere, and especially in Britain. Taking one of the most popular themes in contemporary entertainment, for example, Peter Phillips has used the images of two female film idols (fig 135) and creates an object rather than a painting, in the style of the amusement arcade. It is difficult to think of another style which would be more appropriate of expressing at one and the same time the familiarity and the remoteness which exists between the contemporary public and its popular heroes and heroines.

Fig 135. *For Men only, Marilyn Monroe and Brigitte Bardot starring*, Peter Phillips. British Council, on loan to Calouste Gulbenkian Foundation, London

Like modern artists in many other spheres, the American painter Wesselmann has concentrated on the great popular theme of sex in his 'Bathtub' and 'Great American Nude' series. In these highly original works he not only depicts, frankly, aspects of life which are still subject to obscurantist censorship, but he is also concerned with the formal and symbolic problem of creating an object which is half-way between the reality of the world of the spectator and the illusion of a work of art.

In his 'Great American Nude No. 48, 1963' (fig 136) the window, plastic fruit and flowers, the radiator, table and rug are real objects. The bed, the vase of flowers above it, the replica of the picture by Matisse and the figure are all painted. The artist creates novel visual tensions between different kinds of reality – the physical existence of the flowers on the table, the painted image of the flowers in the background and his reproduction of the flower images created by Matisse. A similar tension is created between the three-dimensional space and two-dimensional painted surface with its illusions of space; this is heightened by the inescapable comparison between the pictorial space in the 'Matisse' and the collaged photograph of the city framed by the window – which is truer, which more real? We are made to reconsider what we mean by reality, and it is ironic to note that the main focus of attention in the work, the nude, is the least 'realistic' part.

Thus to many artists the objects of 'popular art' – posters, signs, advertisements, strip cartoons, etc – have become the most significant part of our environment, and therefore are as valid subjects for painting as were the hand-made everyday objects of the 18th century from which Chardin created his still-life compositions. Thus the American Lichtenstein, has used strip cartoons as the basis for his paintings by greatly enlarging the original images to above life-size. A comparison between the resulting paintings and the originals shows that his images are given a new significance through subtle alterations, whilst the effect of the enormous increase in scale in many of these works is that, as one moves nearer to them the representational image disappears and one is conscious only of the abstract relationships of shape and colour. This is perhaps a solution with a new twist to the artist's problem of reconciling the reality of the external world with the two-dimensional reality of the painting (see Maurice Denis's famous statement, page 113). In fact, of course, the actual graphic style of such strip cartoons is in itself almost as highly simplified and formalised as, say, Egyptian art, and it is only through everyday familiarity with this popular form that most people have come to accept these conventions and to regard such drawing as being realistic.

Fig 136. *The Great American Nude No. 48, 1963*, Tom Wesselmann. Dayton's Gallery 12, New York

The emotional content of the typical strip cartoon is as formalised as is the style of drawing, and some critics have suggested that Lichtenstein's work is an ironic comment on the way in which the emotional life of many people today is being conditioned and ritualised by such popular art. The paintings seem to express both the beauty of certain common emotions and the vulgarity which results from the debasing of emotion, and in this connection the contrast or tension between the highly emotional or violent content of his images (fig 137) and the beauty of the abstracted shapes of which they are composed is particularly significant.

One logical and predictable development of Pop art was to use the actual ephemera of advertising, packaging, etc., itself as a work

Fig 137. *Whaam, 1963*, Roy Lichtenstein. The Tate Gallery, London

of art – Duchamp's 'ready-mades' brought up to date. This is what the American artist Warhol attempted to do in 1964 when he arranged an exhibition consisting entirely of exact facsimiles of commercial packaging repeated in large numbers (fig 138). It was, as if he were suggesting that perhaps the supermarket is the real popular art gallery of today. Warhol has used the theme of repetition in much of his work, as if he accepts, and turns to his own creative purpose just that uniformity and conformity which the machine age imposes, and against which the Action Painters were rebelling. Some of his most interesting works are a series of compositions made up of identical photographs of scenes of violence and disaster. By this repetition of the image he achieved an effect in which the actual content of the scenes seems to disappear leaving one conscious only of the visual pattern which they make. Here, perhaps, Warhol is making a comment on the complex effects of mass media on our awareness of reality – how repetition may implant an image firmly in our minds, but may at the same time reduce our emotional response to events through over-familiarity.

Seen from another point of view the whole development of Pop art might be regarded as a desperate attempt by the artist to escape the domination of an establishment culture. Hitherto commercial images have been despised as being the antithesis of 'fine art'. But, as the old accepted values of 'fine art' became more and more

Fig 138. *Brillo Boxes*, Andy Warhol. Leo Castelli Gallery, New York

irrelevant in modern times, and novelty became the only criterion of the fashionable 'art lover' a situation came about in which as one Pop artist put it, 'even a paint rag could be accepted as a work of art!' To a number of artists the problem then seemed to be how to make something so non-art in character that it would not be accepted: they chose, therefore, to use the despised images of commercial art. But even Pop art, for all its use of the vulgar, the hackneyed and the commonplace, has begun to be accepted as a form of élite art. However, its full cultural potentialities still remain to be realised. Its real significance lies in the way that it has removed art from its traditional pedestal, and taken it out of the artificial atmosphere of the private and public gallery into the mainstream of life. Already it is influencing the world of commercial art which inspired it, in everything from graphics and display to interior decoration. It may yet become one of the main styles of the younger generations, an ephemeral art of cheap throwaway objects which can take their place in the modern environment, from private interior to public places of entertainment.

The Pop art object is no less meaningful for its being ephemeral; the quality of permanence which we have come to look for in traditional art is of doubtful importance in any period and may be altogether irrelevant to many forms of modern art. Indeed, the manner in which the latest piece of Pop art inspires the next and is then itself dead and discarded is wholly appropriate to a culture which accepts the principle of constant change and renewal.

POST-PAINTERLY ABSTRACTION: HARD-EDGE
ABSTRACTION

In both England and America the reaction against Action Painting took yet another form. This was essentially a return to classical abstract art, and some of the earlier pioneers of this form, such as Joseph Albers now became the leaders of this post-war development. This new phase of abstract art usually consists of paintings, often very large, in which the formal structure is worked out according to a clearly defined and easily understood programme. This kind of art has one thing in common with Action Painting however, in that the final results of the programme cannot be foreseen by the artist. That is to say, the artist may for example decide on a composition of a certain order of shapes treated with a planned arrangement of colours without being able to forecast the precise optical effects which these shapes and colours will create. He works, in fact, rather like an experimental scientist who plans a series of experiments hoping for some positive result, the exact nature of which he cannot predict. It is interesting to note that experiments

Fig 139. *Hyena Stomp, 1962*, Frank Stella. The Tate Gallery, London

have already been made in programming computers to produce designs in exactly this way – perhaps another example of the convergence of art and science.

An important feature of this kind of painting is that it often depends on colour relationships to create effects of space, (see Cézanne – Chapter 6), movement and other optical effects such as the flickering of colours or the stimulation of after-images. The American artist Noland uses this technique in one of his paintings in which the composition is strictly formal, a series of circles centred on the exact middle of the square canvas. The use of very intense pure colours to define the shapes creates various effects. Having looked at such a painting for several minutes the circles gradually appear to move in and out, the colours begin to flicker and the whole composition appears to revolve.

Similarly, in Frank Stella's painting (fig 139) the shapes, based on a rectilinear spiral, divided into four sections, are rendered according to a carefully planned colour programme. Here also the colour relationships combining with the geometrical structure, create

surprising effects of space which seem to fluctuate before one's eyes.

Another interesting development in contemporary abstract painting is that artists have begun to break away from the limitations of the rectangular canvas. Many now use eccentrically shaped canvases and some, like the British artist Richard Smith paint on three-dimensional surfaces. By using this form, new relationships are created between real and illusory space in which the colours sometimes enhance and sometimes contradict the actual space.

CONTEMPORARY BRITISH SCULPTURE

The three-dimensional work of such painters as Smith is another typical example of how the barriers between different forms of expression are being broken down. A similar development from sculpture towards painting can be seen in the work of a number of younger British artists who in recent years have been making sculptures in which colour plays an important part.

Fig 140. *Nenuphar, 1965,* Michael Bolus. The Tate Gallery, London

This work clearly represents a reaction against the sculptural principles of such artists as Henry Moore, whose materials and method belong essentially to the traditions of individual handicraft, in which the importance of the unique single piece is stressed. Whereas traditional sculpture always stands on a plinth, the new work always rests on the ground, sometimes, as in Michael Bolus's piece, (fig 140) actually lying flat along the floor. It thus seems to have a point in common with much Pop art, in demanding that the work of art should no longer be regarded as a precious object, but should take its place along with the furniture as part of our environment.

Whereas the earlier sculpture depends for much of its effect on the artist's feeling for his material, and on his ability to discover forms which correspond to the nature of the material, the new sculpture uses whatever materials (sheet metal, aluminium, plastics, synthetic resins, etc) are most suitable to the shapes which the artist desires to make. This implies that the artist has at last accepted modern technology and the idea that a work of art can be machine made. He need no longer be limited by his materials since science can now supply an almost unlimited range of materials to answer particular needs. While the surface quality of much traditional work always derived from the nature of the material and the artist's personal handling of it, the new sculpture is always covered with a skin of paint so that it is virtually impossible to identify the underlying material – Bolus's work, for example, might have been made equally well in plywood, plastic sheet or cardboard: in fact it is aluminium. Moreover, work such as this is often actually made in a workshop by skilled technicians using modern precision machinery, and not touched at all by the artist who may only make a drawing or small model from which the technicians work. Lacking the surface qualities and personal handling of the artist, such as we find in a Moore or Hepworth sculpture and which almost demands that we touch it, this new work, by contrast, with its immaculate painted surface, virtually forbids such contact.

Like the abstract painting described above, the new sculpture is often based on a carefully worked out formula. In the piece by Bolus the three interlocking shapes coloured in yellow, blue, beige and black, form a kind of spiral. The arms are raised at different angles, inversely related to the spatial effect of the colours. In the work by Philip King (fig 141) the formula seems designed to create a state of ambiguity. A series of cones are set, one within the other, at different angles; the positive (convex) outside areas are painted in a negative matt black, and the negative (concave) areas in a very positive, brilliant orange.

Fig 141. *And the Birds began to Sing*, Philip King. The Tate Gallery, London

Both the painting and sculpture just described can be understood as corresponding with and expressing distinctive characteristics of contemporary life. In the first place it is altogether urban and artificial and seems to bear no relationship to nature whatsoever; it thus reflects the kind of environment in which all major cultural development takes place, and in which the majority of people live today. Secondly, this art is often concerned with a kind of visual ambiguity so that, for example, we often seem to be confronted with two kinds of space at once. This may be seen as relating to the importance of ambiguity in modern science, where phenomena such as the electron may only be definable by two contradictory ideas. Thirdly, the effect which is often created of shifting, changing images may correspond with our everyday experience in which our senses are bombarded by the signs, colours, lights and screens of mass media. And finally, the impersonal quality of such work – its deliberate avoidance of emotional expression – by contrast with the highly personal work of the action painters, and of sculptors such as Moore, probably reflects the cultivated detachment and non-involvement of

a large section of the younger generation today. It is perhaps significant that this kind of art has developed at a time when television has become the most influential medium of mass-communication. Television, which McLuhan has described as the ultimate in 'cool' media, has the double effect of involving the viewer to a greater degree than any other medium, whilst at the same time presenting the image in a detached and unemotional way. In the same way much contemporary art involves the viewer, by being a part of his environment, by using light and movement, or even by being under the control of the viewer so that he becomes an active participant in it. Yet at the same time the work itself expresses no emotion. Both TV and contemporary art may of course arouse emotion without themselves being at all 'expressive' in a traditional sense.

OP ART

The special concern which most contemporary artists show for ambiguity, or what we might call 'in-between states' results from a new critical exploration of reality, equally evident in modern philosophy and science, which questions all conventional preconceptions of how we see, think and feel, and which rejects the idea that there can be any clear distinction between so-called objective and subjective reality. Thus the whole process of visual perception has become a key subject for exploration and re-evaluation by artist and scientist alike, and has given rise to a body of artists who have made this the focus of their work.

Allied in some ways to the position of the Post-Painterly Abstractionists, these artists depend almost entirely on the creation of ambiguous *optical* effects, often dispensing with colour, and using only the binary effects of black and white and the simplest geometric shapes and patterns. In the painting (fig 142) by Vasarely, the basic pattern is of black squares on a white background. By progressively enlarging the squares in the upper section of the canvas, Vasarely creates a pulsating effect like slow explosions – the supernovae of his title. Immediately below he creates a dynamic sideways movement in one band of squares by deforming them into diamonds, thus appearing to divide the upper area of the canvas from the lower while at the same time linking them by movement. In the lower section of the canvas some of the squares become progressively enlarged discs, and such is the effect that the black seems to 'glow' with a kind of non-light or, to put it another way, the visual ambiguity is such that it is impossible to decide which shapes are positive and which negative as between the white squares and the black circles. A work such as this seems to refer to both the macrocosm and the micro-

cosm of the universe, from the vast energies of giant stars down to the relationship of sub-atomic particles from which they are composed.

In the painting (fig 143) by Bridget Riley, the artist uses a different

Fig 142. *Supernovae*, Victor Vasarely. The Tate Gallery, London

Fig 143. *Fall, 1963,*
Bridget Riley. The Tate
Gallery, London

kind of visual ambiguity based on even simpler units than those in the Vasarely. The image consists of one undulating line, drawn with a stencil, and repeated over the whole surface of the canvas at regular intervals, 240 times. In this way a violent and disturbing optical effect is set up. The surface of the picture shimmers and shifts; at one moment the crests of the waves project, then seem to become hollows; occasionally all the curves become crests and all the areas in between become hollows which, in fact, is impossible. At other moments whole areas seem to dissolve while others become stronger, and in some circumstances one even begins to see colour in the black and white lines.

The main object then, as seen in these examples is to use pattern and shape to create illusory and ambiguous effects. Essentially, of course, this is much the same as the use of perspective and other devices in traditional art to create the ambiguity of a three-dimensional illusion on a two-dimensional surface, a method which was carried to an extreme degree, in 'deceiving' the eye, in Baroque art. The difference is that traditional perpsective corresponds, more or

less, with the way in which our minds normally work in order to make sense out of our visual perceptions. That is to say, our mind structures what the eye perceives into an understanding of three-dimensional space (although, in fact, perspective does this only in a very limited and often misleading way as was implied in the development of Cubism).

The work of the Op artist challenges conventional ideas of visual perception. Its implications coincide with the findings of modern psychology which have shown that seeing is as much a mental ordering of sense data as it is a physiological experience. It has been suggested that if we can become aware of perception as perception, and go beyond our habitual mental structuring of sense data, which has become conditioned by now redundant cultural patterns, we may be able to achieve a new grasp of phenomena, and deepen our understanding of reality. The 'mind-blowing' effects of drugs such as LSD may do this for some people; Op art and other kinds of modern visual expression may achieve the same sort of result at less risk. At any rate, it can be claimed that this kind of art, and indeed all modern art which questions the relationship between image and reality, may teach us not to be content with formal conceptual ideas or with pre-defined patterns of understanding. Through the new experience which we get from art we may learn to think laterally instead of vertically and, as writers like Edward de Bono have pointed out, there may be much to be gained by that.

A few simple visual exercises will serve to clarify the ideas which underlie Op art. Consider the drawings of a cube (fig 144). Can you decide which way it exists in space; that is, which planes are in front of which, or which do you see as outside and inside? Whether you see (a) as (b) or (c) depends, not on your actual visual experience, but on the way your mind structures the information which your eye provides. In other words, what the eye registers is constant, but the resulting image which you see is chosen mentally. Ambiguity exists even in this simple diagram because despite the clearer definition of the planes even (b) and (c) can be mentally structured so that each can be seen to occupy space in two different ways. And because the mind has a predetermined pattern for interpreting such a

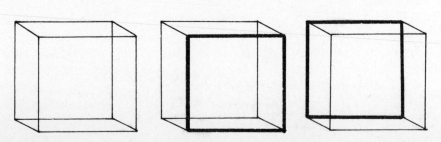

Fig 144. Optical ambiguities in the linear drawing of a cube

Fig 145. Illogical structure
only capable of
expression in a drawn
image

Fig 146. Intersecting lines
creating the illusion of
diagonals or 'moire'
pattern

figure as three-dimensional, it is virtually impossible to see any of
these figures as being two-dimensional.

It is possible to draw many figures which are structurally impos-
sible. In the drawing (fig 145), each corner, regarded separately,
makes sense. But the mind cannot make a logical structure from the
whole form. Nevertheless, an attempt to understand the whole
figure may stretch our minds in such a way as to give us some idea of
what, for example, a four-dimensional space might look like.
Illusion and reality combine again in fig 146. Do the wavy, diagonal
lines really exist? This figure, made by superimposing two identical
grids of parallel lines at a slight angle to each other, creates what is
called a 'moire' pattern, an effect which has been widely used by
Op and Kinetic artists (see Soto below). The creation of the illusion
of patterns which are not actually there is one of the key ideas in
these styles.

Op art and Post-Painterly Abstraction combine in the works of
such artists as Michael Kidner. We find in his 'Orange and Violet'
(fig 147 – facing page 185) that after looking at it for some time, sur-
prising things begin to happen affecting the space, the width of the
bands, the tone of the colours and the relationship of the colours
themselves.

KINETIC ART
It could be said that art first ceased to be static with the coming of the
Baroque period, when the ideas of a dynamic universe became part
of the cultural climate. However, until the 20th century the idea of
movement was symbolised simply by expressive use of shape and
line in what were otherwise static paintings or sculpture. The moving

image only became possible in the industrial age as new ideas of time, space and locomotion developed. The actual or mechanical element of movement in art was presaged, of course, by such novelties as the 19th century kaleidoscope and the early cinematograph. However, it was the cubists who, despite their adherence to conventional painting on canvas, first introduced a new idea of movement in art through their conception of a multiple image implying a sequence of events in time and space. The Cubists, however, were still concerned primarily with the reality of mass and space rather than with movement.

It was the Futurists, a group of Italian artists who flourished between 1910 and 1915, who first proposed an art in which dynamic movement was to be the main element. Influenced by the formal discoveries of the Cubists, but more directly inspired by Bergson's philosophy of change, and by the romantic and violent writings of the poet Marinetti, the group which included such artists as Boccioni, Balla, Carra and Severini, published a series of manifestos proclaiming what they called the new beauty of the modern world. They proposed a new urban aesthetic which repudiated the classical past, and venerated the new power of the machine – its dynamic action, movement, speed and noise.

Their violent statements and noisy propaganda (they would, they said, destroy all the museums) and the discredit which Marinetti's Fascist affinities brought them, has tended to overshadow their serious artistic aims. Chief among these aims was the expression of the dynamism of modern life through painting images of its rhythms

Fig 148. Kinetic Sculpture (Standing Wave), 1920, Naum Gabo. The Tate Gallery, London

Fig 149. Linear Construction, Naum Gabo. The Tate Gallery, London

and movement. Boccioni, the main spokesman for the painters, said 'movement and light dissolve substance' and again 'we want to paint not the motor car but its speed'. For the Futurist 'a galloping horse has twenty legs not four'. Their main object was thus to find formal means of depicting not solid masses but the rhythms and lines of movement made by bodies moving in space. ('The material of our existence is nothing but a system of sensations and movements occupying continually different parts of space' – Bergson.) In the event the Futurists' ideas seemed to outstrip their technical invention. Their images of movement are often naïve, fairly conventional paintings of people or animals with literal suggestions of twenty-four legs to indicate movement. By adhering to conventional oil-painting technique even Boccioni failed to achieve the 'dissolving of substance through movement and light', although it is said that he proposed to use other transparent and linear materials such as glass, plastics and wire. However, there is little doubt that the Futurists made an important contribution to the new climate in which photography, cinematography, as well as painting and sculpture were becoming more and more concerned with the theme of movement. They were, moreover, in the forefront of those artists who first accepted the idea of constant change in the modern world and despite their romanticism, they take their place with artists like Le Corbusier and Léger in understanding the significance of a machine-made environment.

It remained, however, for others less romantic and more scientific in their approach to perfect a new Kinetic art. In 1920 the Russian sculptor, Naum Gabo, published a manifesto on 'Constructive Art', which was one of the key statements in the history of classical abstract art. In it he announced the disappearance of mass as an element in sculpture, proclaimed the use of line as direction and depth as the one form of space, and renounced 'the thousand year old delusion that static rhythm is the only element of sculpture and painting'. This manifesto was a clear and deliberate attempt to relate art to contemporary science and technology, both in the ideas which it expressed and, unlike the Futurists, in the materials and techniques which it used. In the same year Gabo made a Kinetic sculpture (fig 148); a simple metal rod vibrated by an electric motor in such a way that an effect of space and mass is created by a linear movement. Later Gabo was to produce a series of constructions with curved and flat planes of transparent plastic with threads stretched between them. The effect thus created was that the threads forming tangents were integrated into secondary curves, while the moire patterns of the threads caused tertiary curves, so that an entirely new system of sculptural space was created, without any reference at all to the

solid mass of traditional sculpture (fig 149). Such work embodies a variety of contemporary scientific ideas, including that of curved space and the replacement of solid mass by forces operating across spaces – the suspension bridge replaces the solid arch; the radio-wave replaces the mail-coach.

In the 1930s the American Alexander Calder, developed the idea of sculpture in which space would be described by movement. He achieved this by suspending coloured shapes, reminiscent of Miró, on balanced wire rods, in such a way that they would be motivated by the movement of the air (fig 150). The piece was thus given a random movement within the limits of its own structure (see note on uncertainty principle in previous chapter).

In recent years the making of Kinetic compositions which move either by air currents or by motors, has become one of the most important forms of art. Such work is often closely related to Op art, as in Soto's work (fig. 151) in which metal rods, suspended from the centre, swing gently over a striped background, thus creating random moire effects, so that the rods appear to be broken into vibrating lines of colour. The artist has described them as 'transformed into pure vibrations, the matter into energy'.

As with Op art, the main function of much Kinetic art (which might also include Bury's 'Balls and Cubes' – fig 128), seems to be an expansion of our perceptual awareness beyond the normal

Fig 150. Antennae with Red and Blue Dots, Calder. The Tate Gallery, London

Fig 151. *Cardenal*,
Jesus-Raphael Soto. The
Tate Gallery, London

structuring of sense data. It seems to link in a remarkable way,
modern science and technology, with contemporary research into
the coolness of one aspect of modern behaviour, and the stimulation
of the psychedelic light and sound shows of contemporary pop
groups.

Neo-Dada, Pop, Op, contemporary abstraction and Kinetics, the
artist today continues, as ever, to be concerned with some immediate
aspect of reality. At the present time he interprets in one way or
another the whole panorama of modern life from the most complex
and universal ideas of science to the simplest ephemera of popular
entertainment.

Conclusion

Here our study must end for the time being, although it is to be hoped that the reader may have been stimulated to explore the subject well beyond the limits of this book. It is also to be hoped that this last chapter may be revised and expanded at intervals in the future in order to keep abreast of the changing scene.

Meanwhile, without entering the dangerous field of prediction we may venture a few final comments which may help to clarify the present situation, and tentatively indicate some of the directions which art may take in the future. It is almost impossible objectively to analyse or to judge trends when one lives in the middle of the very events which shape them. Moreover, since our responses to art are always relative, and since art today is an integral part of the social changes which are taking place with unprecedented rapidity, it is impossible to say how the forms which are considered significant today will be viewed five or ten years hence. It should be clear from what has been said in the preceding chapters that it is in the nature of art to be unpredictable. The artist, as an explorer of reality is always 'drawing maps of the future', and it is a necessary part of his function that he should constantly surprise or even shock us into a new sense of awareness. We can never say what strange and exciting horizons the artist's private act of creation will next reveal to us.

None the less, since the artist never works in isolation from his times, and art remains as ever, a social activity, we can discern, if incompletely, some of the main tendencies in modern art as a whole. If we cannot say precisely what will be created, we can hazard a guess as to how art is likely to be produced, and how it may be used in the immediate future.

Perhaps the most obvious difference which we have noted between art now and that of the past two centuries or so is that contemporary art is ceasing to be private and exclusive to an élite, and is becoming more and more communal and environmental in character. Although the commercial art gallery remains one of the main outlets for the artist's work, and much contemporary work is still destined to find a home in private collections and conventional 'museums of modern art', a great deal of this work is of a character which does

not belong at all to a gallery environment, nor to that of the private collection. The most typical modern work in painting, graphics and sculpture, seems to demand instead, the natural everyday environ- ment of communal spaces – parks, streets, squares and other places where people gather for relaxation and amusement. Even when used in private the work of art is changing its character. A sculpture is no longer a separate special object standing on a pedestal, but now can stand on the floor, and by its colour and shape can harmonise with or counterpoint the furniture and overall design of the room; a painting is no longer a separate object added to a room, but may, by its scale, colour and form create the main visual and psychological character of its surroundings.

A natural extension of this new interdependence between art and everyday environment is the progressive breakdown of the division between 'fine' and 'functional' art. This has led in the past few years to a new use of colour and shape in every field of architecture and to a design which is at last creating a synthesis between the pioneering work of 19th- and 20th-century painters and sculptors, and that of architects, designers and engineers. This development might be referred to as the 'post-puritan' phase of modern design to indicate how the severe structuralism of early 20th-century architecture and design has come to be enriched by the expressive and decorative qualities of contemporary sculpture and painting.

Art, as we have seen, is always related to the economic pattern of the age and to the demands which the public make on the artist. Thus, the present trend towards environmental uses of art can be seen to result from a new kind of democratic patronage which as yet is only in its early stages. The wealthy collectors still necessarily monopolise the work of the great modern masters, while their dealers still indulge in 'genius building' and contrive to inflate the value of work by younger artists. But the notion that art can be for everyone (the pious and unfulfilled hope of William Morris in the 19th century) is no longer considered strange or impossible. Even the impecunious student today can have popular posters as gay and original as any art on his wall (fig 152). He has no delusions that they are timeless masterpieces; he will throw them away and replace them when they become tattered or when he tires of them.

In other words a demand for cheap non-durable art is creating a new patronage among the younger generations. In an age when youth dominates taste as never before, and when the young have at last their modest share of wealth they are in a position to influence the development of styles in art. Their restricted economic resources, a critical attitude to all established forms, and their demand for constant revaluation and change in life – all these factors have a

Fig 152. Pop poster.
Courtesy Big O Posters Ltd

bearing on the kind of art which will be created in the immediate future. Art, to be available to all cannot be unique or expensive. Thus, just as modern needs for practical things must be satisfied mainly by mass-production, so the multiple manufacture of inexpensive art is the inevitable answer to the new demand. Although

no one can say whether such objects might become collectors' pieces in the future, the basic idea in creating them is that they should be cheap and largely expendable. Already many artists are producing such works, and more and more are being attracted to this new idea of using modern technology to produce an art which is accessible to all (fig 153).

In the field of communal art also, these same factors are gradually modifying the forms and techniques of art. Commissions for unique and durable works will obviously remain an important part of public patronage, but the cost of large pieces in traditional materials such as stone and bronze is one of the main reasons why so few organisations commission this kind of work. This factor is leading to experimentation with new techniques and materials which will give greater flexibility in the conception of art for public use, e.g., cast concrete components for sculpture and reliefs, plastics used in a variety of two- and three-dimensional ways, new durable paints, not to mention the unlimited and largely untried possibilities of decorative and kinetic lighting.

Fig 153. Illuminated Kinetic Sculpture, Patrick Carpenter

Already the numerous new forms of popular art are changing our visual environment almost without our noticing the change, but until Pop art finally withdraws from the old-fashioned art gallery, its full possibilities will not be realised. Most Pop art, whether figurative or abstract, has a kind of topicality, wittiness and gaiety which finds it natural place in the unselfonscious atmosphere of the amusement arcade or pleasure garden. The recreational and educational possibilities of such work can be seen already in the few imaginative sculpture playgrounds for children, where the objects are made to be used as well as seen (fig 154). It now only remains for some imaginative section of public patronage to draw on all the exciting forms of popular art to create a new situation, a kind of 20th-century exhibition/fairground with Pop exhibits, kinetics, performances and happenings in which the public could participate to the full.

Finally, one of the developments which may have the deepest and most lasting influence on the future of art is the renewed influence which the artist is beginning to have on the growth of contemporary ideas. During the Renaissance the artist was valued by his patrons as a philosopher and thinker as well as for his art and, as in the case of Leonardo, he often made a profound contribution

Fig 154. Sculpture Playground
Greater London Council

to the ideas of his time. Since the 19th century, however, the artist, even when his work has been accepted, has been regarded as an outsider, and has been generally debarred from contributing directly to modern scientific thought or to the development of technology. Even the pioneers of contemporary architecture and design were treated with suspicion by the industrial and commercial world, and principles of modern design are still too often accepted only if they fit in with conventional patterns of commerce. In the past hundred years or so the mutual suspicion between artist and scientist has created a schism in cultural life which C. P. Snow has called the 'two cultures'. However, after more than a century of fruitless criticism and counter-criticism, there are signs that art and science are finding common ground in the recognition that one can enrich the other. The artist, while still jealously guarding his individual freedom is exploring more and more, those areas of reality unveiled by science, and no longer hesitates to use machine age technology and its materials.

Among many of the more imaginative leaders of science and industry, on the other hand, there is a growing recognition that the intuitive processes of apprehension by which the artist lives and works are indispensable in any field where people are dealing with creative problems, whether artistic, educational or scientific. A number of enlightened firms, engaged for example in fields of advanced technology such as aerodynamics or cybernetics, have found that the presence of a creative artist in their research teams can stimulate ideas and discover solutions, often at an intuitive rather than an intellectual level, and can thus counteract or by-pass conventional or stereotyped thinking patterns. A similar recognition of the artist's importance in contributing to the overall cultural development of the community is to be seen in the increasing number of resident artists and poets being appointed to colleges and universities where their role is to participate freely in the life and work of all faculties, and thus to broaden the horizons of specialised disciplines.

These comments are not, of course, intended to suggest that the artist is some kind of superior being, having superhuman gifts, to whom the rest of us must look to enrich our mundane lives. Art, no less than any other activity, has been diminished by the fragmentary character of modern society. The new *rapprochement* between art and science also enriches the artist and restores his work to the significant place which it held in great cultural periods in the past. But over and above the respective interests of artist and scientist, this reconciliation may at last lead to a new comprehension of the creative process which could lead not only to new roles for art, but could also change every aspect of culture – philosophical,

educational and scientific – the recognition that the creative impulse is common to all and that each individual has the capacity to make his own imaginative contribution to life if his talents are sympathetically cultivated – as Coomaraswamy said, 'The artist is not a special kind of person, but each person can be a special kind of artist.'

To envisage a world as some social prophets do in which everyone could be so creative that art as a professional activity might disappear would seem to be idealistic in the present circumstances. It is reasonable to suggest, however, that the process by which the artist communicates is becoming more widely understood and is thus assuming a new importance in fields not normally associated with artistic activity. There is no doubt that the mental activity of the creative scientist and that of the artist is similar. In both cases, as Arthur Koestler has pointed out in *The Act of Creation*, the essential process is one of discovering relationships between previously unrelated factors, and, since our conscious minds are trained to think along the well-worn paths of already established relationships, this is a process which seems to take place on a subconscious level. At that level there may be no difference at all between the work of the scientist and that of the artist. Furthermore, in the assessment of the results of this kind of intuitive creativity, aesthetic judgment would seem to be common to both scientist and artist.

All of this is very well illustrated by James Watson's account in *The Double Helix* of the discovery of the DNA molecule for which he, Francis Crick and Maurice Williams received a Nobel award in 1962. Essentially the problem was how to relate the chemical constituents of the molecule of heredity in a three-dimensional structure which would correspond with Wilkin's X-ray diffraction photographs of crystalline DNA and which would explain the manner in which the molecule replicates itself. The solution of this problem would enable science to know how genetic instructions are written in the gene and transmitted from one generation to another; it would be, and was, a major step in twentieth-century knowledge.

Watson describes how 'the main working tools in this task were a set of molecular models superficially resembling the constructional toys of pre-school children,' or, he might have added, resembling the maquettes of a sculptor. The turning point in this enterprise came when Watson, seated at his desk in the Cavendish Laboratory, was engaged in shuffling a set of cardboard shapes about, trying to form a significant pattern from them. At that moment he was, of course, behaving exactly like an abstract artist at work. Suddenly the shapes formed pairs which he instantly recognized as fulfilling all the requirements of the solution, and which would fit inside a double

helix structure. His excitement at this moment of revelation is exactly that of a sculptor when his forms fall into place.

The model which resulted from this activity was, in Watson's words, 'too pretty not to be true'. A new extension of knowledge had been revealed through a visual image. One is left speculating on whether the work of these scientists might not have been considerably speeded up by the inclusion in the team of a sculptor accustomed to thinking in three-dimensional terms. The day may come when an artist wins the Nobel Prize for physics, and, who knows, when a scientist may be acclaimed at the Museum of Modern Art.

The civilizations of the pre-scientific age, and especially those of the East, valued art as one of the main processes by which man might come to know the 'unknowable', and the artist as one who in his work revealed the pattern of the cosmos. The intuitive knowledge of ancient peoples concerning the nature of the universe and its creation is today being substantiated in remarkable detail by the discoveries of science, leading us to a new understanding of the interdependence of all things – an apprehension of the structural unity of the universe which was also the concern of the early mystics and philosophers.

The scientific adventure of modern man can be seen, therefore, as simply an extension of man's perennial quest to recreate the unity of the world, to trace his way back from matter to the original source of energy and light. In this new phase of knowledge the artistic principle is as essential to discovery as it was to the growth of religion and philosophy in the past. After a few centuries in which the artist has become progressively cut off from the mainstream of life, and during which his work was too often reduced to a mere commercial commodity, we may now be witnessing the beginning of an age in which art will regain its true role as a process by which man lives more fully in the exploration of his universe.

List of Illustrations

Index

Page numbers in **bold type** indicate main references
Page numbers in *italic type* indicate picture references

7